THOMSON

COURSE TECHNOLOGY

Professional ■ Technical ■ Reference

A Step-By-Step

Guide to Creating

Fabulous Images

of Any Woman

Digital
BOUDOIR
Photography

John G. Blair

Important: Thomson Course Technology PTR cannot provide software support. Please contact the appropriate software manufacturer's technical support line or Web site for assistance.

Thomson Course Technology PTR and the author have attempted throughout this book to distinguish proprietary trademarks from descriptive terms by following the capitalization style used by the manufacturer.

Information contained in this book has been obtained by Thomson Course Technology PTR from sources believed to be reliable. However, because of the possibility of human or mechanical error by our sources, Thomson Course Technology PTR, or others, the Publisher does not guarantee the accuracy, adequacy, or completeness of any information and is not responsible for any errors or omissions or the results obtained from use of such information. Readers should be particularly aware of the fact that the Internet is an ever-changing entity. Some facts may have changed since this book went to press.

Educational facilities, companies, and organizations interested in multiple copies or licensing of this book should contact the Publisher for quantity discount information. Training manuals, CD-ROMs, and portions of this book are also available individually or can be tailored for specific needs.

ISBN: 1-59863-220-5

Library of Congress Catalog Card Number: 2006923263

Printed in Canada

06 07 08 09 10 TC 10 9 8 7 6 5 4 3 2 1

Publisher and General Manager, Thomson Course Technology PTR:
Stacy L. Hiquet

Associate Director of Marketing:
Sarah O'Donnell

Manager of Editorial Services:
Heather Talbot

Marketing Manager:
Heather Hurley

Acquisitions Editor:
Megan Belanger

Project Editor:
Jenny Davidson

PTR Editorial Services Coordinator:
Elizabeth Furbish

Interior Layout Tech:
Bill Hartman

Cover Designer:
Mike Tanamachi

Indexer:
Kelly D. Henthorne

Proofreader:
Cathleen Snyder

THOMSON

COURSE TECHNOLOGY™

Professional ■ Technical ■ Reference

Thomson Course Technology PTR, a division of Thomson Learning Inc.
25 Thomson Place ■ Boston, MA 02210 ■ http://www.courseptr.com

Every Woman Is Beautiful!

My job, as an artist and photographer, is to release that special beauty and capture it in an image that she will treasure for a lifetime.

—*John G. Blair*

ACKNOWLEDGMENTS

IT WAS OVER 35 YEARS AGO that I realized that I really enjoyed photographing women. I soon found out that I really didn't know what I was doing, so I bought a copy of famous glamour photographer Peter Gowland's book, *How to Photograph Women*. It was through his mastery and explanation of the subject that my learning began. From that simple beginning, a career and love of photography has spanned nearly four decades. I owe him special gratitude for helping me begin.

In every book project there is a group of people working behind the scenes to make this all happen. My agent, Carole McClendon of Waterside Productions, was the one who first suggested that I write a book on boudoir photography after viewing my website. She then contacted various publishers to see where this book would be a good fit. She found Megan Belanger, an editor at Thomson Course Technology PTR, who really liked the concept and carried it through, and who shares my love for DDP. Jenny Davidson was the project editor and her hard work shows throughout the book, as does the work of Bill Hartman, who designed the layout of the book to make it so attractive. Jenny and I shared many long and detailed e-mails at late hours on weekends when all sane people should be sleeping, as we finalized this book to meet printing deadlines. Finally, a special thanks goes to my wife, Aleksandra, to whom I dedicate this book. Without her support and encouragement, as well as taking on extra jobs around the house, this book would not have been possible. I am lucky to have a wife who not only allows me to have beautiful scantily clad women walking about, but who also makes lunch for all of them and encourages me along the path. I love you, Mrs. Sweetie™.

And now on to the book… Good luck with your journey. Feel free to contact me at www.johngblair.com if you have any questions or suggestions along the way.

ABOUT THE AUTHOR

JOHN G. BLAIR began writing and photographing in elementary school, publishing and selling his own newspaper at age 10. He has been a professional photographer for over 35 years, with a specialty of photographing women. He is experienced in boudoir, portrait, wedding, commercial, editorial, and fine art photography. He has worked in various aspects of digital photography since 1991, starting in Photoshop 2.5! His boudoir photography and scenes of him at work were featured on the French television program, *This Crazy World.*

He has taught courses, presented seminars, and lectured on photographic and business topics to groups of all ages from middle school children to professionals. He has presented a number of boudoir and makeup courses to professional photographers as well. John's award-winning work has led to his being named Photographer of the Year twice in five Northern California counties. He has received a number of awards and honors from the Professional Photographers of California. His studio is located in the redwood forests of Northern California, which he shares with his wife and three large dogs. In his spare time, he is a volunteer firefighter.

© Aleksandra Takala

Author with Sequoia, one of his studio assistants.

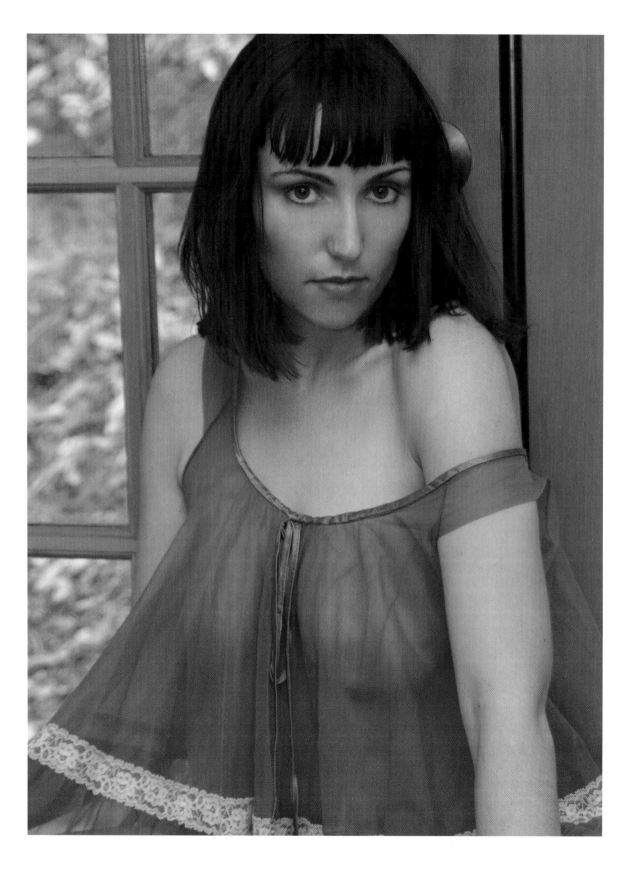

CONTENTS

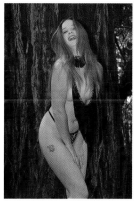

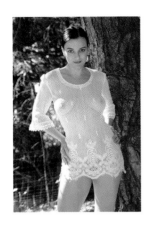

Section 3
Lessons

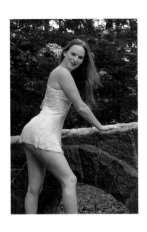

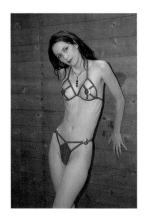

Section 6
Resources 235

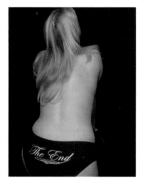

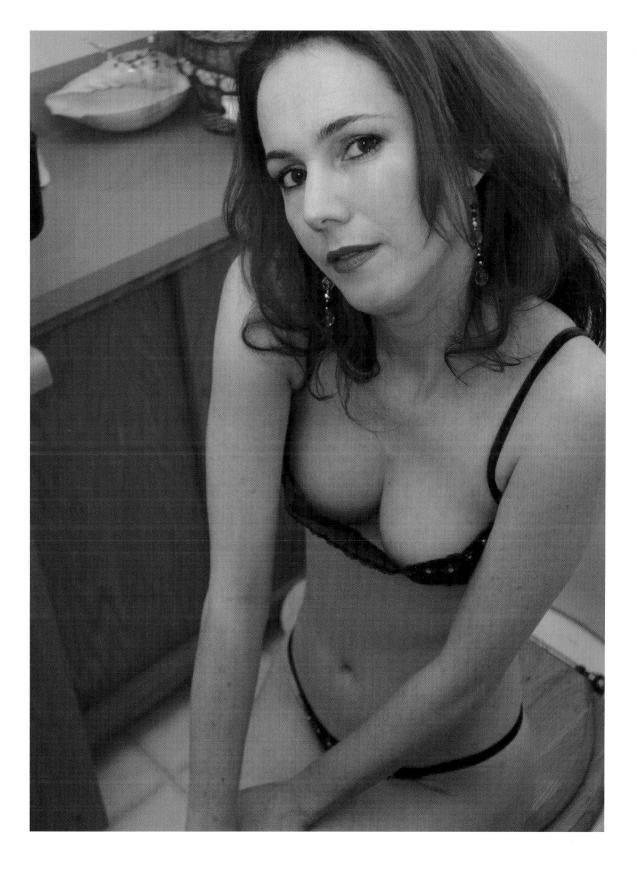

INTRODUCTION

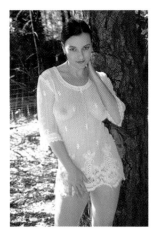

Boudoir photography is the art of creating beautiful, sensual, and sexy images of regular women. You don't have to be an 18-year-old, pencil-thin supermodel to look fabulous in photographs. As the introductory motto says, "Every Woman Is Beautiful." It doesn't matter how young or old you are (as long as you are of minimum legal age, of course), how tall or how thin, the purpose of boudoir photography is to make YOU look great. You don't have to lose ten pounds or have plastic surgery either. This book will show you how to create those images.

Boudoir photography seems to be growing in popularity again, after a decline through the late 1990s. The reason is simple: digital photography. This gives ordinary people the ability to take sexy photographs and keep them private. You don't have to worry about the 18-year-old kid who works at the local mini lab seeing the images. Before digital, some people had darkrooms and could develop and print their own photographs. Developing your own color photography was difficult, messy, and expensive. Even black-and-white photography involved mixing and playing with your own chemistry. Not everyone had access to a space where they could easily set up a darkroom without disrupting the household. All of this, plus the smell and mess of toxic chemicals; no wonder that doing it yourself with digital has taken off. The downside to digital photography is the proliferation of really poor-quality photography. There are so many photographs that accentuate a woman's weak areas and fail to show off her best ones. Visit any file-sharing website and you will be able to see for yourself. This is the reason that this book has come into being.

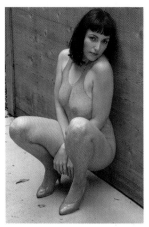

Throughout this book, for ease of language, we will assume that the subject of the photographs is a woman and the photographer is a man. Historically, this has been true in a majority of cases. In reality, there are many fine female boudoir photographers, and men like to be desired and thought of as sexy also. We will refer to the female subject as "the model," but this does not mean that women need to be models to have boudoir photographs taken. In fact, the very subject of boudoir photography is about photographing women who are not models.

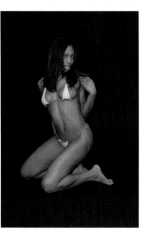

This book is designed for photographers and the women in their lives. The photographers can be amateur, professional, or semi-pro. They can have a wide range of experience and skill. The women include wives, girlfriends, and potential customers. All of these groups will benefit by reading this book and following the lessons inside. The majority of photographs were created with very simple equipment that is not out of the price range of beginning professionals, semi-professionals, and avid amateur photographers. Many of the images could have been done with an inexpensive, compact digital camera. A large studio, assistants, and professional models are not a requirement to apply what you will learn by studying this book.

If you have questions, would like to see technical information on some of the photographs, or have suggestions for future editions, please visit the *Digital Boudoir Photography* section of the author's website at www.johngblair.com.

Before we get into the main part of the book, the models need to be introduced. You will be seeing a lot of them throughout this book. They range in age from 23 to 56. Some are tall and some are short. Some are thin and some are not. They are professionals, students, wives, girlfriends, and mothers. One is a long-term cancer survivor, having endured multiple treatments and surgeries. They are special. They are everywoman. Most of the women traveled to the studio multiple times—some drove two to three hours each way to get here. They endured cold and wet and long hours of work. They all put in a tremendous effort to bring you the example images. Together we created about 12,000 images to be able to choose and illustrate the lessons that follow. A special thanks is due to them for participating in this project and showing the world a more private part of themselves. Many of them started out as strangers to me, but they are all friends now.

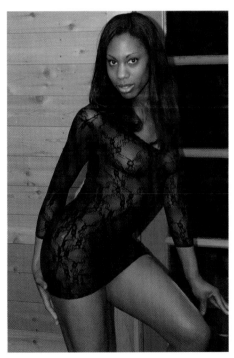

Amelia Marie

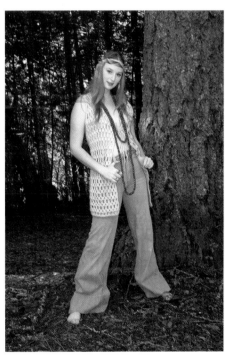

Danaë

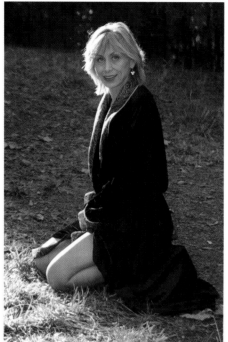

Deborah Shemesh

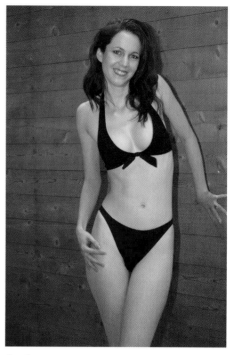

Iona Lynn

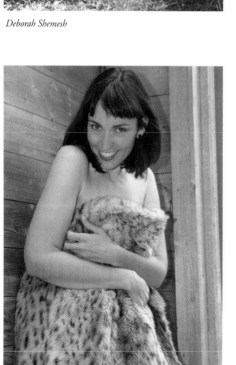

Jessica

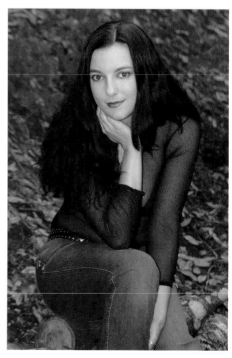

Joanna

Linda

Melanie

Stephanie

Tanya Renee Thrall

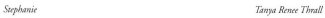

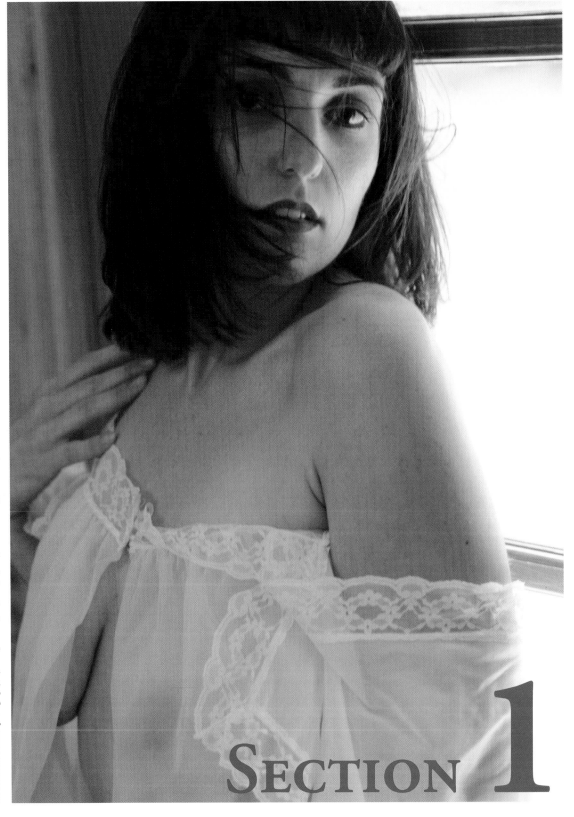

At one time, boudoir photography referred primarily to photographs of women in lingerie, usually in a bedroom scene.

SECTION 1

BACKGROUND

THE SENSUAL DEPICTION of the human female form has been around since cavemen first picked up a piece of charcoal to draw on the wall of a cave. The history of painting is filled with images of women, often portrayed nude or seminude. Early photographers began creating nudes as "artist studies" to get around the moral codes of the day. They would create packets of cards of women in various poses supposedly for artists to use. Photographic albums of nudes appeared around 1890 in France. Then, about 1900, the French postcard was born and sold in secret in shops throughout Paris. These first "sexy" pictures were really a production operation. They were not concerned with the quality of the costumes, models, location, props, or posing. The photographs just had to be sexy and usually have some nudity in them. In 1888, the first camera for amateurs, the Kodak, came out. This allowed anyone to create photographs for the first time without having to deal with all of the chemicals.

According to Carla and Bob Calkins, owners of Motherlode Photography, a professional photography studio in Diamond Springs, California, they invented the term "boudoir portrait" in early 1980 after photographing a client who had trouble describing that she wanted a portrait created with only some of her clothes on. They were looking for a term that offered more elegance than "erotic portrait," "seminude portrait," or "sexy portrait." They chose "boudoir" because it was a French word meaning bedroom. Early boudoir portraits mainly featured women wearing lingerie in bedroom locations. Since then it has grown and grown.

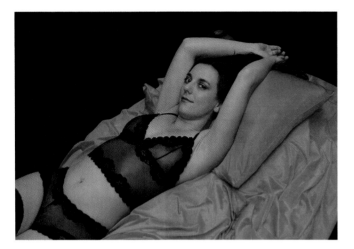

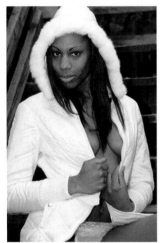

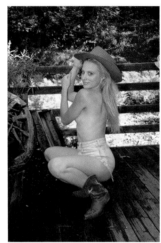

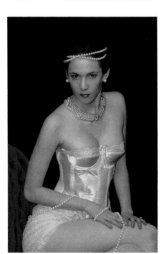

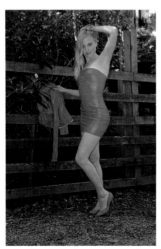

Now the range of what can be considered a boudoir portrait is much wider.

The height of the popularity of boudoir photography was in the late 1980s. It began dying out in the 1990s. At one time, many professional photography studios offered boudoir photography to their clients. Once the fad slowed down, many professional studios dropped it. Now it is much more difficult to find a professional photographer who is really good at creating boudoir portraits. Once digital photography started to become popular after the beginning of the 21st century, ordinary people, mainly men, began taking sexy photographs of their love interests. The privacy and immediacy of digital photography along with the easy distribution of images were the primary driving forces behind this resurgence. But boudoir photography has changed. The term "boudoir photography" can now be applied to nearly any sexy or sensual portrait of a woman. Some photographers specialize in a very soft, sensual style of portrait. Others include artistic nudes or even glamour nudes, such as what might be found in men's magazines. Boudoir photographs can be revealing, but they don't have to be. The usual definition of boudoir photography implies that it is more soft and sensual than erotic and sexual. The latter images are usually called "glamour photographs." "Glamour photographs" should not be confused with the so-called "glamour portraits" which first appeared in malls in the early 1990s. Glamour portraits can generally be described as waist-up or head-and-shoulder portraits of a woman with lots of makeup and often a very large, teased hairdo. It is a far cry from the natural-looking boudoir photography of today. So the definition of boudoir photography we will stick with throughout this book is generally soft, sensual, and sexy portraits of a woman.

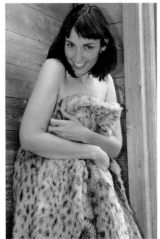
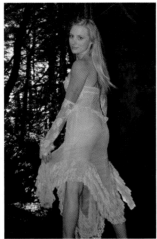

Boudoir photography has some real benefits for both the photographer and the model. Because of pressures of society, women often feel that they are not pretty enough, skinny enough, or sexy enough. The constant media barrage of beautiful, thin models gracing magazine covers reinforces that view. A gorgeous, sexy photograph of your model helps to raise her self-esteem. Boudoir photography is a difficult craft to master. The less clothing that the model is wearing, the more difficult the subject becomes. A photographer who becomes skilled and experienced in making women look fabulous in photographs, no matter their age or weight, will receive lots of positive feedback from his models, raising his own self-esteem as well.

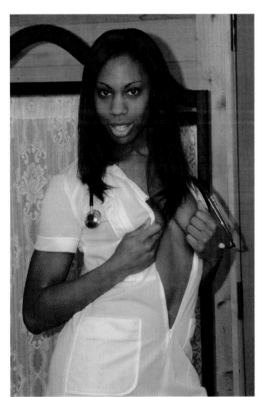
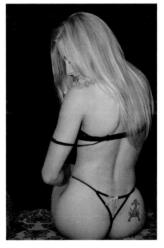
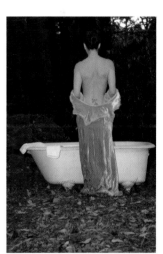
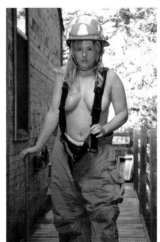
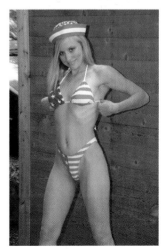

SECTION 2

THE STEPS

PHOTOGRAPHERS AND would-be photographers often ask how they can photograph women and make them look great. I know when I want to learn to do something, I don't want a bunch of flowery words; I just want to be told how to do it in a straightforward manner. I don't want the details left out, but I don't want to have to read a lot of fluff either. That is how I intend to present this section of the book. Simple, easy steps designed to take you from here to there with no muss and no fuss and lots of images along the way to inspire and teach.

In this section, I'm going to lead you step-by-step through the necessary actions to create beautiful, sexy, sensual boudoir images. I know you are anxious to grab the camera and start firing away, but trust me, you will be much more successful in the long run if you take it slow and easy and follow the plan outlined in this section of the book. Even though some of the steps are logical and obvious, it is good discipline to follow them anyway.

Steps 1, 2, and 3 only have to be done once. The other steps should be followed each time you photograph. I follow the steps today, even after 30 years of practice. Let's get started with Step 1.

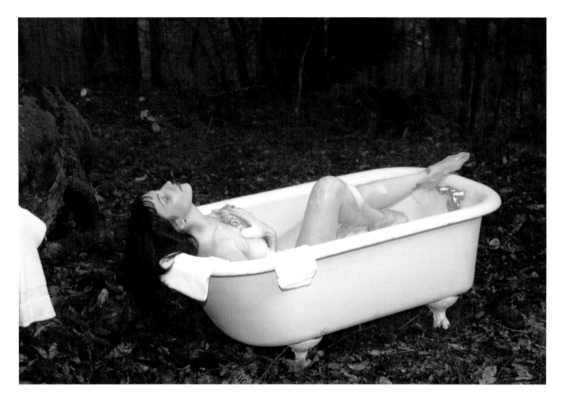

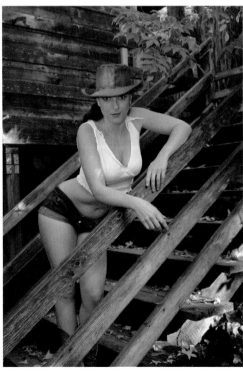

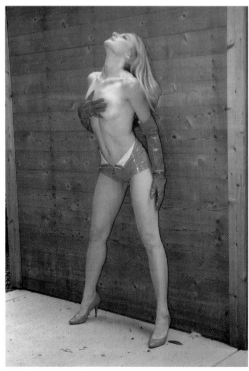

STEP 1: DETERMINING YOUR GOALS

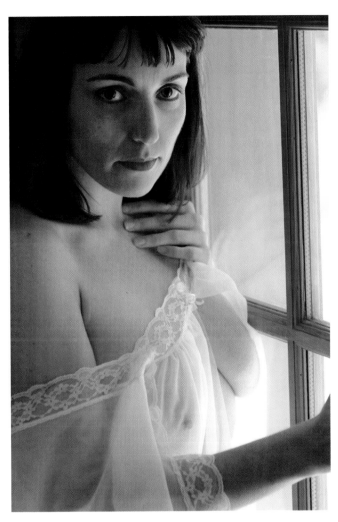

The first step is to ask yourself, "Why am I making these images?" There are a number of possibilities; here are several of the more prominent ones:

- **Just for fun.** You and your wife or girlfriend may just want to try a fun project you can do together. There are opportunities to shop for props and costumes, work together on ideas for scenarios, travel to beautiful locations, have fun doing the actual photography, enjoy editing and selecting images, and retouch the images to create the vision that you both have.

- **To share photographs.** Some people like to make friends online and share photographs as a couple or as an individual. Sometimes these images are shared with close friends who are far away or with potential new friends.

- **As a hobby.** You may enjoy photographing or being photographed ("modeling") as a hobby and you are looking for an interesting or more difficult subject matter.

- **For beginning professional photography.** You are just starting out as a professional photographer—an "emerging photographer" is a term often used—and you want to learn how to deal with this fun and interesting subject.

- **As a new area of professional photography for your studio.** You are a more experienced professional photographer, but you want to learn how to add boudoir photography to your studio's offerings.

Why is determining your goals important? Starting on a boudoir photography project without first determining your goals is like climbing into a car and heading out without a map or any idea where you are going. Who knows where you will end up? It has a big impact on your choice of photography and lighting equipment. For example, if you are going to be doing this professionally, then you are likely to need to purchase more sophisticated lighting equipment than if you were just doing it for fun. It may also limit the amount of money you want to invest in costumes and props. If you are a professional, then you need to consider things like return on investment as you pur-

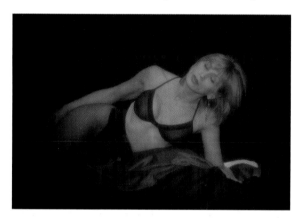

chase props and equipment. If you are doing it for fun, then it comes out of your entertainment budget. If you are purchasing costumes and you are going to do this professionally, then you will want to get a range of sizes and styles to appeal to many women. If you are doing this just for fun, then you only need to get things that fit your wife or girlfriend.

I believe in written goals so that it is easy to tell when you have reached them. In this case, I want you to have an understanding so that the choices you make later will make sense. Now that you have determined your goals, let's move on to Step 2.

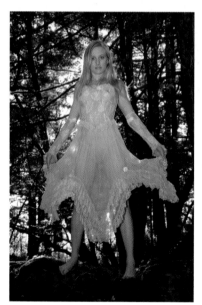

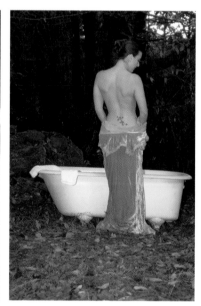

STEP 2: PUTTING TOGETHER SAMPLES: YOUR FIRST PORTFOLIO

Existing Photographs

How do you put together a book of samples, your first portfolio, when you haven't done any sexy photographs yet? You have to start off with the photographs that you already have. You want to give your model confidence that you know what you are doing and that you have the necessary technical skills to make her look good. This is true even if your model is your wife or girlfriend. This is a useful exercise in building every photographer's skill level, and it doesn't matter if this is a hobby or you want to make a career out of it. Go through your image collection and pick the best 10 to 12 photographs, preferably of women, and make 5 × 7 or 8 × 10 prints of them. If you print yourself, you can print 8 × 10s centered on 8 1/2" × 11" paper and use clear document protectors to make an inexpensive portfolio.

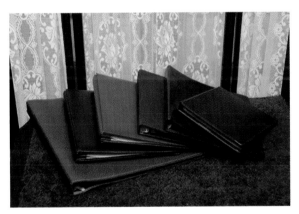

Some of the author's portfolio books.

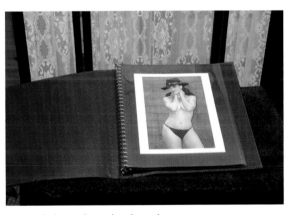

Here is a book open, showing how they work.

What do you do if you haven't photographed women yet? Then you do the same as I mentioned except that you choose your best photographs of any kind. The purpose is to show that you know how to use your camera (proper exposure, focus, and so on) and have an eye for composition to make attractive photographs. You will be able to show prospective models what skills you do have even if you haven't photographed people very often.

Start Small

If you only have a series of snapshots, not really suitable to show off your photography skills, or you have not photographed women very often, then you will need to create some new images. Before asking *any* woman to pose for sexy photographs, you must develop and show that you have the necessary technical and aesthetic skills to make her look great. You may think you can skip this step because you are photographing your wife or girlfriend. *Don't do it!* If you make her look bad in your first session, it is very likely there will not be a second session, or it will be a long time coming. Instead, ask a woman to pose for some portraits. She can wear something nice or

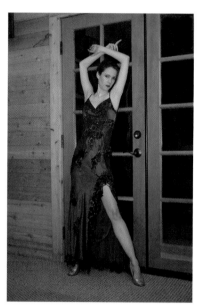

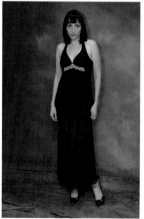

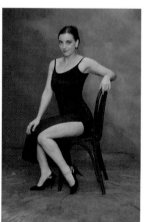

These are the kinds of images that should be in your beginning portfolio of portraits.

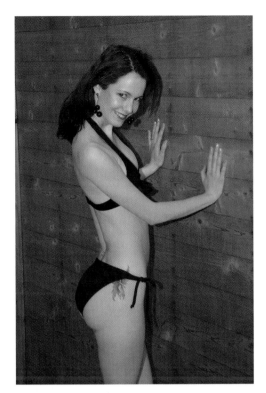

casual, whatever she would like. Start with a standard portrait. Stay away from swimsuits and lingerie until your skill levels are sufficient to do a good job in this area. They are more difficult to do well. Almost any woman will pose for a portrait if you ask nicely. It could be your mom or your sister, a friend, a relative, or a neighbor. Be truthful. Tell them you are practicing and trying to become a better photographer. Once you have a few nice images, move on to another woman and repeat the process. After you are adept at portraits, you can try your hand at photographing a woman in a swimsuit. This is more difficult, but follow the lessons in this book and you will soon improve. It is much easier to ask a woman to pose in a swimsuit than it is in lingerie.

These are the kinds of images that should be in your next portfolio of swimwear.

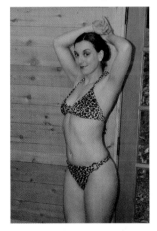

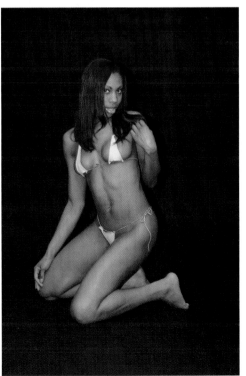

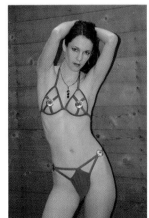

The Portfolio Book

So you now have your starting images. You need to put them in a book of some kind. It is not very professional to hand someone loose prints to look at. Larger images, such as 5 × 7s and 8 × 10s, make a better impression than 4 × 6s. There are a number of ways to put together the portfolio. If you have printed your images centered on 8 1/2" × 11" paper, then you can purchase a package of clear document holders that are three-hole punched to go into a notebook. Buy the heaviest duty ones you can find so they will feel and wear better. Buy a nice, thick, three-ring binder—the nicest you can find. If you are lucky, you can find a leather one for about 20 dollars. It will give you many years of service. You can find those notebooks and the clear sheets in office supply stores or you can order them online. You can also find the three-ring "post binders" style notebooks or albums at craft shops that carry scrapbooking supplies. The leather ones look very nice and cost about 30 dollars each. If you want to go for a nicer look, you can find portfolio books with clear pages and black backing sheets at art supply stores and online. They come in various sizes, shapes, and colors. Prices range from around 30 dollars to nearly $100. Get the size that is appropriate for the images you want to show. Stay away from the "magnetic" styles of albums found in discount stores and camera stores. They are not good for your images and they look cheap. Remember, you are trying to encourage trust and confidence. A nice presentation will go a long way toward helping you accomplish that.

The Idea Book

The Idea Book has several purposes. In the beginning, when you perhaps have a regular portfolio but don't have any boudoir images in it yet, you can use the Idea Book to show your models the kind of images you want to create. Later, it will give you ideas and suggestions for images. This can be useful to stretch yourself as well as a source to go to when your "idea well" is running a bit dry.

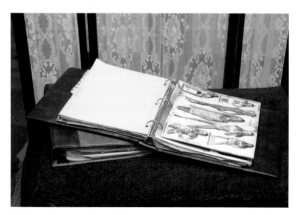

Two Idea Books put together over 25 years.

To create an Idea Book, start saving images from magazines and newspapers and any online sources. Punch three holes into them and put them in a notebook. If the images are too small, tape them to a larger piece of paper and put them in your notebook. Sort them into categories in the notebook. They could be sorted by color or by costume or by location.

How do you work with your Idea Book? First, you show your new model your portfolio so she will know your skill level. Next, you can show her your Idea Book with the types of images you want to create. This is much easier than trying to explain it with words.

Step 3: Selecting Equipment

Now we come to the step that is the favorite of many photographers: choosing equipment. Actually, you need little special equipment to do boudoir photography. Creating great images is more related to technique than to equipment. Keep that in mind as you go through this step.

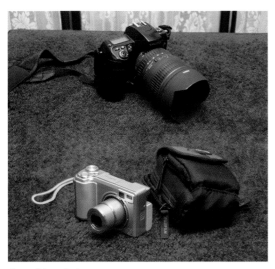

Some of the author's cameras.

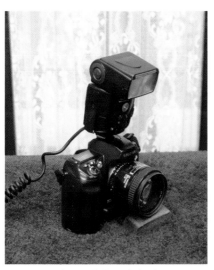

An automatic electronic flash attached to the camera.

Cameras

Obviously you need a digital camera. Most likely, you already have one and are wondering if it will work for boudoir photography. It really depends on the types of images you want to create. Even a simple point-and-shoot or compact camera will do an adequate job for many images. A camera with five or six megapixels will be adequate for most images you will create in boudoir photography. If you need to purchase a camera, visit www.dpreview.com and use their online selection tool to input the features that interest you and see their recommended cameras. A zoom lens that covers from wide angle to moderate telephoto is very useful. If you haven't done much digital photography, start with a fairly inexpensive camera. An excellent compact camera can be found for around $300. If you will be doing any studio work or a lot of indoor photography, a camera that accepts a separate flash unit will be much more versatile and will allow you to experience much better lighting. The built-in electronic flash on most cameras does not work that well. The flash units are not that powerful and the lighting they provide is too harsh for most boudoir photography. However, it can work well enough for a bit of flash fill either indoors or outdoors.

If money is no object, then a digital SLR with one or two lenses is ideal. The average body is around $1,000 by itself. Again, use www.dpreview.com for information. There are many manufacturers and models available. An SLR was used to create most of the images in this book. Don't forget the possibility of borrowing a camera from a relative or friend. This way you can check various functions and see if they are important to you. It will help you to choose the proper camera when it does come time to buy one.

A dome is added to the flash to provide softer lighting.

Lighting

The lighting you need depends on where you will be photographing. If you have a digital SLR camera, an adjustable, automatic electronic flash is something you will use nearly all of the time, both indoors and out. A really good quality unit will cost about $300 and will handle most of your needs. A top-of-the line professional unit with separate battery pack is about $1,000 and is probably more than you need for boudoir portraits. If you will be doing studio work, then either "hot lights" or studio flash equipment with softboxes and umbrellas will be something that you'll want eventually. If you are just starting out, keep it simple and inexpensive and learn as you go along.

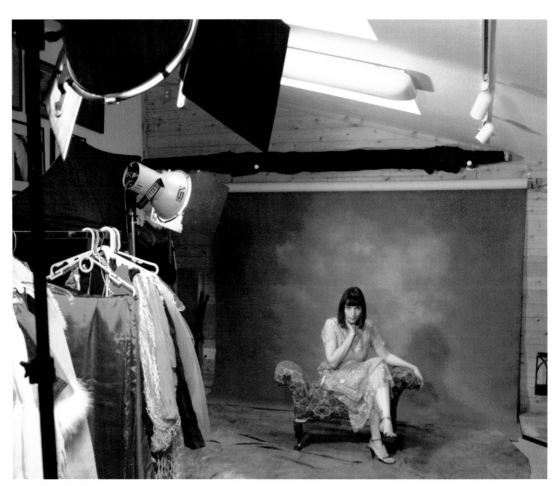

A model with hot lights.

If you want to play with hot lights, you can purchase "clamp lamps" at any hardware store for around 10 dollars each. There are special photoflood lamps available at camera stores. They are 500 watts, last about three hours, and cost about six dollars each. You can also buy 300-watt bulbs at the hardware store, which will last much longer and are good to learn with. Be careful when you use hot lights that you don't exceed the current capacity of your outlet. Also be sure to use heavy-duty extension cords. Check the power rating on the cords. The regular flat household cords (that usually come in brown or white) are not usually heavy duty enough. As the name "hot lights" implies, they get very hot. Don't leave them unattended or let them fall on your model or touch flammable materials. Hot lights make it easier to see the pattern of the light and shadow and are an inexpensive tool to use to learn about studio lighting.

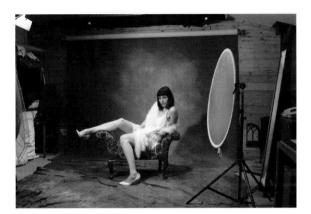

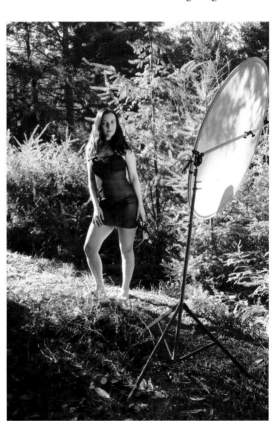

A reflector is used on a stand in the studio and outside. An assistant in the studio can also hold it.

Light Modifiers

What are light modifiers? Reflectors are examples of light modifiers. Shade canopies are another example. The reflector shown on the previous page is commercially made and can be attached to a light stand or held by an assistant. You can also make one out of white foam core with crinkled aluminum foil glued to it. Use spray glue and put the dull side out so that it is not too bright. You can make them any size, but a 4' × 4' piece is a good workable size. To make it easier to carry, before you glue the foil on, cut the foam core in half and use white duct tape along the length of the cut to make a hinge. Now it will fold in half. Glue the foil on the inside so no foil can be seen when folded. This makes it a bit easier to focus the light when it is being used.

Other Photo Equipment

Tripods are very useful and every photographer should have one. Make sure that it is heavy duty enough to hold your camera steady. Lightweight tripods are not terribly useful unless you are going backpacking. You use a tripod in low-light situations, in the studio, and if you are using a telephoto lens. If you notice that your images are not always sharp, consider using a tripod.

Filters were used a lot with film cameras, but they are used less often with digital cameras. A lot of the filter effects can be applied digitally later, which gives you more options. Some photographers enjoy using a soft-focus filter, especially with older women or someone who does not have good skin. A slight softness can be pleasing. Although you can purchase a wide variety of filters for a soft-focus effect, you can easily make your own. Purchase a small amount of black tulle fabric. It comes in a variety of mesh patterns and sizes. For a few dollars, you can purchase a good assortment to play with. Cut the fabric into a square large enough to wrap around the end of the lens. Hold it in place with a rubber band around the lens.

Different filters that can be used with both film and digital cameras.

Black tulle fabric is wrapped around a lens to create a soft-focus effect.

Computers, Software, and Printers

The final equipment that you will need is a computer, the associated software, and perhaps a color printer. Any recent computer will do, but when working with images, the faster the processor, the more memory, and the larger the hard drive, generally the better. If you are familiar with computers, then either a PC or a Mac will work fine. If you are not too knowledgeable, then it is best to choose the same type of computer that is owned by the person who you will be calling for help. If none of these apply, beginners generally find Macs a bit easier to use, although they tend to be a bit more expensive.

You will need software to edit and retouch your images. This software often comes with your camera, computer, or printer. If you need suggestions on software, see Step 15, "Retouching Your Images."

There are a variety of printers available. Usually inkjet printers suitable for photographs can be purchased for less than $100. If you will be printing small quantities, they will work fine. For higher quality or larger volumes, a suitable printer will cost in the range of $500 to $800. Epson and Canon both offer good quality printers in lower price ranges.

A computer set up with two monitors makes working on images faster and easier.

A six-color Epson printer with a continuous inking system (CIS) added to make larger print jobs easier and more cost effective.

STEP 4: GATHERING PROPS AND COSTUMES

Some of the author's outfits, costumes, and props gathered over a 30-year period.

Existing Outfits

Your next step is to begin gathering props, outfits, and costumes to use in your photographs. Before you rush out and start spending money on new things, search around the house to see what you already have. You will be surprised at how many useful items you can find when you put your mind to it. You can also borrow from your family and friends. Nearly any kind of clothing can be made to look sexy or sensual if you work at it a bit, but some things seem to work better than others. Here are a number of examples to help get your creative juices flowing:

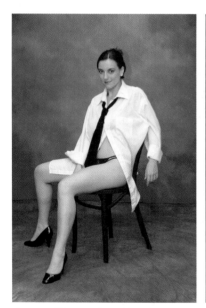

Joanna models a man's shirt and tie, which, when a pair of heels is added, makes a very fetching outfit.

A simple man's t-shirt is very sexy on Tanya, especially when it is the thin variety and wet. It can be dipped in the sink to wet it or it can be sprayed with a spray bottle filled with water.

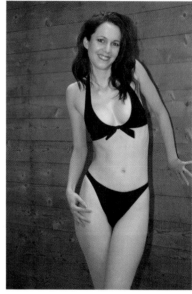

A bikini is always a popular look and a good way to start photographing a woman who is a bit shy about modeling lingerie.

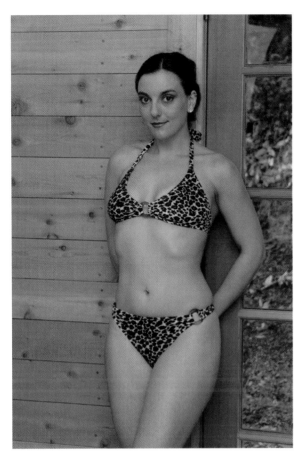

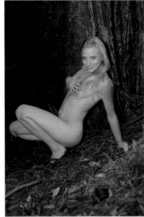

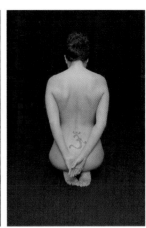

Outdoor figure pretzel demonstrated by Melanie.

More pose variety.

Bikinis are available in a wide variety of styles and colors.

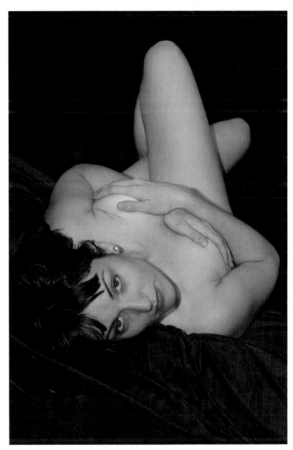

Even a theme bikini may be in your model's wardrobe.

A robe over a bra and panty set is simple and often easily available, yet still sexy.

More daring, but not necessarily more revealing, is no costume at all. Even in this case the variety of poses is large.

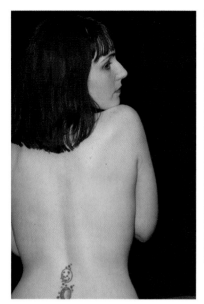

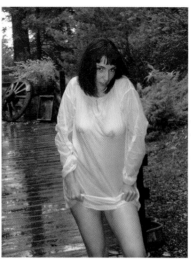

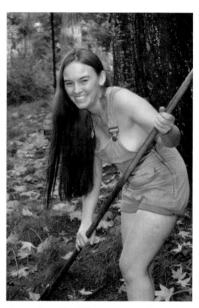

Besides a wet t-shirt, other outfits may lend themselves to being wet, such as this white negligee. It makes a nice excuse to shoot outside on a rainy day.

A pose like this can be used to show off body art like these back tattoos on Jessica.

A pair of overalls will fit an assortment of sizes and looks quite cute when nothing is worn underneath.

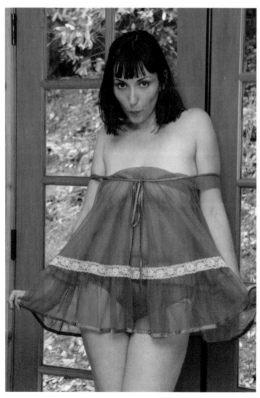

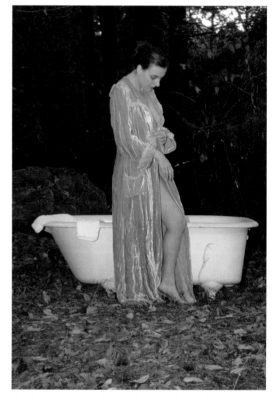

Vintage lingerie is often found in the bottom of drawers. This babydoll negligee from the 1960s is an example.

Another vintage piece is this velvet lounging robe from the 1920s.

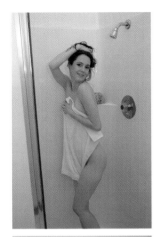

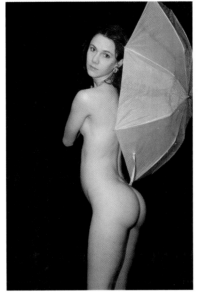

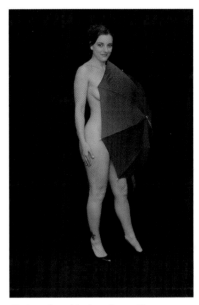

An umbrella can be used for more rainy day fun, even on a dark day.

Or, it can be used in the studio as well.

An evening gown can provide a more sensual and softer look to your photographs.

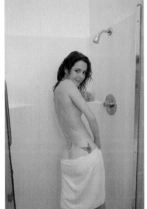

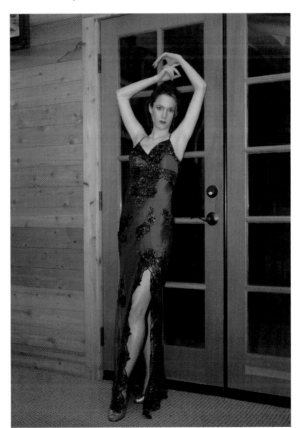

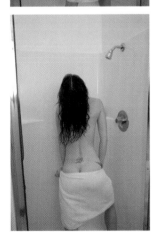

Even an ordinary towel has lots of possibilities, as Iona demonstrates.

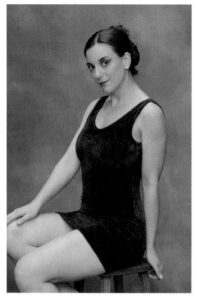

A mini dress is an outfit that many women already own.

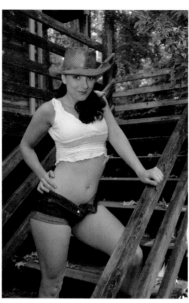

Shorts and a crop top will work well outdoors.

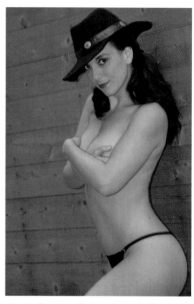

A pair of panties and a hat, along with the right pose, produces a sexy image of Joanna.

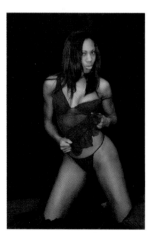

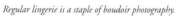

Regular lingerie is a staple of boudoir photography.

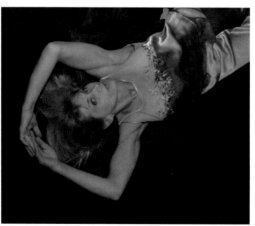

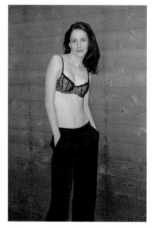

You can mix lingerie with regular clothes, as Iona does with a bra and pair of pants.

Buying Outfits

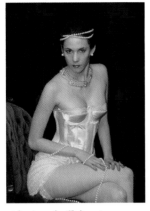

A bustier and ruffled panties came from thrift shops.

Once you have explored all of the existing outfits you or your model own or can borrow, it may be time to start shopping for some special items to add to your collection. Sometimes you can go to your favorite stores to look for specific items. Other times, it is fun to just go out and look for ideas. If you shop regularly at a particular store, especially if it is a smaller one, sometimes the staff will call you when something special comes in. When you find items at a flea market with regular vendors, you can ask them to keep on the lookout for the kinds of items you like. Also, if you buy a number of items on a regular basis, you can negotiate special, lower pricing. If you know what you are looking for, don't forget eBay or other online auction locations. The number of choices is nearly unlimited, but here are some suggestions.

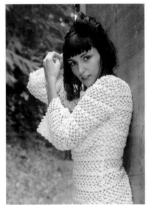

A vintage crocheted top will work nicely as a mini dress.

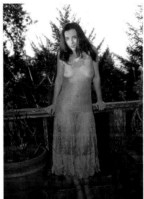

A vintage sheer dress, designed to be worn over a slip, is very sensual when it is worn by itself, as Joanna shows us in the warm, late afternoon light.

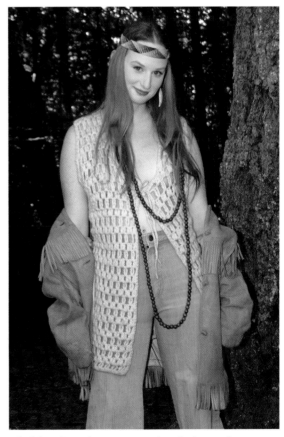

Thrift shops, flea markets, swap meets, and even local garage sales are great places to shop for outfits for your photography. Here are vintage bellbottom jeans, a crocheted vest, and a leather fringe jacket, as well as a few props, which were all obtained from thrift stores.

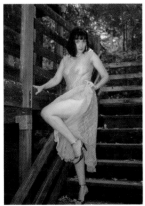

Jessica shows how the same dress can be sexier with a different pose.

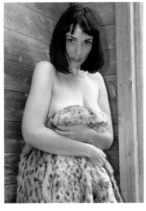

A vintage faux-fur coat can be used with other clothing, or just by itself.

Besides thrift stores, there are an endless variety of lingerie stores, both locally-owned as well as national chains such as Victoria's Secret and Frederick's of Hollywood. You can also find distributors online. Some of these items are fairly inexpensive, as well as cheaply made. For a photograph, the quality is not necessarily as important, since the emphasis is on the woman rather than on the clothing. Some samples of the kinds of items you might purchase are shown here.

This sheer and very sexy rainbow dress and matching panties were purchased online.

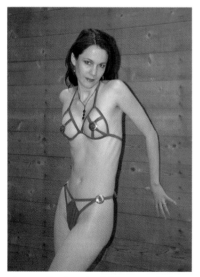

An unusual spider-web-style bikini was ordered from an online supplier.

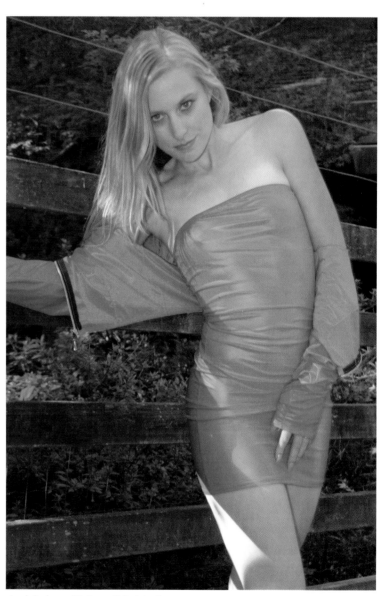

A red pleather, multi-piece outfit is always fun.

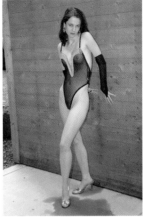

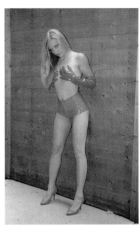

A fishnet outfit with gold trim and matching gloves came from an online supplier and the vintage gold heels were found at a flea market.

Melanie is modeling red vinyl shorts and using her matching red vinyl gloves as a top. They were also purchased online.

Here, a leather miniskirt, a leather hat, a leather bra-top, and hip-length leather boots rolled down make up the complete outfit. The hat came from a garage sale, the boots were purchased at a flea market, and the rest was purchased online.

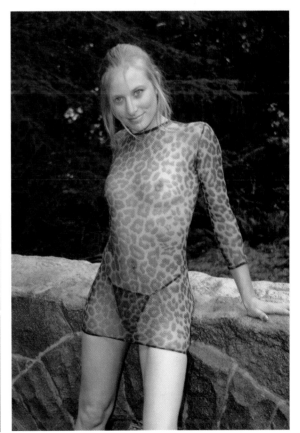

Black vinyl looks great on Iona and was purchased online.

Typical of the kinds of lingerie available at lingerie stores, this long negligee looks great out in the woods.

This sheer, leopard dress came from the rainbow dress supplier. Animal prints can provide a nice look, especially if you add appropriate props.

Make Your Own Outfits

Another fun project is to make your own outfits. It is a project you can work on together with your model. Sure, you can get patterns and sew elaborate clothes, but these examples are things nearly anyone can make with very little skill required.

Chamois leather can be purchased at any auto supply or hardware store. It is usually used to dry off cars after they are washed. It is not very expensive considering the small amount that you need. The pieces are cut to size, based on your model's proportions. Create a paper pattern until you have it right. Then use the paper pattern to cut the chamois material. Thin pieces of leather thongs, available at a crafts store, are used to tie the pieces of the bikini together. Add a few props like jewelry, a headband, or a leopard-patterned bedspread, and it is a very earthy and sexy look.

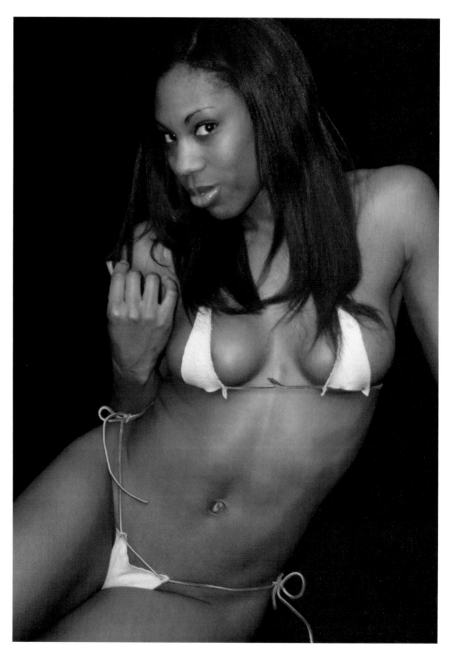

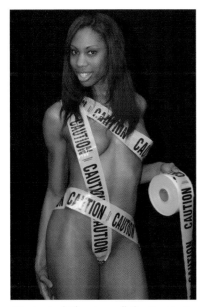

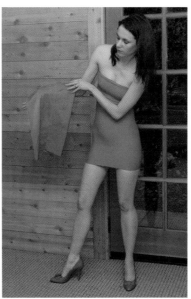

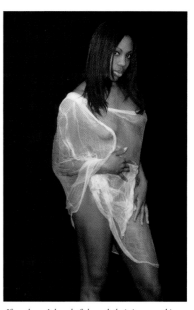

Here is a simple idea using a roll of caution tape. A piece of tape was used to hold it in the back and then it was wrapped around Amelia. For more variety, add a construction hardhat or mix it up with jeans.

A tube dress made of stretch lycra is very form fitting and looks great with nothing more than a pair of heels. The fabric was purchased in 2/3 of a yard increments and simply sewn together into a tube. Although you can do this yourself if you have the sewing machine and skill, a local seamstress sewed together a number of these in different lengths and colors for a few dollars. Here, Iona is wearing one dress and holding another.

If you haven't heard of cheesecloth, it is a very thin, gauze-like material available at hardware stores for less than two dollars. It can easily be draped over a woman to make any kind of dream-like outfit. Here, water was added to make it cling tightly to Amelia. By making it single or multiple layers, you can make it as modest or revealing as you like.

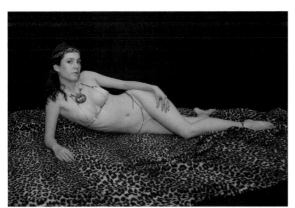

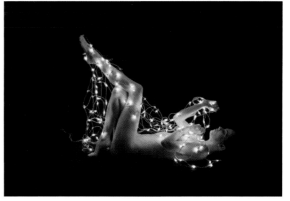

A leopard bedspread purchased for seven dollars at a swap meet provided a nice touch to this image.

Christmas lights come in a grid or blanket. Be careful when playing with electricity and watch how hot the lights get, especially if your model is wearing skimpy clothing. This particular set did not get too hot as long as Iona did not lie on the grid. The studio in which this was photographed was built with all GFCI (ground fault circuit interrupter) outlets to help protect models (and photographers) against broken bulbs or short circuits. That is an important safeguard to consider. It can be dangerous to mix electricity with wet fabrics.

Costumes

How are "costumes" different from "outfits?" A costume is a uniform that indicates a specific job that you would perform. Some examples would be clothing worn by military personnel, firefighters, police, nurses, secretaries, maids, lifeguards, postal carriers, construction workers, or wherever your fantasies might take you. Some of these, like the French maid's outfit, are designed for photography or play. Others are found at the usual places like flea markets or online vendors. Here are some examples to get you started.

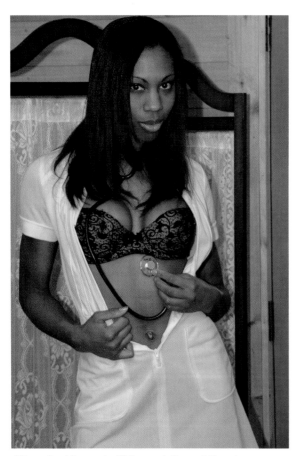

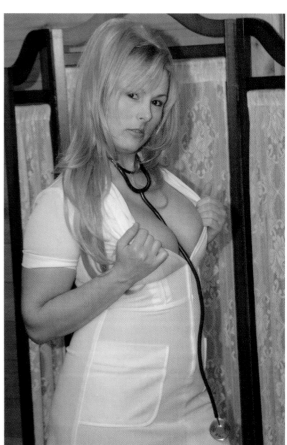

This was found for a couple of dollars at a thrift store. Add a stethoscope prop and you are set.

This is the same costume, but this time worn by Tanya without lingerie showing underneath it.

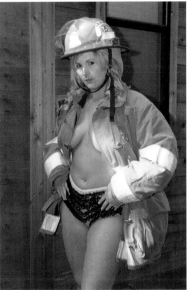

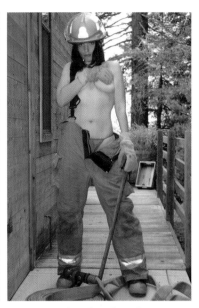

A leather lederhosen costume is fun to use. The straps can be undone and held like Joanna is doing here, or left fastened. Add a Tyrolean hat and hiking stick for more variety.

Firefighters are a popular fantasy. Perhaps you know a firefighter and can borrow an extra set of gear. Be careful about showing logos or identifiers (usually on the back of the jacket or helmet). Many departments are sensitive about their names being used in a situation like this. These sets of gear belong to the author and were purchased on eBay. Here Tanya wears the turnout jacket and a pair of heels. Use a hose and nozzle, fire extinguisher, or an axe as a prop.

Jessica shows us the traditional way of wearing it— just the suspenders without the jacket. She is wearing panties (red, naturally!) underneath. You could add a red bra for a bit more modest appearance.

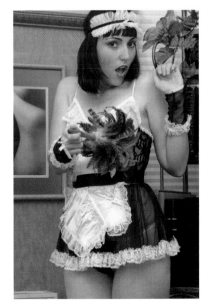

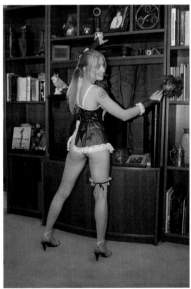

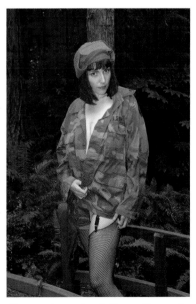

The French maid's costume was purchased online and is designed for fun rather than utility. Although somewhat cheaply made, it photographs well. As you can see, expression counts for a lot.

Another take on the French maid's costume. A feather duster was added so that Melanie could dust the studio office as she was photographed.

There are a large variety of military uniforms available either from friends, thrift stores, or Army surplus stores. Don't forget vintage uniforms as well. Here Jessica has added a garter belt and fishnet stockings for a different look.

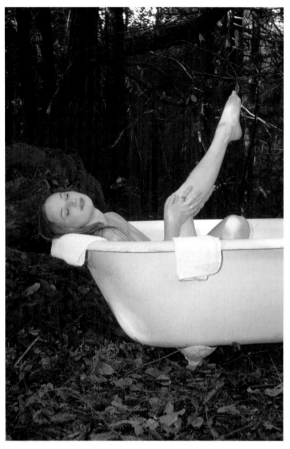

Props

Anything that you add to the photograph besides the model and what she is wearing is considered a prop. The use of props will add interest and variety to your photographs. Be careful about overdoing it, however. Overly complex photographs filled with props will often distract from the most important visual element, which is the woman in the photograph. Choose items carefully to support your concept and not overwhelm her. Here are some examples to show you and give you ideas.

A claw foot bathtub was purchased from a home wrecking company for 95 dollars. It is cast iron and extremely heavy, but a set of rollers was built to roll it around in the studio until it was moved outdoors and covered with a tarp when not in use. It is one of the most popular props at the studio. A few towels are added for effect as well as a brush and sea-sponge.

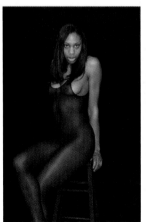

A stool purchased at a flea market was spray-painted matte black. It is very easy to use and doesn't distract.

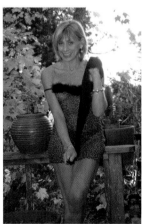

A couple of bracelets are added in this image of Deborah. Jewelry is simple and relatively inexpensive at thrift stores and swap meets. A good collection, kept together in small plastic zip-open bags, will allow you to grab something when a photograph calls for it.

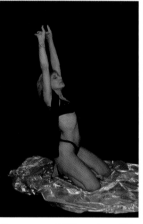

An assortment of different pieces of fabric is very useful to have. Here a piece of gold lamé is used to help separate Deborah from the black background.

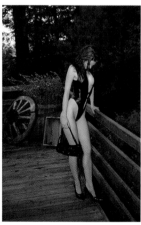

Iona carries a purse, which adds a bit of mystery of "why."

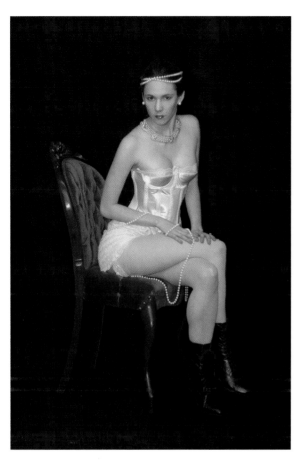

A long strand of faux pearls, a vintage pearl collar, and a velvet chair are used here to add to the feeling of the image. All of these are available at thrift stores and similar locations.

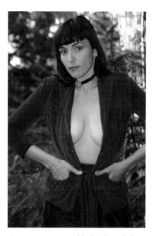

Jessica is wearing a black velvet choker with a cameo. It adds a touch of elegance.

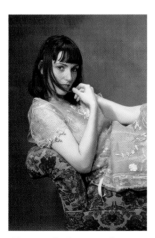

This particular fainting couch is one made especially for photographers and is available in catalogs through photography supply stores. Keep your eye out for similar items while you are out shopping.

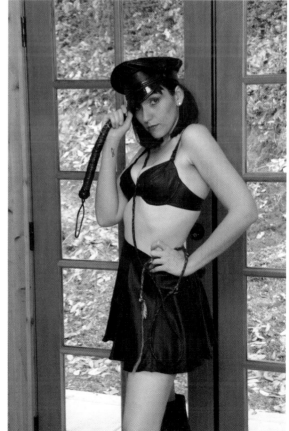

Jessica thought that this hat and a whip from a thrift store would help convey the image she wanted with this outfit.

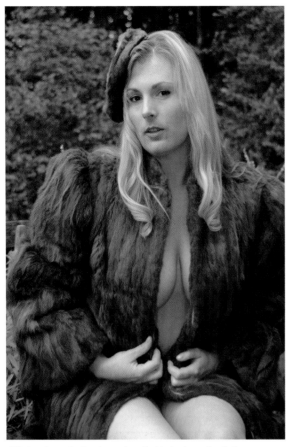

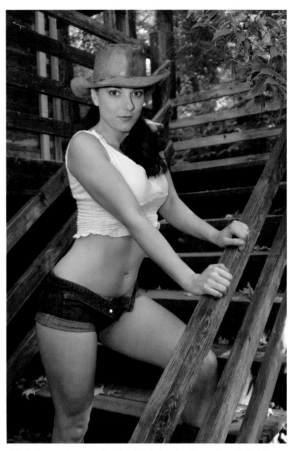

This is a vintage fur hat that works well with the vintage fur. Both were purchased at thrift stores, but at different times. The hat really helps to give an old-time flavor to the photograph.

This is the same hat as used in the photo below, but Joanna has switched the leather vest for a white crop top. The difference in color and style makes this image simple to do and helps give variety to one photography session.

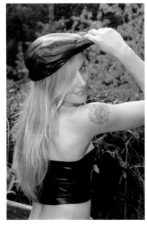

A black leather hat gives Melanie a "tougher" look.

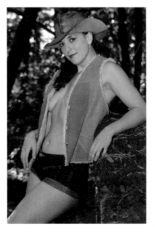

A leather hat helps to give a bit of western flavor to Joanna's vest and shorts.

STEP 5: SELECTING YOUR LOCATION

Where will you start photographing? There are a number of possibilities, depending on where you live and the kinds of access you have to different locations. You can certainly photograph in your home or your model's home. You may also be able to use the homes of friends and relatives. You can use your yard or that of your friends and relatives. These all have the advantage of privacy. Sometimes you will be able to photograph outdoors in a wilderness area, at a lake, or at a secluded beach. Be careful and respectful of others. Don't violate local laws. You might be having a great time, but the family with young children that comes walking into your scene from around the corner might not think so. Your garage or living room can often be converted temporarily into a simple studio with very little work. Some communities have studio spaces that you can rent by the hour or by the day. It is often better to figure out the best ways to use your own space, no matter what you might have available. You will have absolute control, access 24 hours a day, privacy, and familiarity. You won't have to waste time fumbling around or looking for things or traveling to and from the studio. You can have everything ready in advance and you won't have to worry about forgetting that perfect prop or key piece of equipment.

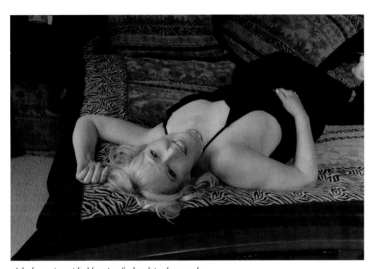

A bedroom is an ideal location for boudoir photography.

Many photographers miss possibilities by looking at a space too broadly. It really doesn't take much space. Every image does not have to be a full-length photograph. Practice "seeing" the different ways you can create an image in a small or cluttered space. Think about making small changes like moving a piece of furniture or closing the blinds. Use the lessons in this book. Over time you will improve and eventually be able to create gorgeous images nearly anywhere.

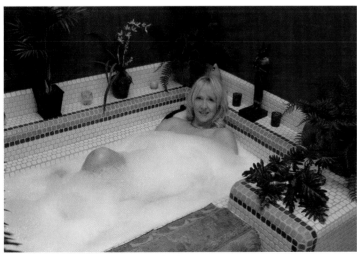

A decorative bathtub is a perfect location for boudoir images.

Outdoors on a woodpile.

A kitchen counter with things moved out of the background.

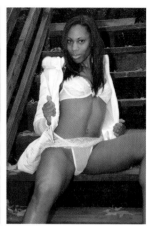

A set of outdoor steps makes a great posing location.

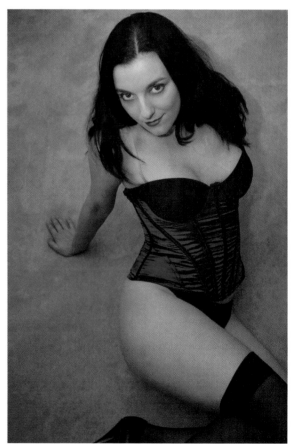

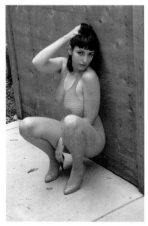

A tiny space against a wall is all you need.

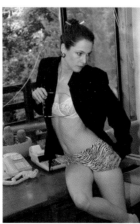

A home office.

A 4' × 6' space was cleared on the floor for this image.

STEP 6: FINDING AND SELECTING YOUR TEST SUBJECT

Using your wife or girlfriend is the most common method of starting in boudoir photography.

Wife or Girlfriend

This is a very important step. You need to find someone to photograph! If you are planning to photograph your wife or girlfriend, then this is easy. You have selected her already and can move ahead once you have her agreement. If she has concerns about being photographed, then go back to Step 2 and start with a portrait session rather than a boudoir session. It is a lot easier to get agreement with a more modest approach. Once you have demonstrated a degree of skill in producing pleasing images of her, she will be more likely to agree to more sensual images. Too many photographers make the mistake of jumping in and starting with the more difficult images first. If you do this and do a less than credible job, it will be much more difficult for you to convince her to try again.

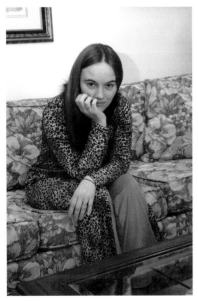

If your wife or girlfriend is not available, perhaps you have a friend who is interested in helping you.

Friend

If you don't have a willing female partner, then asking a friend is the next step. This is where having a portfolio of beautiful images will help. If you don't have your portfolio put together yet, then ask a friend to pose for a regular portrait session so you can start it. It is much easier to start like that, even though you are excited about getting started with a boudoir session. Once you have shown that you are skilled with your photographic technique, a woman will be more likely to consider boudoir or other sensual images.

Model

Asking a model to pose is the next step once you have exhausted the possibilities of friends and relatives. You can contact a modeling agency, but they will often not be willing to send out models to unknown photographers. In addition, models working with an agency will typically cost more than $100 per hour, even for beginning models. Visiting an online modeling site will give you a better chance for less expensive or even free models. Experienced, web-based models will charge rates beginning at 50 dollars per hour and going up from there, depending on the level of nudity and the usage of the images. If you are doing photographs just for your portfolio, some models will often give you a better hourly rate. Keep in mind that the model release must state it is for "portfolio use only" for them to give you that rate. It is best to find a model with about the same level of experience as you have. If you are a beginner, then look for models just starting out. They will be more likely to offer to do the modeling "in trade." They will trade their modeling services (and a signed release) in exchange for prints (TFP = trade for prints) or for a CD of the images (TFCD) instead of being paid in cash. If you are just starting out in photography, it is usually not worthwhile to contact experienced models unless you are willing to pay them. There are so many mediocre photographs that they are usually only willing to do TFP with photographers who can show a portfolio (usually on their website) of images that are better and different from the ones the model already has. After all, they are in business to make a living from their modeling.

Some places online to check for models include OneModelPlace.com, ModelMayhem.com, and some of the modeling groups on Tribe.net. Some photographers have had success with craigslist.org, although since some of the other groups are moderated, their members seem to have better manners than those on craigslist with its free-for-all culture. Before you agree to work with a model, especially if you are paying her, it is a good idea to see her online portfolio, if she has one. If she is just beginning, then you may have to be content with seeing snapshots of her. It wouldn't hurt, if she were close by, to schedule a meeting. If you are a professional photographer, then it is no problem to meet her at your studio. If you are not, then encourage her to bring a friend along, or agree to meet at a nearby coffee shop or other public place, rather than your home. It is encouraging to her if you do everything you can to build her trust. A portfolio, a website, and a professional manner will go a long way in that department, even if photography is just a hobby for you.

When you don't have a wife, girlfriend, or friend who is willing, then you need to turn to models. Here a model has brought her portfolio to show the kinds of work she has done before.

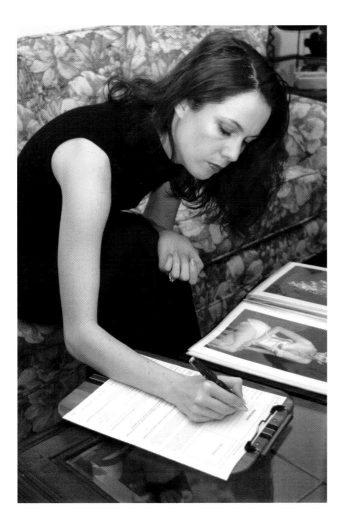

Model Releases

Any time that you will be showing photographs to someone besides the model, you need to have her written permission just to be safe. Having her sign a "model release" does this. The more intimate the photograph, the more likely it is that she will have concerns about where it will end up.

This is simple. If you ever want to show anyone the images you create, you need a written model release signed by the model to be safe. This includes use on your website or in your printed portfolio. This protects you and the model. The form can be as simple as you would like. It needs to state what you plan to do with the photographs and what she receives in return. The more complicated the release, the more difficult it will be to get it signed. Simple is better. Make sure to discuss the model release with the model when you first meet with her. Also, have her sign the release before you start photographing. That way if she has any questions, you can iron them out in advance. It will also prevent you from forgetting to have her sign it before she leaves. If you spoke with her about it in advance, then there should not be any question. Since this book is not giving legal advice, and legal documents do change, do an online search if you would like to use an existing release, or contact your attorney. You can also see the end of the book for suggested reading material.

STEP 7: MAKEUP AND HAIR

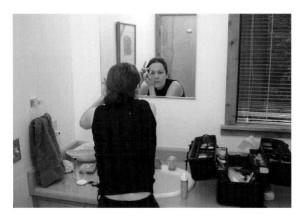

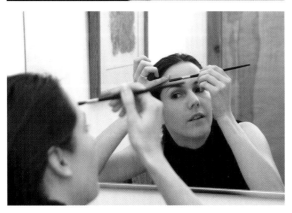

Hair is pulled back and makeup is applied in a series of steps.

This is Step 7 in the process, but really the first step of the photography session itself. Typically, in photography, the model needs to wear more makeup than she does when she goes out in public. The best thing is to tell the model to wear heavy evening makeup, as if she was getting dressed up for a fancy evening out. In the photographs she will look like she has very little makeup on. You are striving to have smooth skin with the blemishes covered. A nice coating of matte powder over the top will help to reduce shine. You want the eyes to stand out with eyeliner and several coats of mascara, but not be overdone. A good coat of matching lipstick should be applied evenly and neatly. The nails should be done, both fingernails and toenails.

Styles in makeup and hair, just like styles in clothing, change frequently. It is beyond the scope of this book to go into too much detail here. Makeup and hair is a huge subject that can take up an entire book on its own. Any details given could easily be out of date by the time you read this section. Ten years ago it was a bigger issue. It was difficult and expensive to retouch images, and many women did not know how to do their own makeup and hair. The photographer or a stylist often needed to do her makeup. That is much rarer today. Many more women seem to know how to do a nice job with their own hair and makeup and often have very particular ideas on what needs to be done. In any case, the photographer needs to inspect the model's makeup and hair to make sure that it looks nice. It will save hours of Photoshop retouching work later on. This is an area you learn with experience and practice. If you need more help, get a book on makeup for photography.

Your model should be sure to shave her legs, under her arms, and around her bikini line if necessary about 12 hours before the photography session. If she waits until just before the session, she may have red marks on her body or fresh nicks and scratches, which will show in the photographs. Even though they can be retouched if necessary, it is better not to have to.

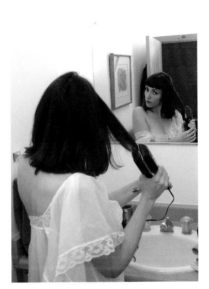
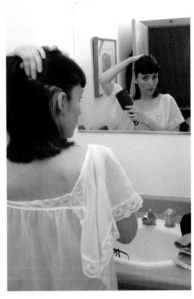

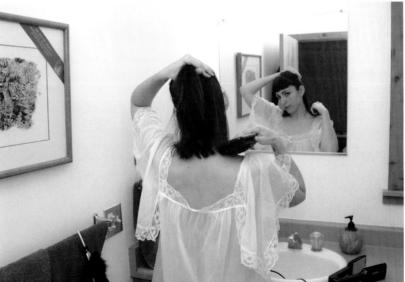

The hair is brushed and styled.

STEP 8: PLANNING THE LIGHTING

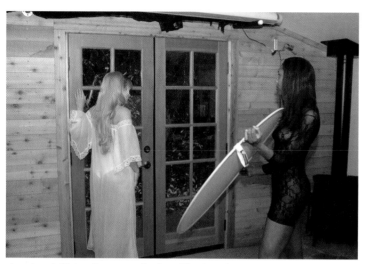

An assistant holds the reflector to provide reflector fill in the studio.

Before starting your session, you need to plan the kind of lighting you will use. You can use an on-camera electronic flash, studio lighting, hot lights, natural light, a light modifier such as a reflector, or some combination of these. Consider these questions:

Will you be photographing during the day or after dark?
If after dark, then you will definitely need supplemental light of some kind.

Will you be photographing indoors or outdoors?
Indoors it is likely that you will need lighting of some kind.

If outdoors, is there shade?
If there is shade, you will most likely need a reflector or on-camera flash; otherwise, you will pick up the color of the shade (green if it is from plants) and the light may be dull as well.

If outdoors, how is the weather? Bright sun? Overcast?
Bright sun means that you will want a reflector or an on-camera flash. Overcast provides nice, soft, even lighting. You may not need supplemental lighting unless the lighting is too dull.

Will you be photographing at the beach or in snow where the background is very bright?
If so, you will need a reflector or on-camera flash to balance the harshness of the light.

If indoors, are there windows available for light? Skylights?
With window light, your lighting may be fine as is. Some windows have a film on them that may give an unacceptable color to your photograph.

If indoors, do you have plenty of electricity available if you want to use hot lights?
If indoors, how much space will you have?
If the quarters are tight, then hot lights probably won't work well, and you should consider an on-camera flash.

Once you know the answers, then select your lighting gear. It is not a bad idea to take along backup gear so you are prepared for unknown situations or changes in weather.

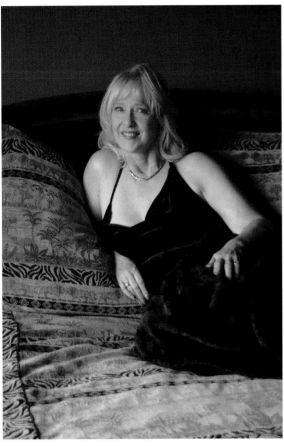

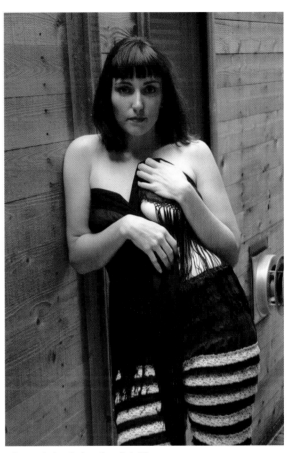

Indoors with window light. Note how the color is affected by the window coating as compared to the figure below, which uses flash fill.

Photographed in shade without flash fill.

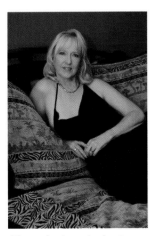

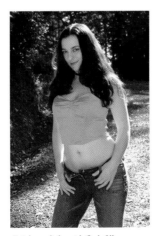

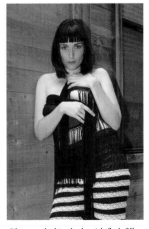

The same location as the above image except that flash fill has been used.

Bright sunlight with flash fill.

Photographed in shade with flash fill.

STEP 9: HOW TO "SEE" A WOMAN

If you have been following all of the steps up until now, then you are almost ready to begin photographing your model. But before you can pull out that camera, it is important that you really "see" your model. You have to look closely at her strengths, or areas to emphasize in your photographs, and her weak areas, or areas to deemphasize. It takes time and practice to learn to do that effectively. You need to be able to make your assessment without staring and making the woman uncomfortable.

When you "look" at a woman...

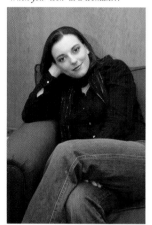
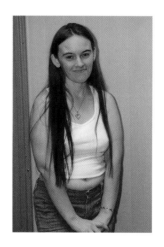

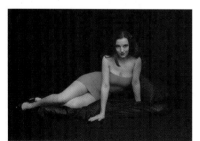
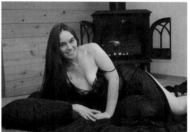
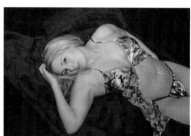

...you need to be able to "SEE" the woman inside.

The first step is to ask your model about her favorite areas of her body. It is important to ask in a gentle way, especially if you don't know her well. You may have to press her a bit if she is very modest. You can make suggestions. Be sure to use the proper names of body parts and not slang. Keep it professional. Take notes so you won't forget.

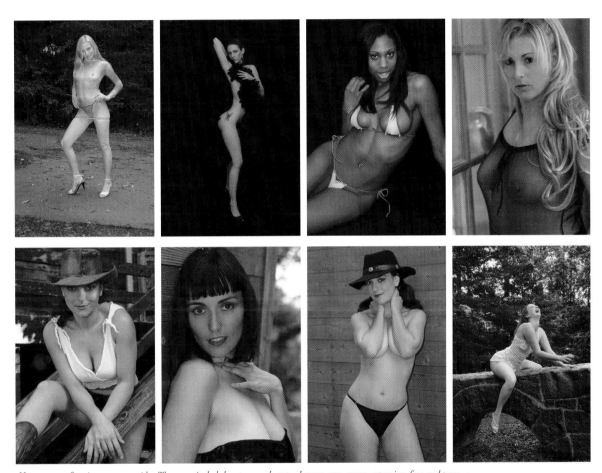

Here are some favorite areas to consider. These may include legs, tummy, breasts, cleavage, eyes, curves, expression, face, and poses.

Next ask her about her least favorite spots. These are often tummy, legs, thighs, bottom, and upper arms. When she tells you, it is important to take note. It is likely that she will be very critical of herself in those areas. You need to be extra careful and try to make the photos as flattering as possible. Finally, you need to learn how to feature some areas and deemphasize others. This will involve posing, clothing, propping, lighting, and finally, retouching, if necessary, which will be covered in later lessons.

As a photographer, you need to see beyond the obvious and look for the beauty that your trained eye can observe. With skill and experience, you will be able to show her beauty and sensuality that she was not aware of. That should always be your goal.

STEP 10: WORKING WITH THE SUBJECT

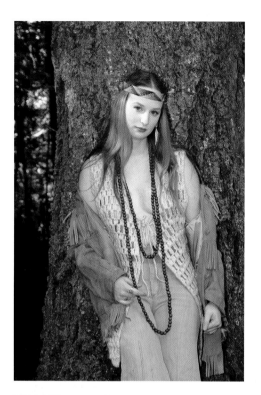

The key to good portrait photography of any kind is based on how you work with the subject or model in the photograph. With boudoir photography this is even more important because women often feel more vulnerable when they are wearing less in the way of clothing. Besides the pressures of the higher intimacy, many women will be worried greatly about their "flaws," either real or perceived.

Dealing with Her Concerns

Nearly every woman will have concerns about being photographed. She is worried that she will not look as pretty as she hopes. The more you can reassure her, the higher the level of trust she will have in you and the resulting photographs. Don't just ignore any concerns when she brings them up. Point out that you are only interested in making her look sensual, sexy, and fabulous. Any images that look otherwise will be due to errors on your part, not hers, and you will edit them out (ideally before you show them to her). Listen carefully when she tells you that she does not like her tummy or chin or other part of her body. You need to think about these things as you photograph, as you know that she will look carefully at those areas. Don't be surprised if she is super critical about the way she looks even if you think she looks great. She may not want the photographs to be too revealing. Make sure you both agree as to how sexy the photographs will be even before you pull out your camera. If you want to be able to photograph her again, you need to work extra hard to please her. If she is not your wife or girlfriend, or even if she is, you need to think about how the photographs will affect your reputation as a photographer.

Developing Rapport

If you spend some time dealing with her concerns, then you are well on your way to developing rapport. Developing rapport means building trust. This will help a great deal when you move to the section on expressions.

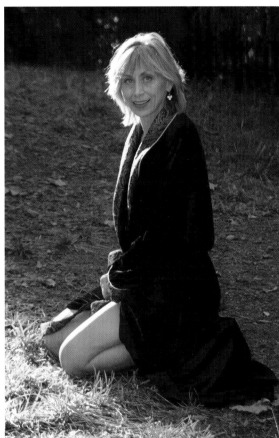

Subject Comfort

If you think about your model's comfort, it will provide you with much better photographs in the long run. It is always a good idea to provide a variety of snacks and drinks, and even a complete meal if the session will run more than three to four hours. This will keep the model's, as well as the photographer's, energy level higher. Light snack foods will be best. Some suggestions would be cheese and crackers, fruit, yogurt, and vegetables. On cold days, provide hot beverages if she desires, and the opposite on hot days. Bottled or purified water is always popular. Avoid alcoholic beverages as they may affect your work or the model's perception of you.

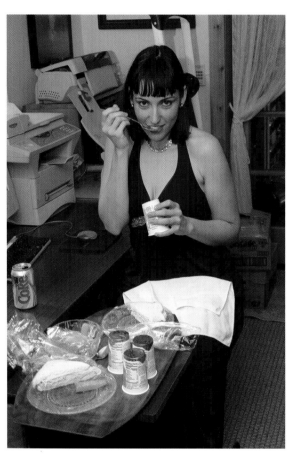

Jessica is working her way through some yogurt and carrot sticks as well as a half-sandwich.

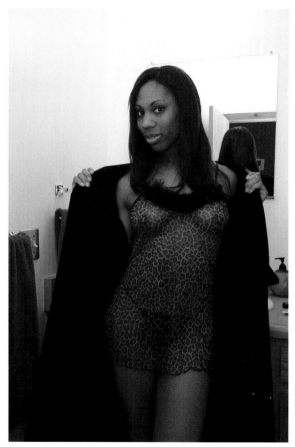

Amelia is putting on one of the studio robes. In this case, it is a black, terrycloth robe that is very cozy. The studio also has a satin robe and a silk robe to use on warmer days. The nice fabric touching her skin helps maintain the mood of the session.

Think of her physical comfort as well. Provide a robe for her to wear in between the times that you are photographing her. This allows a bit of modesty as well as warmth. Unless it is a very warm day, the photographer needs to remember that his model is not dressed as warmly as he is. The photographer should wear something light such as a t-shirt and shorts to remind him about warmth.

While working, try to keep the model as comfortable as the setup will allow. If she will be lying down, which is a great pose to use for many reasons, a few large throw pillows can be tossed down and some fabric put over the top. She will feel more comfortable and it will show in her expressions.

 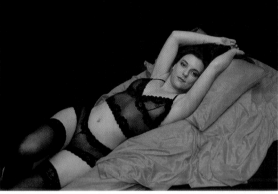

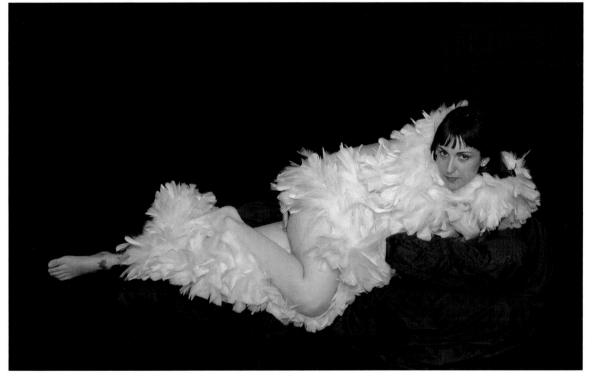

Good Expressions

Famous portrait and wedding photographer, Donald Jack coined an expression he called "E.S.P.," which stands for "Expressions Sell Photographs." Even if you are just photographing for fun, it applies to you. The greatest and sexiest image in the world will be worthless without a great expression on your model. How do you get great expressions? First, of course, you have to build trust and develop rapport. You have to give her permission to act a bit crazy at times. You can do that by acting a bit crazy yourself. Encourage her by telling her how great she looks and making comments like "I love that expression" or "Oh that is really cute." Talk to her. Tell her jokes. Give her scenes to play out. Avoid being crude, even if she is your wife or girlfriend. Encourage her without trying to sound sexy, which would come off poorly. Treat her with respect. Talk to her like you would want any other man talking to her. When she feels beautiful and sexy and special, you will see it in her eyes. Her expressions will be wonderful and will make your photographs even better.

Some women are comfortable in front of a camera from the very beginning. With others, it takes time and encouragement on your part to bring that out. Stephanie demonstrates a large variety of expressions below and on the following pages.

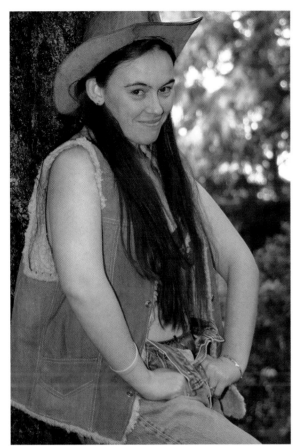

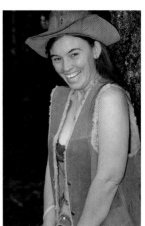
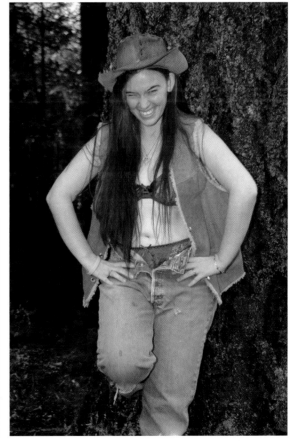

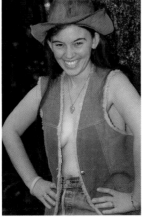

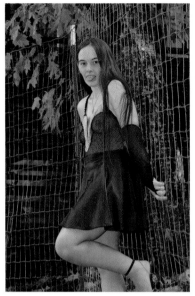
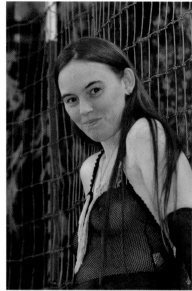
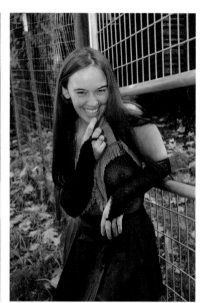

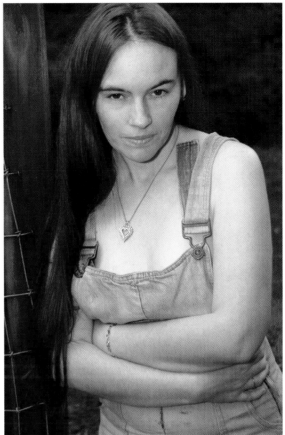

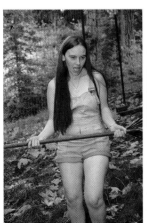
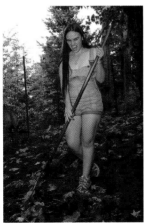
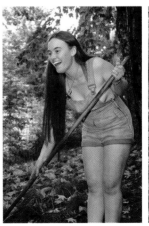
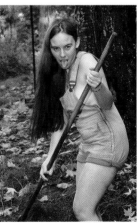

STEP 11: POSING

Posing can make or break a photograph. There is no question about that. While there are always exceptions, these general suggestions will provide a very pleasing result. Also look at the examples of before and after photographs with descriptions of what the model did to improve the photo. Different poses will work better with certain body types and styles. Try them out so that you will understand what each figure requires to look its best. You want to play up the model's best features and downplay any figure flaws she may have. Posing is a powerful tool to help you accomplish that goal.

- Have the model curve her body.

- Have the model arch her back.

- Have the model point her toes to make her legs look longer.

- Make her waist appear slimmer by keeping her arms away from her body.

- Watch her hand placement. Use her hands to cover or hide areas.

- Have the model stretch her body to make it look longer.

- In general, don't let your model bend her wrists forward. Either keep them straight or bend them back.

- Have the model slightly in profile towards the camera, which will make her look slimmer.

- Don't let her slouch.

- Have the model put her hips slightly in profile and then twist her chest towards the camera.

- Have the model tighten her stomach just before the photograph is taken.

- When standing, have the model place one thigh in front of the other, by either bending one knee towards the other side or by putting the front foot on the other side of the back foot. This curves the hips nicely and gives an overall curvier look.

- Have the model raise one hip and the opposite shoulder to give you a nice curve.

- Always watch for details such as hands out of place or awkward curves to the figure.

- Look at your Idea Book for examples of good posing.

- Have your model practice in front of a mirror before the session so she will have an idea of what poses make her look best.

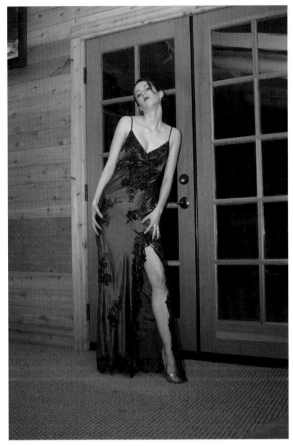

Placement of the head looks awkward.

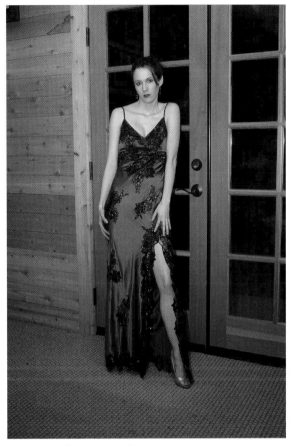

Moving the head down improves this image.

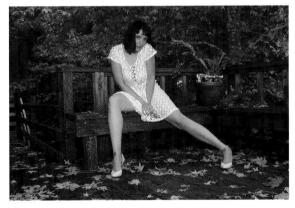

The foot placement is distracting here.

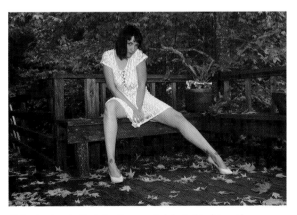

Following the rule of pointing the toes really helps in this photograph.

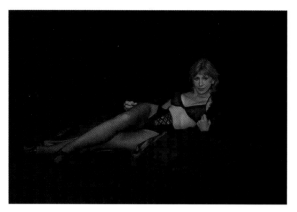

Deborah's leg looks awkward in this position.

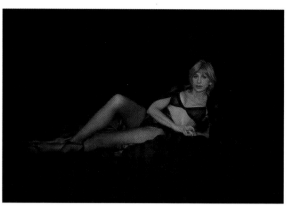

Here she puts her right leg up to make it more attractive, but it is still not quite right.

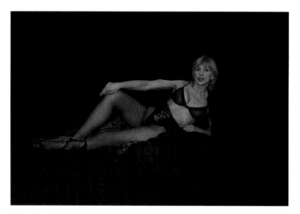

Now she adds her arm up on her leg to make another interesting line.

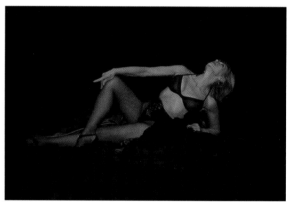

Throwing her head back gives another variation.

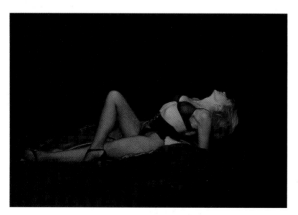

Dropping the arm while still keeping her head back gives a second variation.

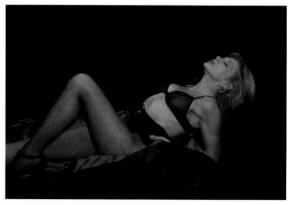

She switches her leg positions for a third variation.

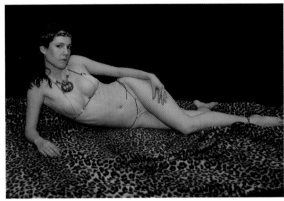

Notice how her lower leg looks like it is cut off.

When she dropped her knee in front of the lower leg, it not only helped the awkward leg, but it also made her hip curvier.

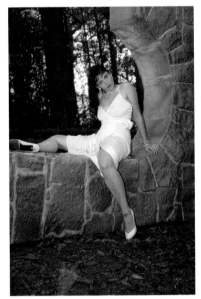

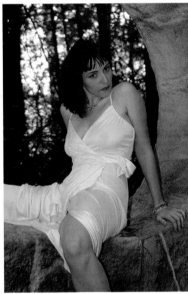

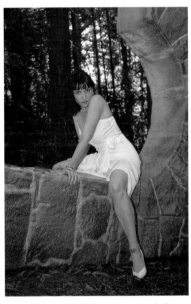

Jessica's leg position is quite awkward. How to handle this?

The first way to handle the awkward leg in the previous figure is to move in, zoom in, or simply crop the image.

A second way to deal with it is by moving the leg.

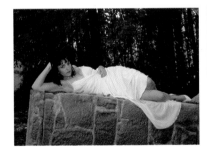

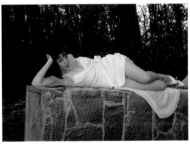

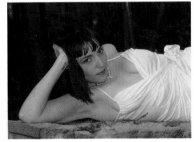

While lying down, her top leg looks strange.

Move the top leg so it looks nicer.

Another way is to move in, zoom in, or crop it after the fact.

STEP 12: TECHNICAL DETAILS

There are so many things to watch out for when you photograph. The great thing about digital is that you can learn much faster with the instant feedback. Also, you can make a lot of mistakes and not spend a fortune on film and processing. It is easier to throw away all of your mistakes so that no one sees them too. Some of the things to watch for are reflections of the photographer or the flash in windows, mirrors, and shiny objects. Watch for straps and underwear popping up where you don't expect it. There are panty lines, bad backgrounds, things growing out of your model's head, and clothing tags that seem to show up also. Certain clothing lines can be adjusted to look better, even though it makes the clothing uncomfortable to wear. A thong is a good example. It usually looks better when pulled up really high on the hips. This gives a nice curved, instead of straight, panty line across the tummy and provides a longer leg line as well. However, it is often not very comfortable to wear like that. We are going to show you a lot of examples of what to do and what not to do.

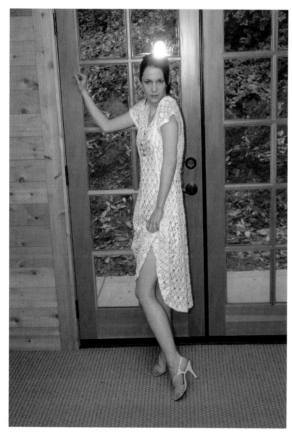

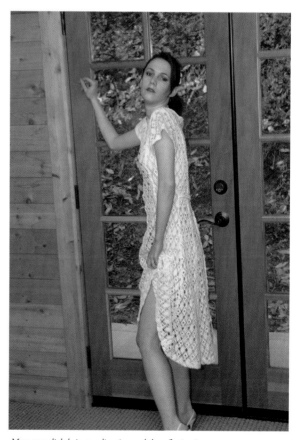

Whenever you are photographing with a flash around glass, mirrors, or shiny objects, watch out for reflections. Here you can see the glare of the reflected flash. It looks very distracting and not very professional.

Move over slightly in one direction and the reflection is gone.

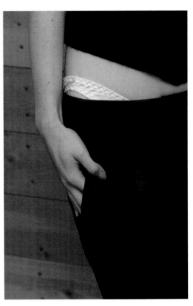

Clothing straps have a habit of falling out of place when they shouldn't. Catch it while you are photographing to save yourself a lot of retouching.

Here the strap has been fixed.

Here a panty has popped up where we don't want it to be. With today's fashions, this is very easy to miss. It is okay if you want to show lingerie, after all this is boudoir photography, but this looks accidental and does not add anything to the image.

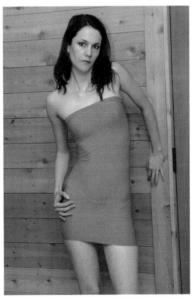

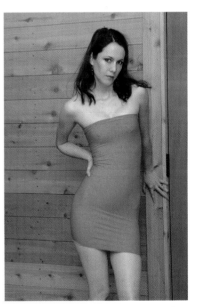

Speaking of panties, this close-up shows the panty, which can be seen through the skin-tight dress and is distracting to the smooth line we are trying to get.

Here is a full-length photograph showing the panty line.

Here the model has removed her panties so they don't show through. As a general rule, don't let your model wear underwear unless you are showing it in the photograph.

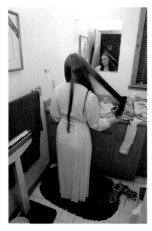

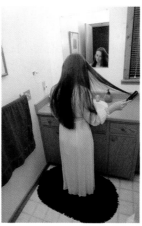

Here is a typical scene of what the studio bathroom looks like during a studio session. There are clothes and makeup everywhere. It is not a very attractive background for this photograph.

It took about one minute to push the stuff on the counter and the floor off to one side and remove the scale from the photograph.

It is distracting to see things that appear to be growing out of the model's head, as in this photograph of Linda. The plant appears to be part of her.

Move over slightly to give a different view. You can have your model move over, you can move, you can move the plant (if it is portable), and you can have your model move forward so the plant is more out of focus. We did all of those things here because the space was a little tight. This image is better than the previous one, but it would have been even better if the plant could have been moved more so it wasn't behind her at all.

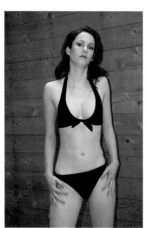

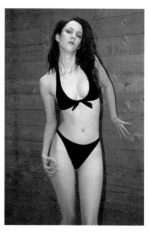

Iona has the thong on so that the straps or edges are straight across.

Here is a close up of what the thong bottom looks like with the top fairly straight.

Have your model pull up the sides to the top of her hips, making the bottom a curve rather than a straight line.

A curved line is usually more flattering on a woman and it gives her longer legs as well. The eyes compute the length of her legs from the ground to the edge of the clothing. In this case, her legs are about four inches longer just by pulling up the sides of the thong.

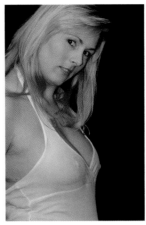 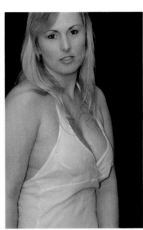

One thing to try is to simply move your camera slightly as we did here to crop out the offending bleb. It looks a little unbalanced, so we will try again.

Here we had Tanya move her arm to cover the bleb. Now she looks as if she is slouching… not attractive either.

Depending on the pose and costume, you will find skin wrinkles in places that don't look attractive. The technical term is "blebs," and no one likes them. If you are photographing your wife or girlfriend, she will be quite upset if you show her like this. If you are a professional, your client won't purchase copies.

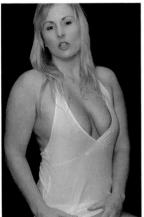 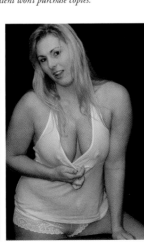

Rotate your model a little and you can see it improve, but it's still not quite right. This image could be fixed with a bit of retouching if necessary.

We have Tanya turn some more, and this is the best of the series so far.

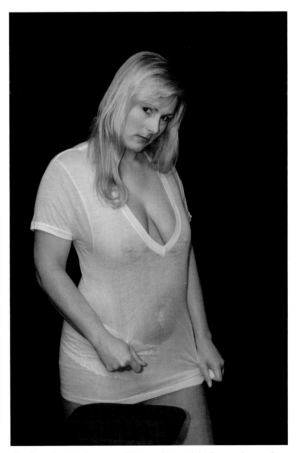

Finally, we had her change to a different t-shirt, and this becomes the most flattering image of the series.

STEP 13: DIGITAL IMAGE PROCESSING

What does "digital image processing" mean? In the old days of film, if you wanted to process your images, you had to load the images onto a reel and put it into a tank, all in total darkness. After that you could turn on the lights and begin adding various chemicals and, keeping the temperature constant, agitate the tank to keep the chemicals mixed. Finally, you would hang up the film to dry. Once it was dry, you would cut the film, make a contact sheet, number it, and you were ready to begin printing. We will do the same here, except using digital techniques. The goal is to have your images ready for printing.

Memory card in a card reader.

The simple steps in digital are downloading the image, numbering it, backing it up, and organizing your images. These are all very similar to the things done with film.

First you need to download your images. This means transferring them from your memory card or camera onto the hard drive of your computer. As suggested under Step 3, "Selecting Equipment," it is easier and less prone to error if you use a card reader to do the downloading rather than attaching your camera to the computer. Simply remove the memory card from the camera, place it into the reader, and watch it show up on your desktop. Make a new folder and name it appropriately. One suggestion is to use the date and a short description. If you use the date as YYMMDD (for example, 060315 means March 15, 2006), then they will automatically sort in date order. So the complete name would be: "060315-Susan beach." If you have more than one session or location on your memory card, set up folders for each. Then simply drag the photographs from the memory card on the desktop into the various folders.

Eject the memory card from your desktop. Do not erase or reformat the card on your computer. Check that the photographs transferred okay by looking at them with your image software. You need to consider whether you want to renumber your images. Some photographers will simply use the number assigned by the camera. It might be something like "DSCF7479." Others will change it slightly by adding letters that refer to the session, such as "Susan01-7479" (Susan01 means the first session with Susan). Finally, others will rename the images entirely to something like "Susan01-001," "Susan01-002," and so on. Choose the one that works best for you and renumber the images if you'd like. Many image programs, such as Photoshop, have a renumbering feature built-in. If not, there are a number of programs available for PC and for Mac that will enable you to renumber easily.

Gold CD and gold DVD. These were made by MAM-A, Inc.

Now that the images are all downloaded, checked to make sure they downloaded okay, and renumbered, it is time to back up. Backing up means to make additional copies so you don't have to worry about erasing them. This is a *critical* step that many, many people skip. If you learned nothing else from this book but this step, it will have been a great investment for you. Everyone will lose images at some point in time due to hardware failure, software failure, or operator error. It is not a question of "if," just "when" it will happen. The ideal way to back up is to drag all of your folders to a second hard drive, either internal or external. Then burn another copy onto a CD or DVD. These can't be erased accidentally. Don't use the cheap, no-brand, or store-brand CDs or DVDs for this purpose. Those are fine for sending images to people and similar tasks, but for backing up, you want to use gold CDs or DVDs. They are more expensive, but much longer lasting. Cheap CDs cost about 25 cents each. The good ones cost about one dollar each, so you are not talking about a huge fortune to invest. You will be glad you paid more when your hard drive crashes or gets erased accidentally.

Do not erase, reformat, or reuse your memory cards until you have backed up. Always erase or reformat in your camera. It will do a better job of setting up the file structure the way that it likes it. If you do it on your computer, it sometimes causes a problem. Don't forget: back up, back up, back up!

Now you need to organize your images so you can find them easily. You often see a simple set of folders under a main folder (such as PHOTOGRAPHS). Inside that folder is another folder labeled BOUDOIR PHOTOGRAPHS. Inside that one is a folder called SUSAN. Then inside SUSAN you have "060315-Susan," "060401-Susan," and so on. Your structure will be a little different if you are only photographing one woman, such as your wife or girlfriend, and have no plans to photograph other women. In that case you would not need the folder called SUSAN. Besides a simple folder organization system, there are numerous software programs that allow you to organize your photographs. iPhoto, a Mac program, will handle that chore for Macintosh computers. There are similar programs for the PC. Professional photographers doing boudoir portraits for clients will usually only need the folder organization system. All of the images and final, retouched files are kept in the master folder with the client's name on it. Once that client is finished, make another copy on CD or DVD of the entire file, and put it into the client's physical folder before removing it from your hard drive. If you are doing it for fun, you may not run out of space for a long time if you have a large enough hard drive.

One last thing: Back up!

STEP 14: EDITING AND SELECTING IMAGES

Using iPhoto to edit a group of photographs.

So you now have your images available on your computer. Now comes the fun part: reviewing and selecting the best images. What software to use? There are a number of choices. Of course if you have Photoshop CS or Photoshop CS2, you can use the Browser function. Most computers and digital cameras come with viewing software that will work. On Macintosh computers, the software is Preview and iPhoto. Besides those, you can find shareware software on websites such as download.com, which has software available for PCs and Macs.

Like anything, editing and selecting images is a skill that needs to be learned and developed. Some photographers never seem to be able to learn to edit their own images and need someone to help them. Others learn quite quickly. The important thing is to train your eye to see the image and all of the details. You do this by looking at lots and lots of photographs until you can see the differences between really good photography and poor photography. Visit museums, buy books, go to the library, read lots of magazines, and visit a number of websites looking for the differences. After a while you will be able to see the quality difference. It can literally hit you overnight.

Using the browser in Photoshop CS to edit a group of photographs.

Here is one way to go about it.

1. In your sorting/imaging program, line up all of the images.

2. Remove the ones that are too overexposed or underexposed to be saved. This can be done in small thumbnail size and almost at a glance.

3. Look for other technical flaws such as flash not firing, glare from reflections, flare from the sun, and so on.

4. Look at them in more detail and pull out the ones where eyes are closed, that are blurry from camera movement, that are out of focus, or where the model has an awkward pose.

5. Transfer all of these to another folder called "Rejects" that is set up in the folder for this session. You'll never know when you might need to take another look at one of these and have to fix it.

6. Now, in detail, look at the photograph and react to it emotionally. Let it flow over you. You need to be in your artistic mode, the right side of your brain. You already did the left-brain work above. Now just react to the image. Don't stare at it, just react. Do you love it? Hate it? Not sure? Sort the images into different folders or mark them if your program allows it. Go through the images at full screen size, but do it quickly. Take only about two seconds per image, no more. If you are not sure, just move on. After you have gone through the images, give it a rest and then do it again. You may need to go through them a number of times. You will be interested to find out what happens. Some images "grow" on you. Over repeated viewings, you begin to like them more and more until they become your favorites. Other images will grow tired as you see them more often. And still other images will sit solidly as your favorites. With practice, you can get yourself into "right-brain mode" quickly. You must have done the left-brain work of removing the problem images earlier, or it won't work. With the problem images still there, you may fall in love with an image that is not technically perfect enough to be shown to others. Experience has shown that the right side of the brain is often not as discriminating about the details as is the left side of your brain.

7. Take all of these favorites to show the model or client. Never show them unedited files. By not showing all of your mistakes and problems, you will earn the reputation of being a fabulous photographer.

STEP 15: RETOUCHING YOUR IMAGES

Nearly every image will need some retouching. Usually you will need to adjust the brightness and contrast, perhaps retouch out a blemish here and there, and crop it to the proportions of the photograph that you will print out. There are many software applications that can do those things for you, from the simple and inexpensive to the complicated and expensive. At the top of the heap is Adobe Photoshop. The current version is CS2, and Adobe puts out a new version nearly every year. If you are going to do any heavy photo manipulation, then, at some point, you will have to bite the bullet and purchase this software. If you are a fulltime student or teacher, Adobe offers educational discounts. Since photographers depend on copyright to stop people from copying their work, it is only fair to respect Adobe's copyright and huge investment and not "borrow" a friend's copy.

If you are a hobbyist or someone who just wants to play a bit, you probably don't need Photoshop's power and complicated learning curve. You may already have software that will do the job without a problem. Oftentimes, your digital camera, computer, or even inkjet printer will come with software for retouching. It will be on the CD that came in the packaging. Look for names like PhotoDeluxe, Photoshop LE, or Photoshop Elements. Besides these applications, there are various free and shareware programs. For a Windows PC, consider Picasa, a free program now owned by Google. You can use it for retouching and managing your image files. For Mac, there is iPhoto, which comes with most Macs now. Besides those applications, go to a website, such as download.com, and look for image-editing programs that will run on whatever computer you have: PC or Mac. If you are looking for a bit more sophistication than the shareware programs, Adobe Photoshop Elements, available for both PC and Mac, is probably the best choice. It costs just under $100. It has a lot of power, and it will take you a while to learn how to use it. It will be worth it in the end. Because of the power of the software, there is a lot to learn and much more than we could cover here. With the variety of software and computer platforms, it is much better to get a book or DVD to help you learn to retouch your images.

On the following pages you will see some before and after images. These are basic and simple corrections that anyone can learn to do. Photoshop was used and the individual Photoshop tools are listed. If you use different software, there will be similar tools, but they are likely to have different names. These examples are not meant to be tutorials, but just to show you what is possible and why you need to learn to use your chosen software. The "before" image is the photograph straight from the camera.

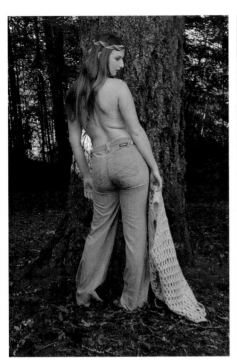 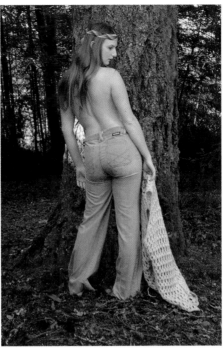

Left: This is the image direct from the camera. It is a little dark and dull and the twisting angle of her shoulders and hips has wrinkled her back. It is not a very attractive look.

Right: Brightness and contrast were adjusted by using the Curves tool in Photoshop. The Healing Brush was used to remove the wrinkles. Now the image looks much better.

Left: The image is a bit dull and needs to be brightened. The angle of her head has twisted her neck, causing the wrinkles.

Right: Photoshop was used to brighten the image as in the previous example. Next it was used to remove the wrinkles with the Healing Brush. The image was softened using a Gaussian Blur. Then, using the Erase to History function, it returned the sharpness of the eyes, lips, and hairline around the face.

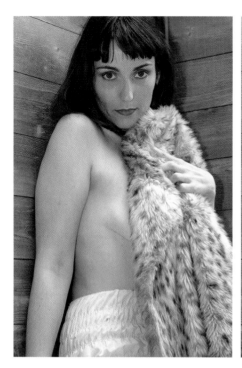
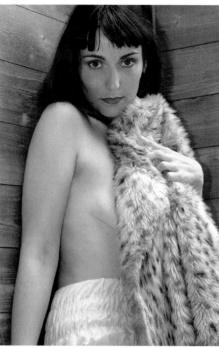

Left: The exposure on this image is pretty close to being correct, but Jessica's arm is pressed tightly against her. It flattens the top of her arm and makes it look much wider than normal.

Right: The Liquify tool in Photoshop allows you to literally push things around. Using it here allows us to push Jessica's arm back into place so it looks correct. The Clone tool was used to remove some small rust spots on her ruffled panties.

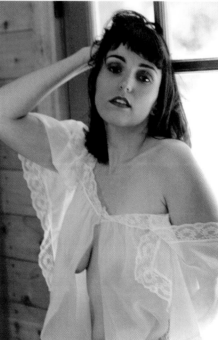

Left: This image is backlit by the light coming through the French doors behind her. The auto-exposure on the camera was fooled and her face is too dark.

Right: Using the Curves tool in Photoshop allows the exposure to be corrected. The focus is just a little soft, so a sharpening tool called, paradoxically, Unsharp Mask is used to sharpen it just a bit and make it look crisper.

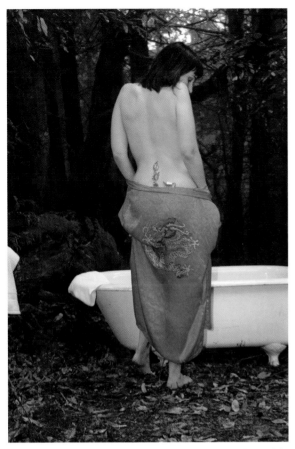

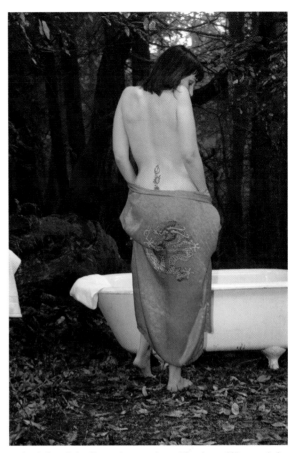

This image is properly exposed, but when looked at in more detail, the tag of the robe is showing.

A few clicks with the Clone tool removes the tag. This also would have worked with any blemishes she might have. Blemishes often seem to be the result of stress. Posing for a boudoir session can be stressful for many women who are not models, so this is something that a photographer needs to learn to deal with on a regular basis.

STEP 16: VIEWING THE IMAGES

Viewing the images means sharing them with your model or client. There are a number of ways that you can do this. You could order "proof" prints of all of the edited, selected images. You would do this by preparing 4 × 6 images and ordering them from your lab or printing them yourself. (See Step 17.) Depending on how many images you created, this could get expensive. This is often how it was done in the film days, but now we have digital techniques. You can view the images on your monitor by using the same software that you used to edit your images. Usually you will want to show the model or client the largest images you can, up to full monitor size if possible.

Photographers have used contact sheets for many, many years. Contact sheets got their name because negatives were laid on a sheet of photo paper (thus "contact") with a sheet of glass over the top to hold it all flat. The resulting images were exactly the same size as the negatives. Digital contact sheets are actually sheets of small, thumbnail images. Software such as Photoshop allows you to set the size of the images to be whatever you like. You can even format it as five rows of four images each, or whatever pattern you would like. Then, you print it out to show your client. This is handy to keep track of all of the images, but it is not as useful as the digital tools we have. If you are not used to them, the small images on the sheets are hard to read. Most of time, photographers use some electronic means to show the images on the monitor (or even a projector if you want to get really fancy). This is generally faster and less expensive than any other method.

Some software will allow you to make a little slideshow and play it back. If this is the case, always start with your favorite, the strongest image. End it with another strong image, probably your second favorite. Sometimes this slideshow can be saved in a movie format such as QuickTime, which will allow you to share it and play it on any computer.

Joanna looks at a photo on the computer monitor.

Here is a digital contact sheet produced by Photoshop.

STEP 17: PRINTING YOUR IMAGES

One of the great advantages of the digital revolution is the ability to easily, and fairly inexpensively, print your own color images without messy chemicals or a darkroom. There are a variety of color printers available for less than $100 that do a very good job with the right software and images. The other advantage is privacy. If you are creating these images for yourself, you don't have to worry about other people seeing them at a lab. This might be important to a wife or girlfriend who is a bit shy about posing for boudoir photographs and having other people see the images.

Jessica looks at a photo just after it comes out of the printer.

Print coming out of printer capable of printing up to 13 × 19.

Print coming out of a printer that can print up to 8 1/2 × 11.

It does take time to do it yourself, plus additional technical skills that you will need to learn. The ability to print is usually in the software that you use to do the retouching (see Step 15). You will need to crop the image to the proportions that you want to print (4 × 6, 5 × 7, or 8 × 10, for instance). To do that you use a cropping tool in your chosen software program and set the size and resolution (see below). You click on the starting location and drag across to frame the image.

The other option besides printing them yourself is to send the images to a lab to be printed. You can take your memory card to a lab or you can create a CD on your computer and take it to the lab. Several discount stores such as Costco and Sam's Club offer inexpensive prints, which can be quite nice if you follow color management techniques to control the color on your end. There are lots of labs conveniently located in many neighborhoods. Besides those options, there are many labs located online. You upload the images to them and they print your images and mail them to you. With some of the labs you can upload the images and have them in your hands a few days later. If you use an outside lab, you need to find out the technical specifications they require. Most will want the photographs in the same color space that your camera typically produces (sRGB for the technically inclined), which is why we are not delving into that difficult, technical subject. They will also specify the resolution (often 250 ppi or 300 ppi) at the size of the print you will be ordering. Once you learn this, you simply set your software to that and it will be done automatically when you crop your image for printing. Professional labs will usually give you the information you need to set things up and will talk you through it if necessary. The same is true of local labs and even those at Sam's Club or Costco.

No matter how you do it, it is special to see the images that you chose printed the first time. Your client or model will want photographs for herself and perhaps to share with others, and you will need images for your own portfolio. Happy printing!

STEP 18: SHARING YOUR IMAGES

There are a number of ways to share your photographs with others and many reasons for wanting to. In some cases, you simply want to show other photographers what you are doing and get feedback. In other cases, you may want to have a website to show potential clients samples of your work. You may want to try licensing your images as stock photography or to sell fine-art prints. You might want to just show friends and keep it somewhat private. There are electronic and physical means to share your images:

- You can send a print or show your portfolio.

- You can send images on a CD or DVD.

- You can e-mail your images.

- You can put them on a website.

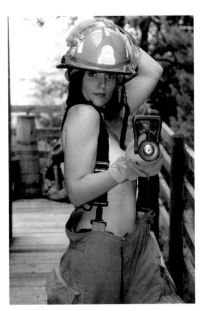

If you have a hot photograph, don't call the fire department; share it!

We talked about a printing the images in Step 17. We have also described the printed portfolio in Step 2 and will mention it again in the next step, Step 19.

It is easy to transfer images to a CD or DVD. In modern computers, with the right software (usually available built-in on your computer), you simply drag a folder of images to the software that will "burn" them onto the CD or DVD. In addition, there are a number of programs that will allow you to create a slideshow of images. Photoshop will allow you to do this, as well as a number of free or inexpensive shareware programs. Once you create a slideshow, you simply drag it onto the CD through the software and burn a copy. Some software will allow you to make a slideshow that will play on a home DVD player. Although a computer is required to create the slideshow and burn it on the DVD (your computer will need to have a DVD burner built in or attached as an external device), no computer will be needed to play it back if you have created it with the proper software.

Most e-mail programs will easily allow you to attach images before sending them. It is best that your images are sized somewhat smaller (say no larger than 4 × 6 at 72 ppi) and you only attach a couple to any single e-mail. Some people's e-mail system cannot easily handle the large files that are typical of photographs. Be sure to let the recipient know that you will be sending the photographs so she won't think it is a virus or spam.

The final method mentioned, putting images on a website, has the most variations. There are photo-sharing websites, photo forum/critique websites, and, of course, creating your own website. If you are not familiar with the photo-sharing websites such as flickr.com, you should check them out. Go to your favorite search engine and type

in "website for sharing photographs" (without the quotes) and you will get a huge list of possible sites and reviews on each one. Some of them are (in no particular order and without any kind of endorsement):

- flickr.com (now owned by Yahoo)—they allow up to 200 images, privacy, and the basic level is free
- snapfish.com (now owned by Hewlett-Packard)
- dotphoto.com
- photosite.com
- smugmug.com

Some of these sites offer software editing and retouching tools; allow you to order prints; have your images put on calendars, mugs, mouse pads, and similar merchandise; share photographs only with family or friends; and totally control how everything works.

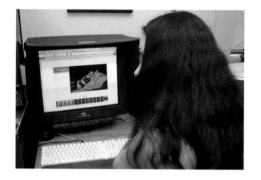

A little bit different are the photo-sharing/critique sites. These sites allow a limited number of photographs to be uploaded to gather comments from other photographers, both professional and amateur. They are generally free or low cost. They usually do not have privacy controls since the purpose is to share with a larger community and get feedback. If you are looking for feedback on the images you are creating, they may be ideal for you. Here is a list of a few of them. The same search terms given earlier will provide more names. Each one has different requirements about how many images you can upload, how often you can upload images, the total amount of space, and so on. They do not provide as much flexibility as do the first group, but they do provide a built-in community of photographers with whom you can discuss images.

- photoforums.com
- shuttercity.com
- usefilm.com (no, you don't have to shoot with film to use this site)
- webaperture.com
- webphotoforum.com

The final method is to set up your own website. You can do that for about $100 per year, including the website name and the hosting of your site through companies such as pair.net. You can also utilize many companies, such as EarthLink and AOL, that allow you to have a free personal website as part of your account for accessing the web. In that case, you control everything about your website. It can be a bit more technically challenging, but freedom has its price.

STEP 19: UPDATING YOUR PORTFOLIO

Some of the author's portfolio books. Consider upgrading from the black notebook style on the right to a nicer style, such as the burgundy leather one on the left.

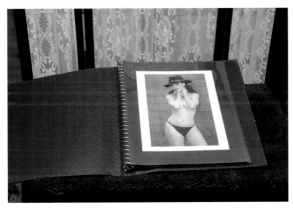

The inside of a good quality 11 × 14 portfolio book with 8 × 10 images inside.

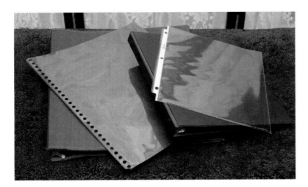

Here are several types of pages to fit the books shown.

No matter how nice your portfolio is, you will need to update it. If you want to be a professional photographer, it is a continuous process. You will need to keep up with hairstyles, fashions, and makeup styles. You should be growing as a photographer, learning new techniques, and exploring new ideas. As one image is completed, it should be added to your portfolio, replacing another image. At the same time, consider upgrading the portfolio book to a higher quality and more professional style. If you use a book with clear plastic pages, you will have to watch them to see when they become scratched and need to be replaced. Nothing detracts from your presentation more that scratched plastic pages. Even if you are just photographing your wife or girlfriend, you will want to continue showing off your best work and improve as you go along.

How often should you replace the images in your portfolio book? Keep in mind the old adage that you will be remembered by the worst image in your portfolio. You should look through it periodically, and whenever you see an image that you know you can do better or one that looks dated, it is time to replace that image. If you are growing, then the majority of your portfolio images should last only about a year or less. Be cautious of the tendency to just keep adding more and more images to it without removing any. If you haven't changed images, then you should question if you are growing enough.

If you are a professional, you will most likely have an online portfolio as well. You can also have an electronic portfolio you show to potential clients, but nothing will take the place of a portfolio book of actual photographs. Most clients will want to purchase prints, so you want to be able to show them what they will look like. Be sure to have a signed model release for every image in your portfolio, whether it is a physical book or on a website.

SECTION 3

LESSONS

THIS SECTION IS the "meat" of the book. It contains numerous lessons broken down into the subject areas of Posing, Lighting, Costuming, Locations, Props, Photographing Angles, and Breaking the Rules. Each lesson is designed to show you what to do and, in some cases, what not to do. Each lesson contains numerous figures to help stimulate your own creativity and show you what can be done to create your own boudoir portrait images. There are literally hundreds of photographs in this section. When you see an example, it may give you other ideas. Don't be afraid to run with them. With digital photography, the cost of experimentation is lowered. By experimenting, you will be able to learn much more quickly than if you had to develop the film and wait for prints. If your experiment fails and the images are horrible, then simply erase them and start again. Digital is a powerful learning tool. Use it to its best advantage and turn the page.

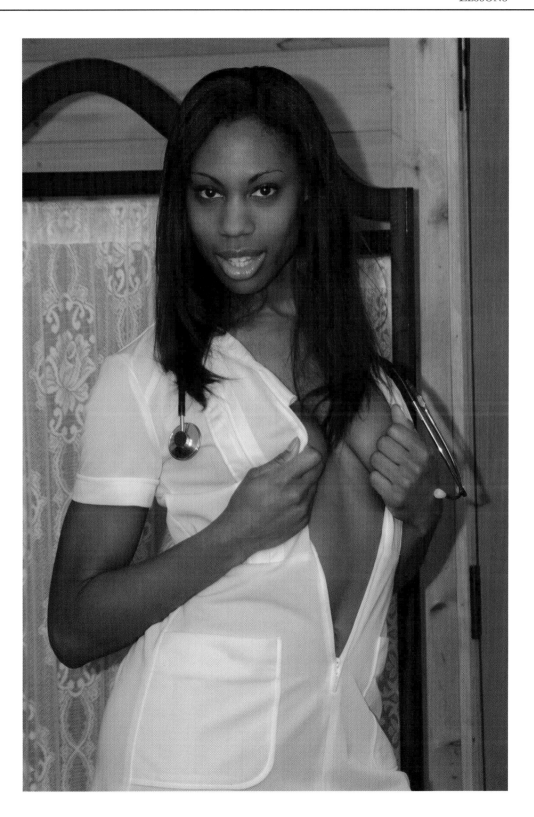

POSING

Posing is a very important part of a boudoir photograph. The key is to pose the model without making her look, well… posed. Awkward placement of hands will detract from the image and the woman. In the worst cases, it will make her look heavy or short or certainly not how she wants to see herself. It will also reflect poorly on you as a photographer. In the days of using film, each image cost money to create, so it was important to just photograph the best poses. Now that digital is being used, it is much less expensive to create a number of images. Still, it is better to learn about posing that makes the woman look sexy and alluring and not just hope you will get a "good one." In the following lessons, you will see a number of good posing ideas and examples as well as samples of what not to do.

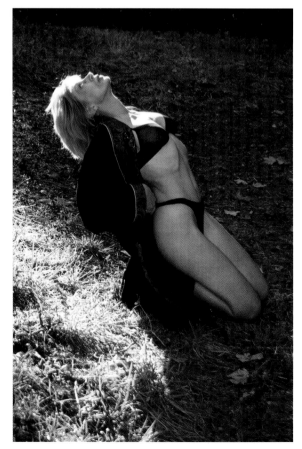

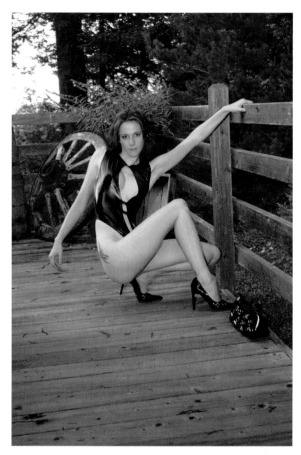

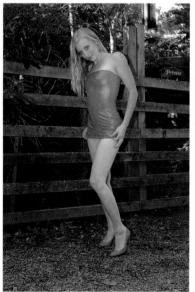

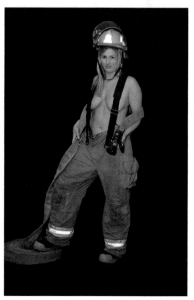

Graceful Does It—"S" Curve Posing

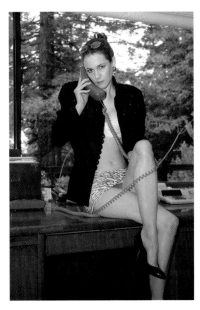 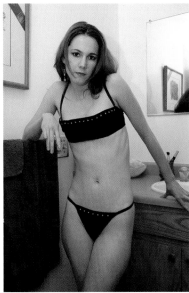

Women look better with curves, and posing that accentuates curves is the most attractive. What are "S" curve poses? If you divide the body into sections starting at the top, you have head/neck, torso, hips/waist, upper leg/thighs, lower legs, and feet. An "S" curve means each section of the body points in the opposite direction of the section below it.

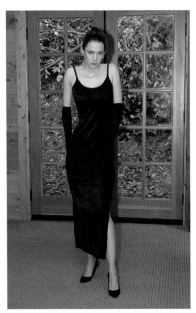 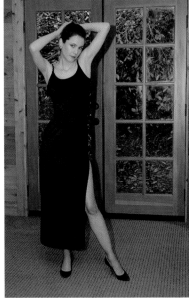

If everything is straight, then the pose looks stiff. Putting in some curves by moving each section of the body in the opposite way makes the image much more elegant, soft, and feminine.

Stiff **Curved**

The same is true for the next two pairs of figures. The photos with curves are much more pleasing to the eye than the ones that are stiff and straight. Practice this and teach your models. It is a key point to creating beautiful and sensual images.

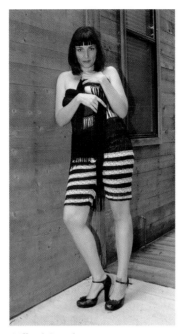 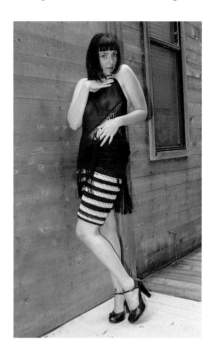

Stiff and Curved

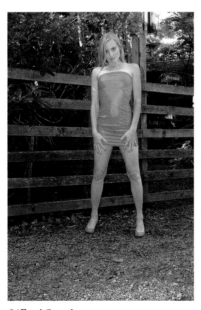 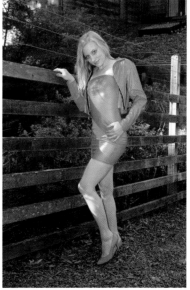

Stiff and Curved

"C" Pose *Here is a typical "C" pose.*

"C" Curve Posing

Similar to the previous section on "S" curve posing is this section on "C" curve posing. A "C" curve is when the body is shaped in a curved manner resembling the letter "C."

Why should you care? As mentioned before, curved poses look more feminine and sensual on a woman's body. Always aim for a curvier pose whenever you can. It will show off your model's figure better and be more pleasing to the eye. The next three figures show the differences between the poses

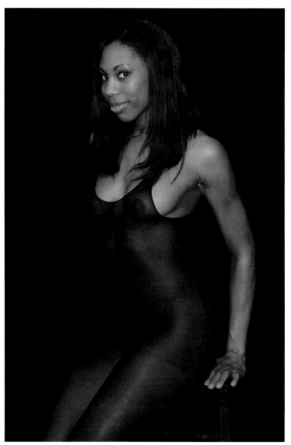

"C" Curve *Turning her head the other way, her body falls into more of a "C" shape.*

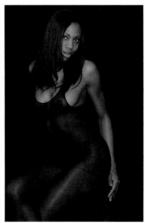

Stiff and Straight *There is no curve in Amelia's body as she stands fairly stiff and straight.*

"S" Curve *Having her sit on the stool and lean her head to the side, she falls naturally into an "S" curve pose.*

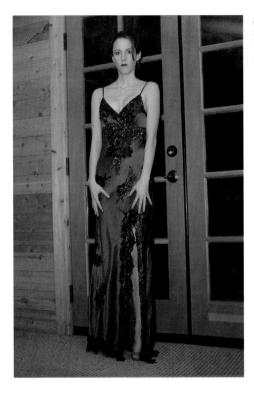

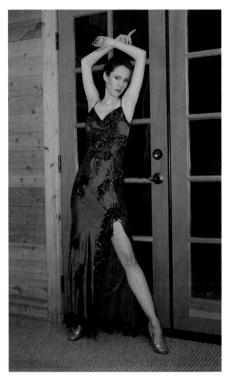

Stiff and Straight *Here is a second example, this time with Iona standing stiff and straight.*

Cover Up *Extending one leg and leaning her head to the side makes a "C" shape and a much more pleasing and sensual image.*

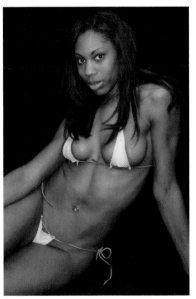

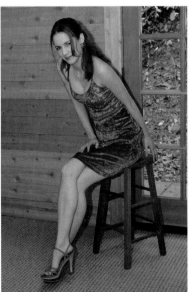

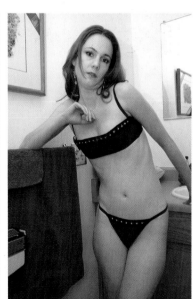

More "C" Poses *More examples of "C" poses.*

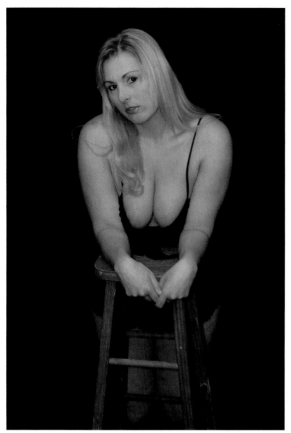

Gravity Is Our Friend

Different poses can really help define the shape of a woman's body. Depending on the size, shape, and firmness of a woman's breasts, some costumes will not be as flattering as others. The pose can make a big difference. In these samples, we use gravity to help us by having the model either bend over or lie on her stomach. If she bends over, putting her elbows on a railing or piece of furniture, it will help to provide nice form, shape, and cleavage. If she lies on her stomach and either pushes up or places something under her stomach, then her breasts will often look more flattering as well.

Using a Stool *Tanya uses a stool and gravity to provide nice shape and cleavage. Using her arms and elbows, she pushes her breasts together slightly to give better shape to her cleavage.*

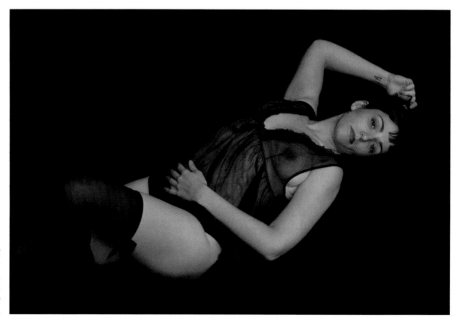

Lying Down *Jessica is lying down on her back in a negligee. This pose is attractive, but doesn't provide cleavage, which many women are looking for in an image.*

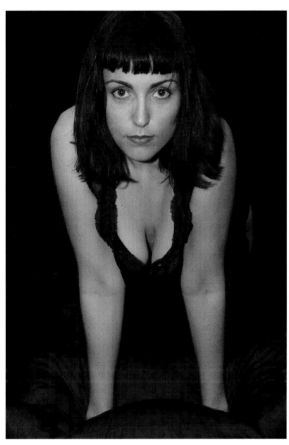

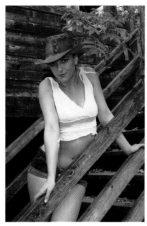

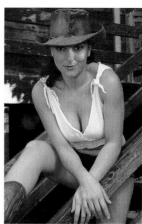

Standing *This is a nice photograph of Joanna standing, but it doesn't show off her nice figure as well as it could. There is little cleavage showing.*

On the Rail *By having her lean over the stair's railing as well as pushing her breasts together slightly with her arms, more cleavage is shown and the photograph is a bit sexier.*

On the Ground *Jessica uses a kneeling pose with the same outfit as in the first figure to provide better cleavage.*

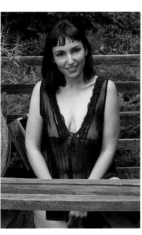

On the Ground *Lying on her stomach is another pose Jessica used. Here we used a pillow under her tummy to lift her up and give her breasts more space so that gravity can help.*

Standing *An example showing Jessica standing …*

On the Rail *… and leaning over the fence railing.*

Watch the Tummy

Many women are concerned about their stomach. The current desired look, as popularized by the super-skinny models of women's fashion magazines, is for a very flat tummy. Even women with a flat tummy are often critical about how they look. This is a detail area that you must keep your eye on if you want your photographs to be popular with women. No matter how flat a woman's tummy is, a pose that bunches up in the middle will generally not be as flattering.

In general, you should stretch out the pose for a more flattering appearance. By bending backwards, a very similar pose will be more flattering. Usually, a good rule is to always stretch out every pose.

For even more stretching, try putting a pillow under the small of her back. This will drop her head down lower than her hips and provide the maximum stretch for the tummy.

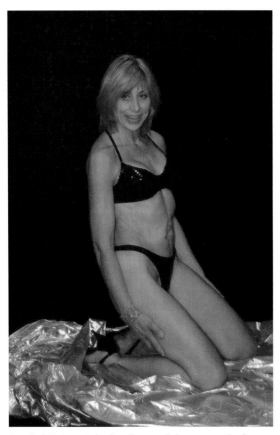

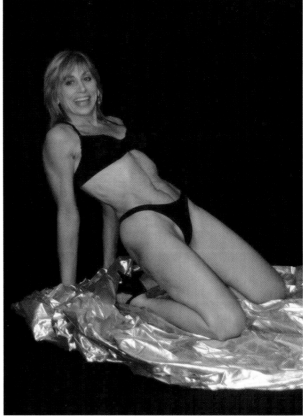

Bunched Up Pose *Deborah works out regularly to maintain her flat tummy, but even with her figure, this pose will not be as flattering as the following one.*

Stretch It Out *She leans back, and poof! Her tummy is flat again.*

If stretching is not enough for a pleasing look, try using a costume that covers up her tummy. You can also use fabric of various kinds. You can do the cover up when she is laying down or even standing up.

Finally you can move in closer or crop the final image tighter to eliminate the tummy from the photograph.

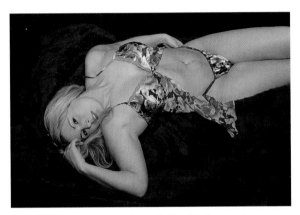

Maximum Stretch *We put a pillow under Tanya's back to curve her pose and stretch her out.*

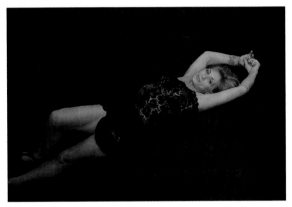

Laying Down Cover Up *A piece of lace covers up the tummy. Black is a good choice in this case since it blends with the background.*

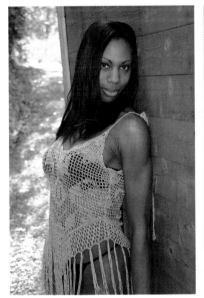

Standing Up Cover Up *Clothing that drapes over her tummy will cover it up and yet it still looks natural. Amelia's crocheted top does this perfectly. It is just see-thru enough to be sexy, yet still provides tummy cover if needed.*

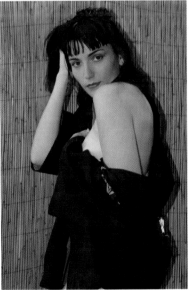

Cover Up *More clothing cover up.*

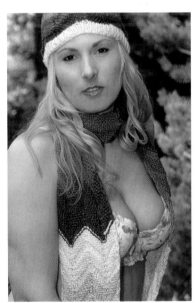

Move in Closer *Moving in closer and eliminating the tummy from view is sometimes the fastest and easiest way to proceed.*

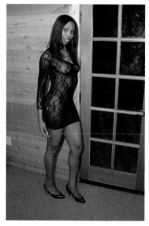

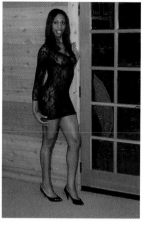

Wide-Angle Lens *Here the photographer has used a wide-angle lens and is standing close to the model. This makes Amelia's legs appear much shorter than they actually are.*

Telephoto Lens *Here the photographer has used a telephoto position on his lens and is standing farther from the model. This makes Amelia's legs look longer.*

Longer Legs

Longer legs are another desire for many women and something that photographers need to learn to deal with. There are a number of ways to improve the length of any woman's legs, such as choosing a longer (more telephoto) lens or zoom position, squatting down to a lower angle, choosing costumes that flatter the legs, working with costumes to better show off the legs, and selecting poses that are more flattering.

Some costumes provide a longer leg line because they are higher cut.

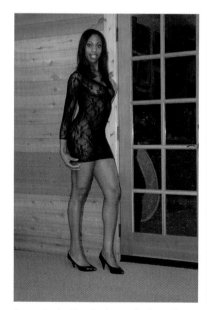

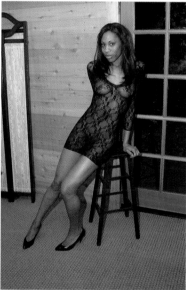

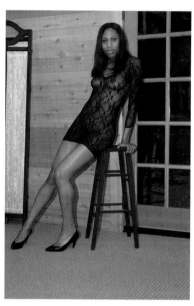

Lower Angle *Here the photographer has used the same lens and position as before except that he has gone down to his knees and is shooting up at the model. This makes Amelia's legs look as long as possible.*

Wide-Angle Lens *Here the photographer has used a wide-angle lens and is standing close to the model.*

Lower Angle *Here the photographer has used a telephoto lens and is squatting down.*

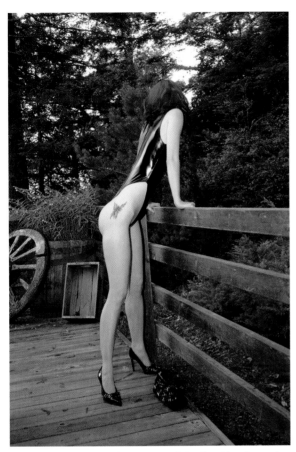

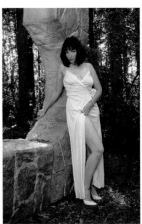

Short Dress *A really short dress, or in this case a top masquerading as a dress, makes the legs appear longer.*

High Cut *A dress that is slit really high will show off a lot of leg and make the legs appear to be longer.*

High Cut *A high cut on the leg gives Iona really long legs. A low photography angle and slightly telephoto lens helped also.*

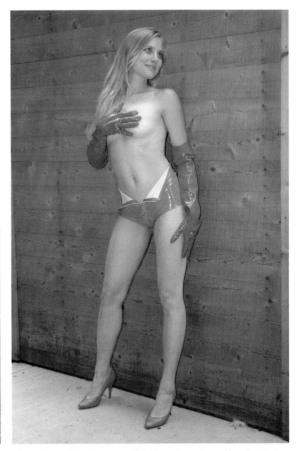

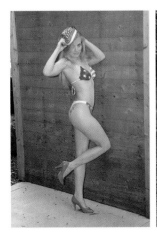

Bikini *A high-cut bikini will show off the legs nicely, as Melanie shows us.*

Micromini *A micromini looks nice on Melanie.*

Short-Shorts *Short-shorts, or really high cut shorts, also produce a long leg line.*

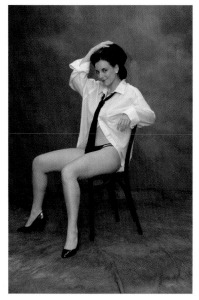

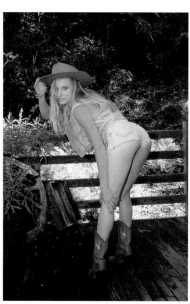

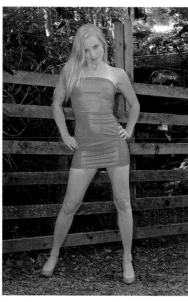

Working with the Costume *Joanna pulls back the man's shirt she is wearing to reveal more leg and thus make them appear longer.*

Posing *Wearing short-shorts and then bending over to show the maximum amount of leg shows the advantages of proper posing.*

Leg-Flattering Pose *This is another leg-flattering pose.*

Working with the Costume *Jessica does the same by pulling up her evening gown to show off her legs.*

Posing *Jessica strikes a pose that features her legs.*

Watch the Eyes

"The eyes are the mirror of the soul" is an old proverb that applies especially to photography. A woman's eyes are a very key part of images, especially when they are more closely cropped. When the eyes are staring directly at the camera, it engages the viewer and draws him into the scene in a way that the model looking away doesn't.

Sure, there are times when the model will look away and it will work great as a photograph. Those images tend to be 3/4 or full length, showing more of the model. They also work best when she is focused on doing something rather than just staring off in space.

Importance of the Eyes *The eyes are very important to the photograph.*

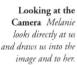

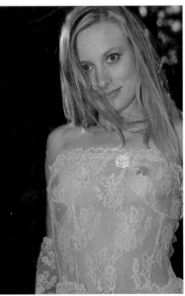

Looking at the Camera *Melanie looks directly at us and draws us into the image and to her.*

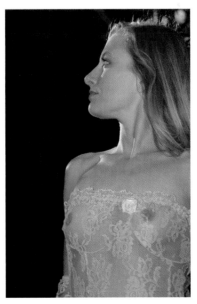

Looking Away *When she looks away, it tends to make us want to know what she is looking at and takes us away from her.*

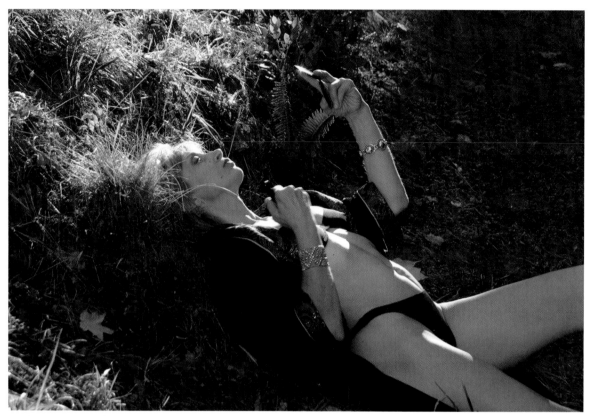

Looking Away *Since Deborah is not looking at the camera, it makes this photograph more private and more voyeuristic. Notice how this photograph works since you can see her mirror and makeup brush. We know what she is doing. Contrast this image with the previous figure where we don't know what the model is looking at.*

Besides having the model look at the camera, "how" she looks at the camera will greatly affect the final result. When she has her chin raised, it gives the photograph a bit of an "attitude" and generally shows confidence. If you have her drop her chin down and use a higher angle by being higher than she is and shooting down at her a bit, it will create a more sensual or sexual look. You need to see the whites of her eyes below her iris to achieve this look. The whites of her eyes will only be seen below her eyes and not above it. In this case a more serious expression or very slight smile seems to work best.

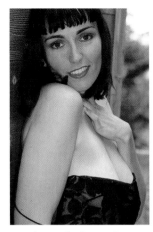

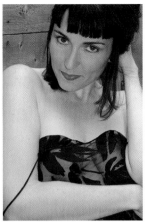

Straight into the Camera *Jessica looks us straight in the eye and shows us her confidence.*

Lowered Chin *She drops her chin a bit and adds just a slight smile, making this image have a sexier flavor.*

Chin Raised *Iona raises her chin and it gives her a confident appearance. Notice that the whites of her eyes are not visible below her irises.*

Chin Lowered *Iona lowers her chin, and look at the difference it makes. The photograph is much more sensual. You can see the whites of her eyes along the bottom of her eyes.*

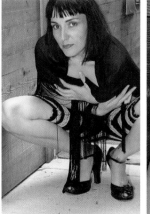

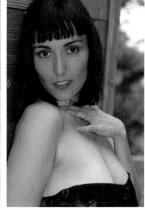

Eyes at the Camera *Having Joanna look directly at us brings us into the image.*

LIGHTING

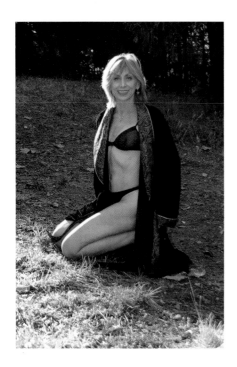

The lighting that you choose to create your images can make or break them. The following lessons will show you how to use some of the common lighting you will encounter and how to deal with some difficult situations as well. Soft, even lighting is often desirable, but it is not always available. You will have to deal with light that is too bright, light that comes from the wrong direction, not enough light, or other situations. These lessons will help you to make your images more natural looking and more attractive.

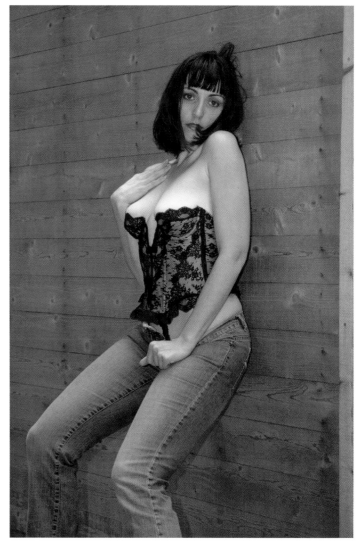

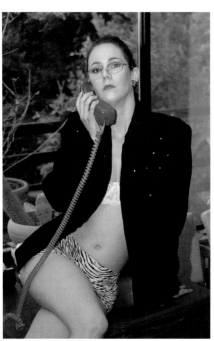

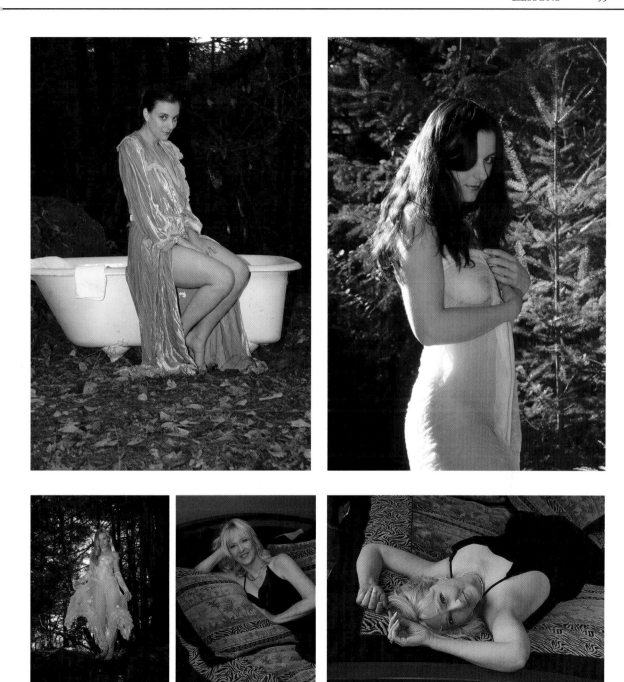

Using Natural Light Outdoors

Natural light is all around us. Photographing in natural light is, well, natural. You need the least amount of equipment, such as lights, flashes, and so on. However, it is still not always easy to get pleasing results unless you pay attention to what the lighting is doing to your model. Oftentimes, if the light is coming from the side or back, you need to be aware of how the eyes look. If there is no large white object behind you to reflect light into the eyes or if you are not using a flash fill, the eyes will appear "dead." They will be very dark and missing the catch light in the pupil. Catch lights give the eyes dimension.

Natural Light *When using natural light, there are often more extremes in the lighting. Notice the blown out (too bright) highlights on the left side of the photograph.*

Flash Fill *This is the same setup as the previous figure, but a flash fill was used in addition to the natural light. The background goes darker and the flash flattens the light on her face.*

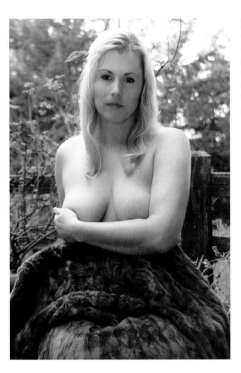

Natural Light *In this case, the light is coming from behind the model on the left side of the photograph. This tends to make the face go dark, which was adjusted using the Curves tool in Photoshop.*

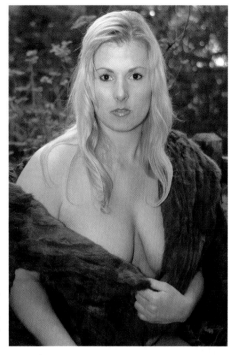

Flash Fill *Just like in the earlier figures, the flash fill makes the lighting flatter and makes the background darker.*

Catch Lights *You can see the catch lights in Iona's eyes in this image.*

No Catch Lights *This is the same figure as the previous one but with the catch lights digitally removed. Notice how the photograph becomes lifeless. This is why close-ups of faces need either flash fill or a reflector to add life to the eyes. One other option is to add the catch light later with Photoshop or similar software.*

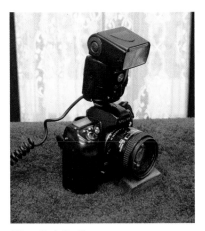

Direct Flash On-Camera

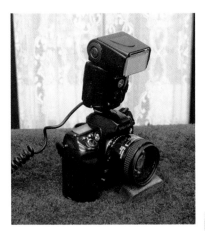

Flash with Diffuser

Using Flash

It is important to have good quality light to make sensual boudoir portraits. The light generally needs to be balanced and not too harsh. One way to do that is by using an on-camera flash, even outdoors. If you are using a compact point-and-shoot camera, you may not be able to add on a separate flash. You may be limited to using the flash you have built-in. This will not give you as much power or control and it is difficult to add on modifiers to soften the harsh light of the tiny flash.

The key to the softness of the light has to do with what is called "apparent size." Sunlight is very harsh. Even though the sun is huge, the "apparent size" of the sun is quite small in comparison to a person. It looks like a very small point source light. That is what makes the light harsh. Instead, if you have a large softbox, dome, or even an overcast day, the light will appear to be much softer. Soft light is when the edges of the shadows have a large transition between very dark and the lighter area beyond the shadow. Harsh, or "hard light," has a very sharp shadow line.

Using Linda as our model, we tried five different lighting combinations. We had direct flash, flash with the small flat diffuser on the flash pulled down, flash with a small dome, flash with a larger dome (called the Portrait Dome), and finally a kind of clear diffuser which points upward, bouncing the light around, known as a Lightsphere Photojournalist, or PJ. See the figures for samples of what they look like.

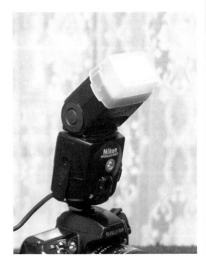

Flash with Small Dome

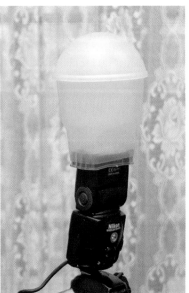

Flash with Large Dome

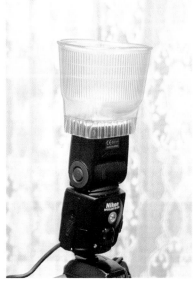

Flash with Photojournalist

Now we will look at sample images of Linda, taken at the same location with just a swapping of the flash attachments. You can see that the light becomes progressively softer with larger flash. There are very few differences between some of the images. For example, there is almost no difference between the first two images. The PJ produces the softest light of all because it allows some light to go straight up and bounce off of the ceiling and some to go out in all directions and bounce about the room. This bouncing about the room tends to wrap the light around the model and diffuse the shadows. The PJ was used to create most of the images in this book. It was used for the fill flash indoors and outdoors as well. It costs about 50 dollars from digitalphotographers.net and comes in different sizes to fit a wide variety of flash units. The only way to tell if flash attachments will work with your equipment is to test them under controlled conditions as we have done here and look for the differences. Just because a device is called a light diffuser, doesn't mean that it will work for you. Use the advantages of digital and test.

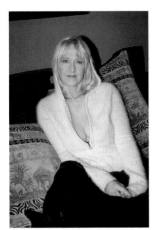

Direct Flash On-Camera

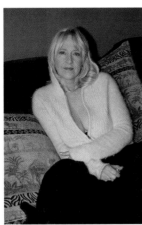

Flash with Diffuser

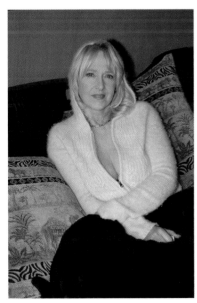

Flash with Small Dome

Flash with Large Dome

Flash with PhotoJournalist

Using Window Light

Window light is often the most flattering kind of light. You need to look for window light around your home. Windows that face north are the best because they will provide light without bright direct sunlight. In fact, when photography first began, photographers built studios with huge north-facing windows and skylights to provide the light for their photographs. You can also use any window that doesn't have sunlight coming in directly. Watch for colorcasts generated by large colored items, such as trees, right outside the window. The green reflected from trees is usually not very flattering for portraits.

Expose Properly *When using window light, the outdoors is often brighter than the model. If using automatic mode on your camera, you will need to adjust so that the model is not underexposed. In this case, the outdoors will be overexposed, but it does not affect the image as much as if the model is too dark.*

Turn with the Light *Joanna turns so that her face and figure are in view. Notice how the pretty light sculpts her bust line and facial features.*

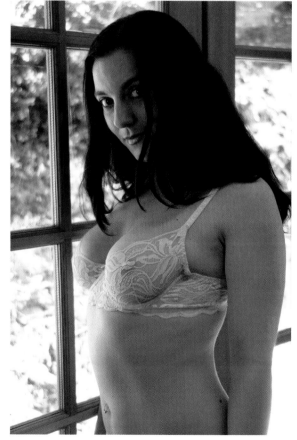

Adjust Position *Make small adjustments in your view and see how it changes her cleavage, making it more prominent.*

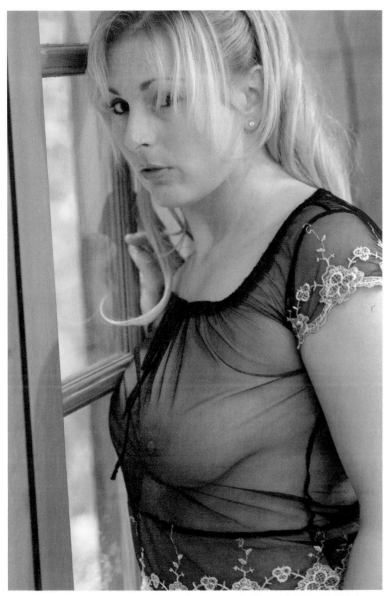

Turn Her Face *We turn Tanya's face so that it gets more light from the skylight.*

Use Skylights as Well *A skylight can also be used. Here Tanya's face has more light from the skylight above her on the right side of the photograph than from the window behind her.*

Turn into the light *Turning her face even more into the light gives another pose possibility.*

When Natural Light Is Too Bright

Sometimes when we photograph outdoors, we don't have a choice as to the day or even the time of day. We are stuck dealing with whatever natural light is available at the moment. When given a choice, generally sunrise and sunset are the most flattering times for lighting. Starting about an hour before sunset will usually provide warm, soft, and beautiful light. But what can you do when you have to photograph outdoors at noon on a summer day? Here are some suggestions for you to try.

Light Is Too Bright *Joanna squints as she stares into the bright sun. This is what happens when you follow the rule about the bright light coming over the photographer's shoulder.*

Close Your Eyes *We have Joanna turn directly into the light and close her eyes so she won't squint. Lifting her head up makes it look like she is enjoying the warmth. Unfortunately, the direct light takes away any shadows of her cleavage and flattens her bust line.*

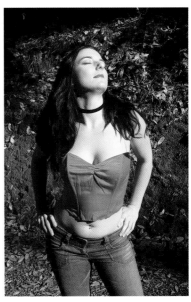

Turn to Enhance Cleavage *Turn her so that the light skims across her chest to form the shadow that shows cleavage. This image is marred by seeing the photographer's shadow, a detail that you need to watch for.*

Move to Avoid Shadow *Moving slightly to the model's side means the photographer's shadow does not show. Still, the harsh shadow on Joanna's face is not as flattering as it could be.*

Turn Her Face into the Light *This image is an improvement on the previous one by simply having her turn her face into the light, but keeping her body and particularly her chest at an angle to it.*

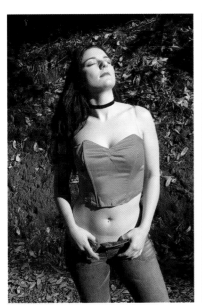

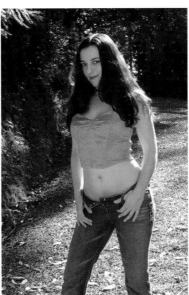

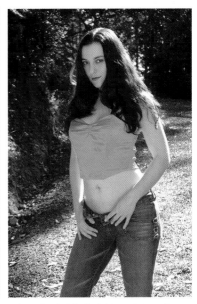

Hand Placement *Having her unbutton the front of her jeans and move her hands flatters her tummy better, provides a more pleasing position of her hands, and is sexier overall.*

Back to the Light *Putting Joanna's back to the light is another nice way to pose her in bright light. The light on her hair and shoulders separates her from the background and gives her a slight glow. An on-camera flash is used to keep her face from being too dark.*

Adjust Hands *The final thing to do is to adjust her hand position so it is more attractive and a bit sexier than in the previous figure.*

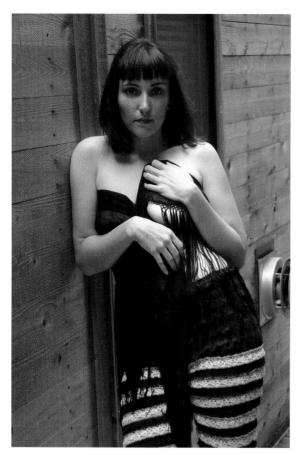

No Flash Fill *Here is an outdoor photograph of Jessica. Note the dark circles under her eyes. We call these "raccoon eyes."*

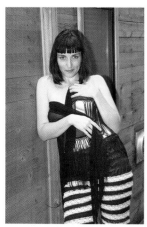

Flash Fill *Here the dark circles are gone and there is a catch light in her eyes.*

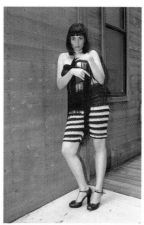

No Flash Fill *Similar to the first figure except it is full length.*

Outdoor Flash Fill

Using an on-camera flash outdoors as a fill light is an important skill for photographers to learn. Depending on your equipment, you may be able to set the flash on manual or just dial down its power to have the amount of fill light that you need. Fill light will often produce better and more vibrant colors as well as adding a catch light to the eyes. It will fill in the dark shadows often found under eyes as well. Overdone, it will turn the background very dark. Done properly, it will put more emphasis on the model.

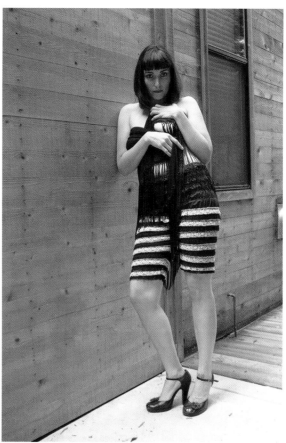

Flash Fill *Similar to the second figure, except this one is full length. A catch light in the eyes is not as important when the photograph is full length.*

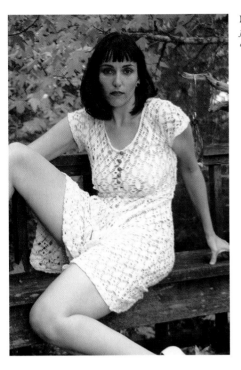

No Flash Fill *Soft lighting from natural shade, with dark circles under her eyes.*

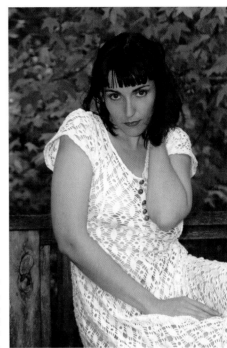

Flash Fill *A little flash fill was used to brighten up this image. The background is only a little darker and the colors are more vibrant in this version of the image.*

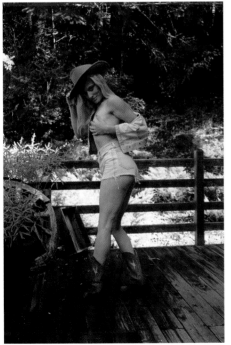

No Flash Fill *No flash fill was used in this image. Compare the background in this image with the next image. Notice that the backgrounds are properly exposed, but the model is too dark in this image. If this image were brightened so the model was not so dark, the background would be too bright.*

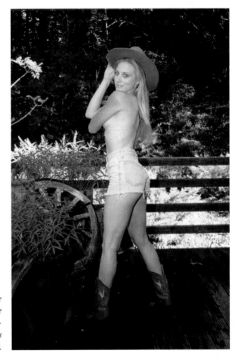

Flash Fill *Using some flash fill in this image keeps the background looking natural and the colors of the model bright.*

Reflector Fill

When the light is coming from the side or back, usually there are undesirable or unattractive shadows on the face. It may also just be too dark on the front of the model's body. To fix that, you need to add fill light. One way is to use fill flash, and that is quick and easy if you have an electronic flash. If you are using the camera's built-in flash, you may find times when it is just not powerful enough, especially outside on a bright day. In those cases, you can use a reflector instead of a flash, but the principle is the same: Put more light on the face and body in the front. A reflector works by bouncing some of that light coming from the back. Here we use a collapsible reflector that is white on one side and gold on the other to add warmth. The reflectors are also available in silver. If you want to save money, you can make your own with a piece of cardboard and some aluminum foil. Crumple the foil so it is not too smooth and glue or tape it on your cardboard so the dull side is out. The shiny side is very bright when you point it at your subject. If you want to be very versatile in your construction, use a piece of white cardboard or white foam core (available at professional photography stores, art stores, and large stationary stores) so that it is white on one side and has the foil on the other. When you want a lot of light, use the foil side. When the foil is too bright, or you just want less light, use the white side of the reflector. Practice with it until you can focus the light where you want it. Be careful not to blind your subject. You can move it closer or farther away as well as adjust the angle. If you have someone helping you, he or she can hold it. Or, you can clamp it to something, lean it against an object, or use a stand as we did in the outside images.

Indoors *A reflector can be used indoors as well. Here it is being used with window light to add more light to the side of the face. The camera position was close to the double French doors.*

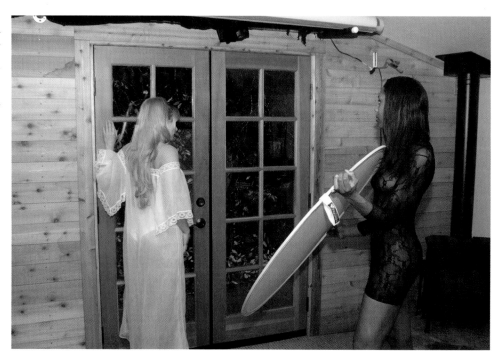

No Fill *This is what Joanna looks like when the light is behind her and there is no fill light.*

With Fill Light *Here we have set up a fill light using a reflector. Now there is light on her face and figure, but the shadows are a little unattractive.*

Turn Her Face *Here we have Joanna turn her face more into the light so that the shadows are more attractive.*

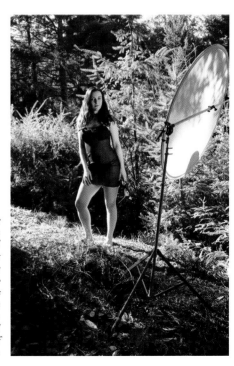

Reflector Fill Setup *The gold reflector was clamped in a holder, which was mounted on a regular light stand so it could be aimed. This way you don't need anyone to help you. This photograph was taken from the same position as the previous two images. The lens was simply zoomed back to reveal the reflector off to one side.*

COSTUMING

Costuming is usually a very fun part of the boudoir photography process. If you are photographing your wife or girlfriend, the shopping and collecting activity may appeal to her and help get her more involved with the process of boudoir photography. Once you have collected a number of pieces, you can mix and match them to come up with new photograph ideas.

Costuming can be detailed with lots of pieces:

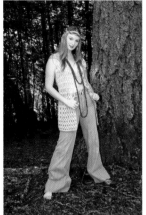 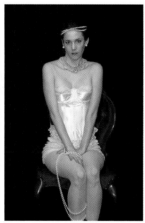 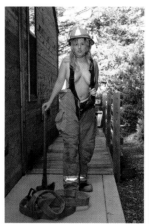 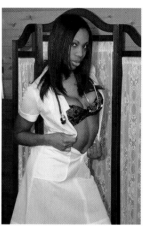

Or it can be very simple with one or two items:

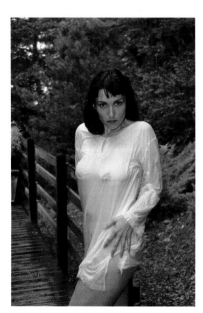 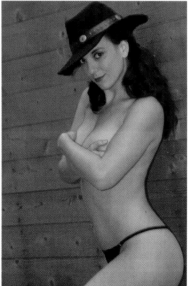

Finally, there might not be a costume at all:

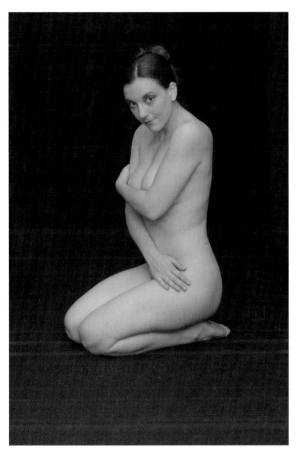 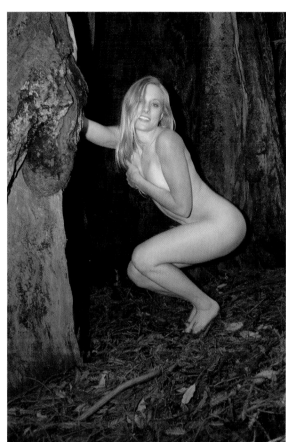

Make Your Own Costume—Tube Dress

It is fun and simple to make your own costumes. This costume is a tube dress made from 2/3 of a yard of stretch Lycra, the same material from which bathing suits are made. This material is 24 inches wide and comes in a variety of colors. It is simply sewn together in a tube shape. Hems are not necessary. If you are handy with a sewing machine, you can easily do it yourself. If you can't sew or don't have a machine, find a local seamstress. About a dozen different tube dresses in different colors and lengths were sewn together for less than 20 dollars.

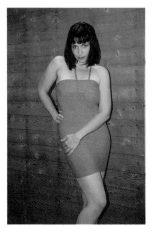

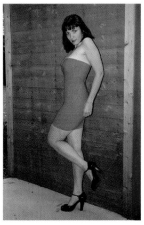

They look good on a variety of figures and are very clingy. Your model should not wear any underwear under the dress. They are so tight that the outline will be seen.

Tube Dress *Here Jessica is holding a lime green tube dress, showing how small it is before it is stretched when putting it on.*

Make Your Own Costume—Caution Tape

You can make another simple costume out of caution tape. Caution tape is available at many hardware stores and is fairly inexpensive. It takes only a few minutes to wrap your model and cover or reveal any particular areas. You can use a piece of tape to hold the caution tape in place before you begin wrapping. This kind of a costume is best used with a model that you have already worked with before. You should be careful when wrapping to keep it professional and not be "grabby" or accidentally brush your hand against her. Your photographs may suffer if she does not appreciate the familiarity, because it will be difficult for her to conceal her feelings while posing. The expressions will definitely show her discomfort. The reputation you develop as a photographer is based on how you behave. Even if the model is your wife or girlfriend, keep it professional.

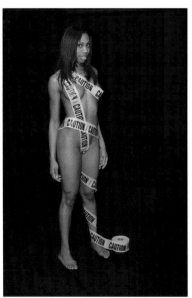
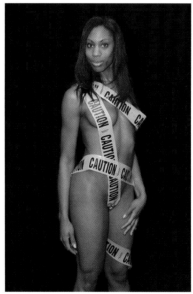
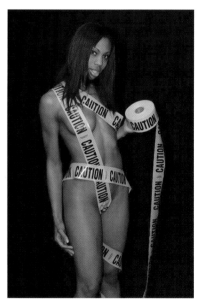

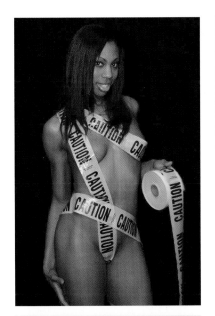

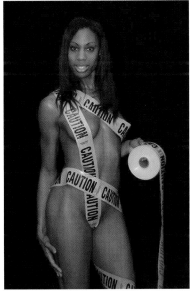

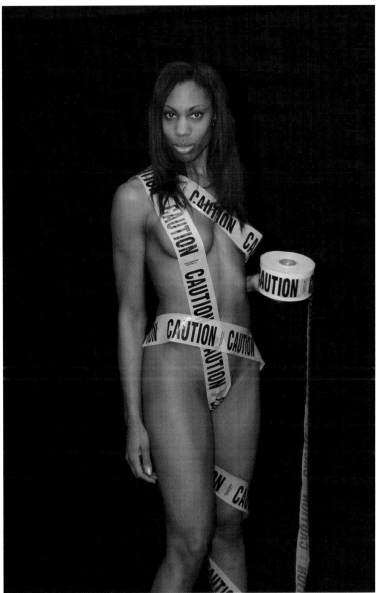

Make Your Own Costume—Chamois Bikini

To make this costume, you will need a package of chamois leather. This is available from any hardware store or auto parts store. Chamois is used to dry off cars after they are washed. The leather is very thin and extremely soft. You will also need some leather thong material, which can be found at a leather or crafts store. If you are not used to making or designing costumes, don't worry. It is easy! Use sheets of paper and sketch out a rough pattern and cut it out with scissors. Try it on your willing model. Keep doing this and adjusting it until you are satisfied with the fit. You need two triangles for the top to cover the breasts. The bottom is one piece designed to wrap between the woman's legs, covering the front pubic area and then underneath and across the bottom like a thong bathing suit would. Each suit piece will be a different size, depending on the amount of pubic hair to cover and the size and shape of her breasts and nipples. It takes a bit of trial and error. If the woman you are working with is a bit modest or simply wants to help, explain what you are doing, and let her cut the paper pattern herself. Once you are satisfied that the fit is good, lay the patterns on the chamois material and cut them out with scissors. You should be able to get several different sizes out of one piece of chamois. Cut your chamois a little larger than your pattern shows. It is much easier to trim it down a bit than to try to stretch it. Once you have a good fit, punch small holes in the corners of the pieces to put the thongs through. Look closely at the figures to see one way that you can attach the leather thong material.

 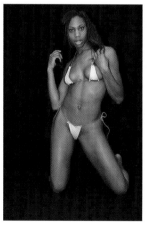

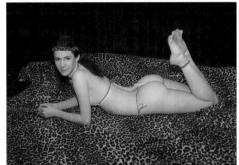

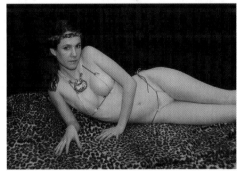

Firefighter

Women seem to love firefighters. In one survey, it was called "the sexiest profession in America." Who can argue with that? If women love firefighters, then what could be sexier than dressing up as one? Getting a real firefighter outfit is a little more difficult than the other costumes. Perhaps you know a firefighter and can borrow an extra set of gear. You can also purchase pieces on eBay. Since you will not be using the equipment to fight fires, you can purchase "out of service" gear and save some money. This gear will be missing a piece, or have some tears in it. Although those kinds of issues are important to firefighters about to enter a burning building, they are not very important to a photography session. To get started, you need a helmet and a pair of turnout pants with suspenders, of course! On eBay, or a similar site, you can find these items for a total cost of less than 50 dollars, perhaps a lot less. If you use borrowed equipment, many fire departments are sensitive about having their name or logo showing in sexy photographs, so be forewarned. Most of the time, the names are on the back of the jacket and on the back or sides of the helmet. It is easy to work around the names if you manage to borrow the turnout gear. Add to the gear an axe, a fire extinguisher, or a hose and nozzle to complete the look. Your model can wear lingerie underneath or nothing at all. If lingerie is going to be used, red is very popular. The posing possibilities are enormous, as shown in these samples.

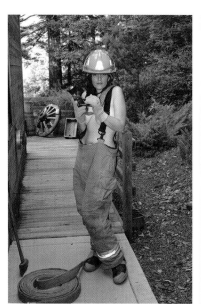
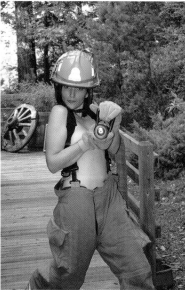
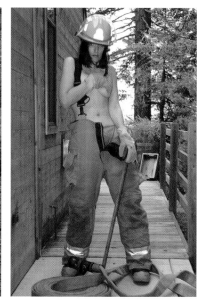

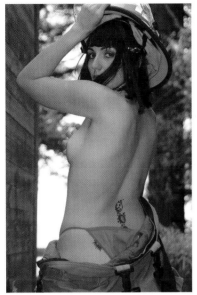
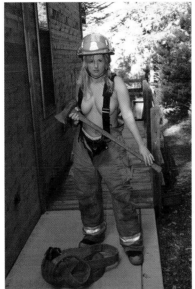
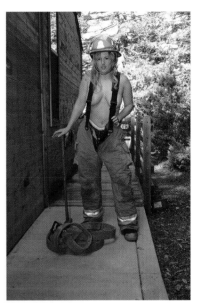
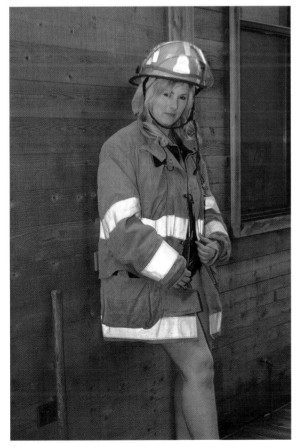
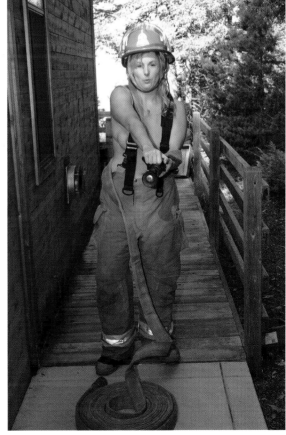

Military Uniforms

Military uniforms are another popular outfit. The pieces to do a costume like this are easily and inexpensively obtained. You may already have some pieces to start with. You can find more for a few dollars at a thrift store, swap meet, garage sale, or flea market. Besides eBay, there are Army/Navy surplus stores as well. Some of your friends and relatives are likely to own some pieces. Don't forget vintage items from earlier conflicts. You can use just the uniform, or add lingerie such as colored panties or fishnet stockings.

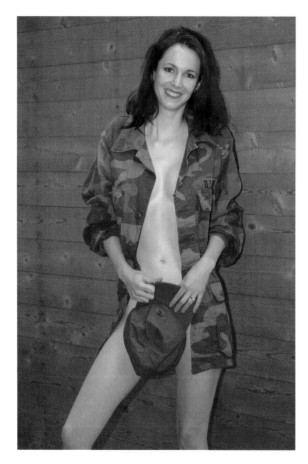
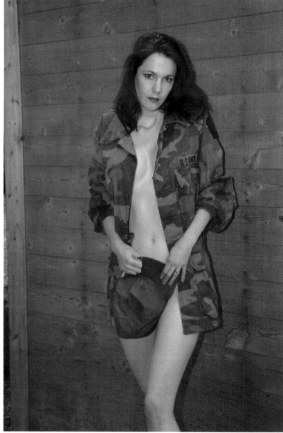

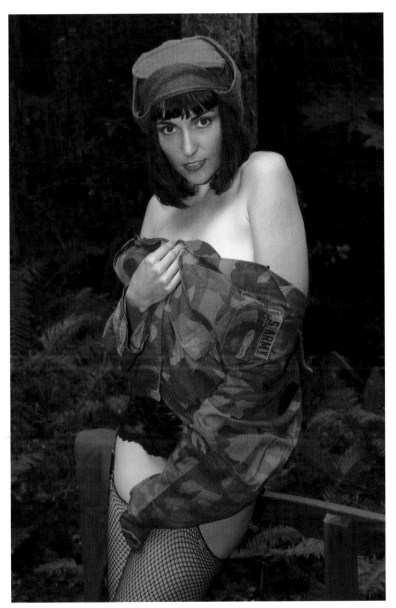

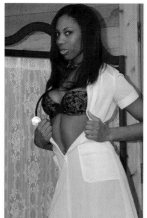
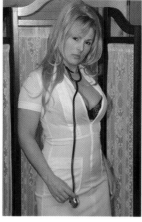

Sexy Doctor or Nurse

Lots of men have a fantasy involving a sexy female doctor or a nurse. This costume costs a few dollars at a thrift store, but you can find them at the usual yard sales, swap meets, and online auctions. You can add props like a hat, a doctor's bag, a stethoscope, lingerie underneath, or whatever you can find or might have already. Keep your eye out when you are out shopping for props to go with this outfit. Here we use the nurse's uniform, some lingerie, and a stethoscope.

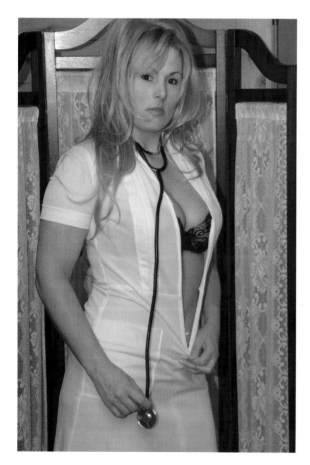
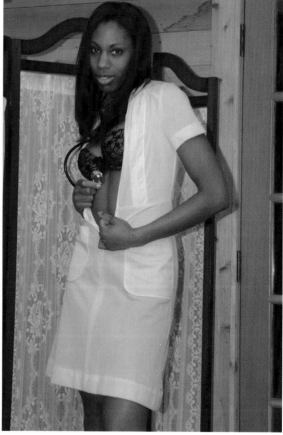

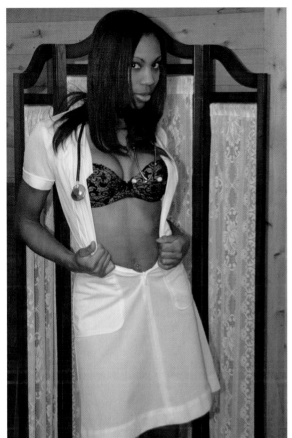
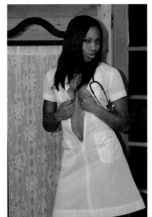
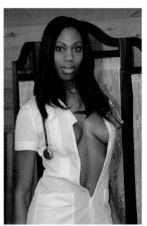
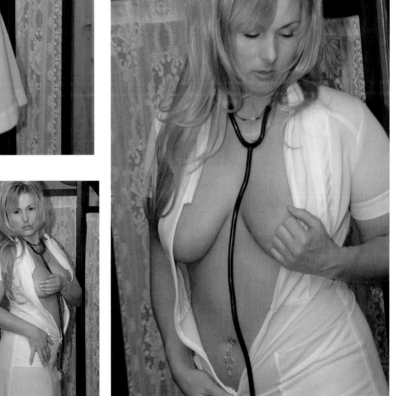
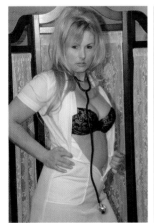
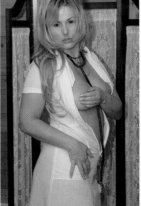

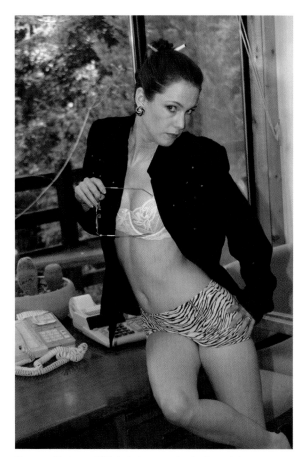

Secretary Costume *With the jacket open, a lace bra is revealed.*

Sexy Secretary

It is a fantasy of many people, both men and women, to have a secretary who is quite sexy looking and available for more than just your typical business activities. This is a very simple costume and fantasy to put together. What do you need to get started? Something in the way of a "business-like" location set up. It could be a desk, a bookcase, or even a desk-style rolling chair. Here are some suggestions for a costume: a miniskirt is nice, along with a suit jacket open to reveal a lacy bra, as demonstrated by Iona in the examples; a dress and blouse with garters and stockings, which Jessica is wearing; or a short skirt, blouse, and thigh-high stockings, also worn by Jessica. Glasses can be added, the hair put up in a bun with pencils, and other props like books and telephones can be used.

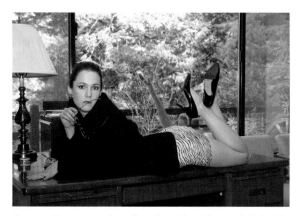

Secretary Costume *A jacket and miniskirt with Iona lying on the desk is all it took for this image.*

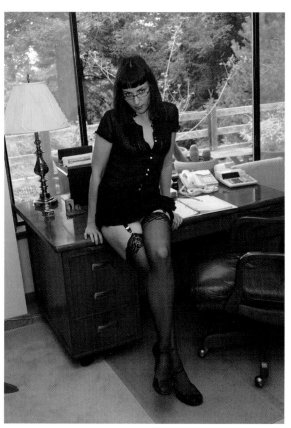

Garter and Stockings *Garters and stockings with a bit of thigh revealed add spice to an image.*

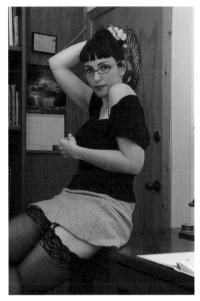

Hair Up *A short skirt and thigh-high stockings contrast with Jessica's hair up in a bun.*

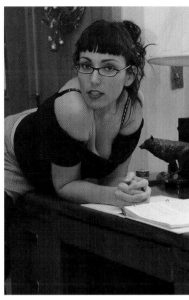

Leaning Over Pose *A simple change of position with a different pose adds a lot of sex appeal.*

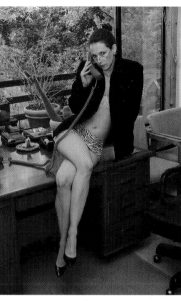

Phone for a Prop *A simple phone prop adds a lot of possibilities to the photograph.*

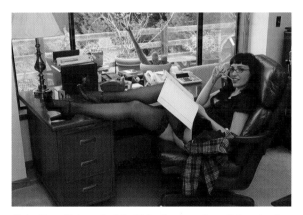

Sitting Pose *Sitting at the desk with her feet up reveals very little, yet is quite provocative.*

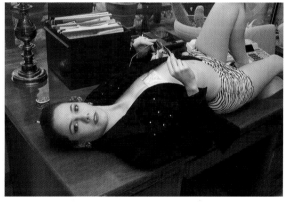

Lying Down Pose *Simply rolling over on her back, Iona gives a completely different look to the photograph.*

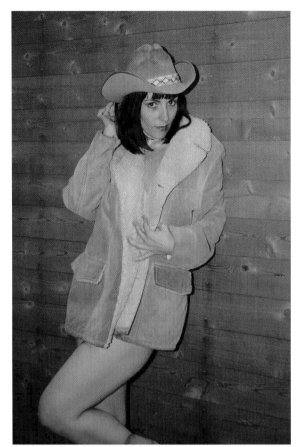

The Western Look

A western look is an easy place to begin your boudoir photography. Almost every woman has a pair of jeans or jean cutoffs. You may have a western jacket and a hat as well. As these examples show, there are lots of costuming and posing possibilities involving the use of jeans, jean shorts, a vest, a western jacket, cowboy boots, and a hat. A more modest woman could start with lingerie underneath the jacket or vest and work her way up to something a little sexier.

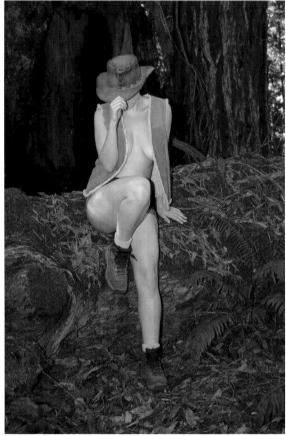

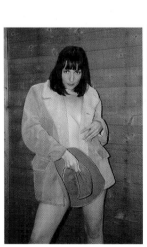

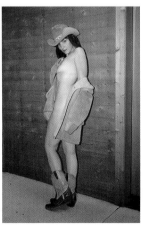

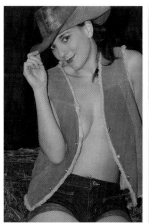

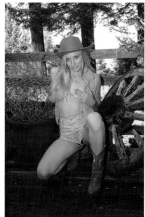
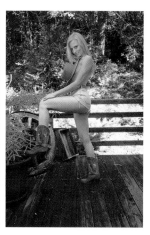

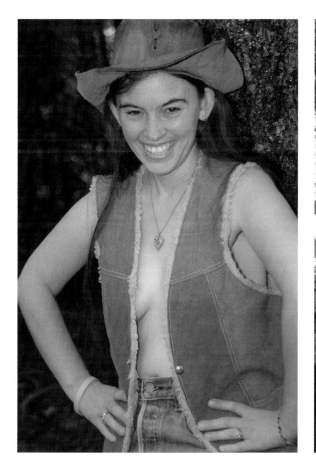

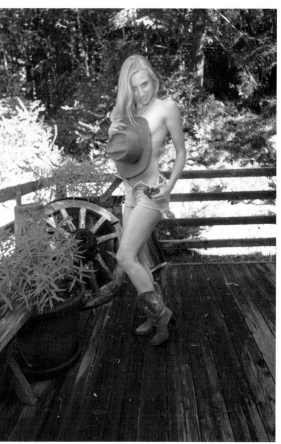

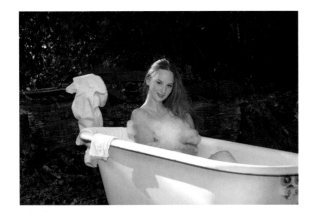

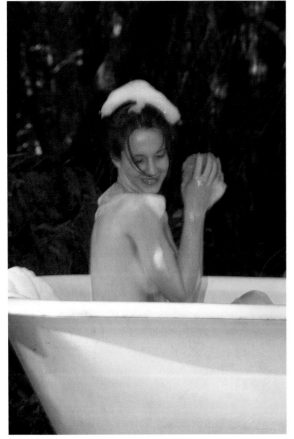

The Wet Look

There is just something sexy about a woman and water. Women understand that as well because "a wet look" is a very popular request at the studio. The question comes down to how many different ways can you get a woman wet? There are a number of issues that you have to deal with. You need to make sure that she is warm between photographs. Give her a bathrobe to put on when you are not photographing. A thick, terrycloth robe works well. Keep lots of towels on hand. If you want to score points, make sure that they are large, soft, and fluffy. Have a towel for her to dry off with, one to wrap around her, and one for her hair. Make sure that all of her makeup is waterproof, or you will end up with a model with raccoon eyes. You can photograph outdoors in a swimming pool or spa, an old bathtub you set up in your yard, a wading pool, an old galvanized tub, or just the garden hose. You can have her wear a swimsuit, a thin t-shirt, or nightgown, or even just some bubbles. She can be bathing, running in the rain, washing the car, or just standing around. The possibilities are limitless. Don't forget the bathtub and shower indoors as well.

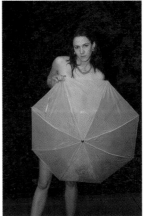

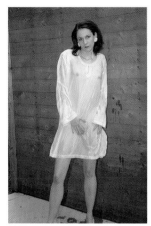
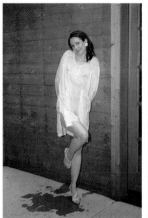
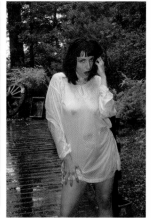
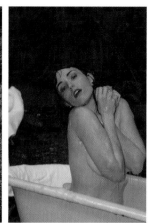

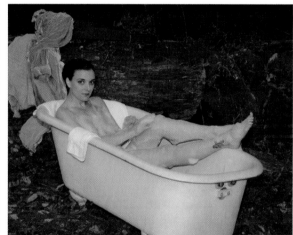

Traditional Lingerie

What is "traditional lingerie"? Traditional lingerie is the kind of lingerie that nearly every woman already owns. The great thing about starting with this kind of costume is that there is little expense. The woman you are photographing is likely to already own several of these kinds of outfits. She knows that they fit her, and this will make it easy to get started with the photography. Even though lingerie is typically found in the bedroom, you can use it indoors, outdoors, and in the studio.

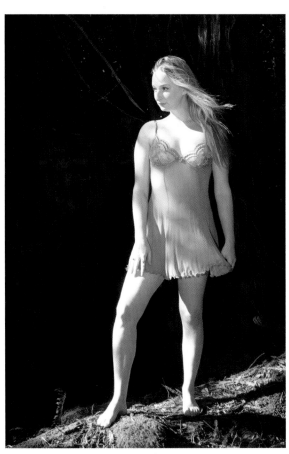

Camisole and Panties *Amelia wears a short camisole with panties against a black background in the studio.*

Short Negligee *A short negligee will work outside as well as in the bedroom, as Danaë demonstrates by posing on a large redwood log.*

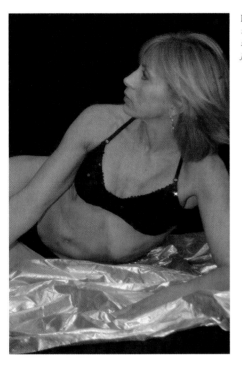

Bra and Panties *Deborah models a black bra and panty set, lying on a piece of gold fabric in the studio.*

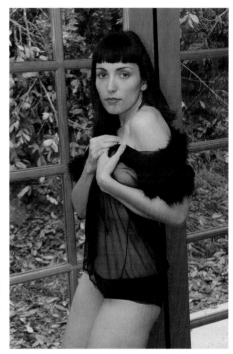

Sheer Robe and Panties *Traditional lingerie will work anywhere. Jessica is posing in a sheer robe with black panties underneath against a set of French doors.*

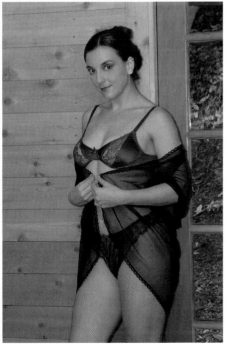

Sheer Robe over Bra and Panties *A bra and panty set can be jazzed up a bit with a sheer robe, as Joanna shows.*

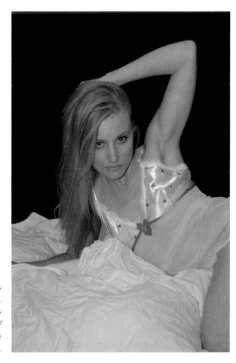

Short Negligee *A white sheet goes well as background for Melanie's white negligee, which is typical of the kinds of negligee that many women own.*

Mixing Lingerie and Regular Clothes

If your collection of lingerie is a bit small, this lesson will show you one way to enlarge it without rushing out to buy more, although that can be fun too. Start using the lingerie with other outfits that your model already owns. Here we mix lingerie with coats, robes, jackets, jeans, and skirts. The possibilities are nearly limitless.

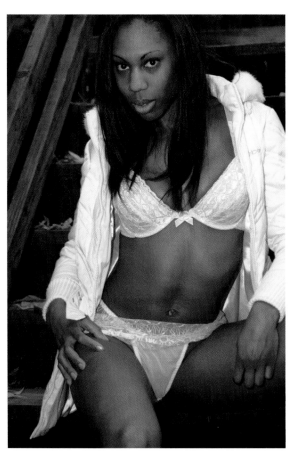

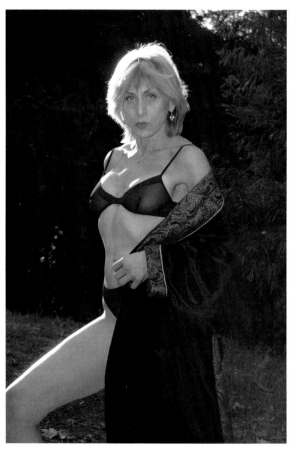

White Jacket with Bra and Panty *A white ski jacket goes nicely with a white bra and panty set on Amelia.*

Bunched Up Pose *Deborah adds a robe over her sheer black bra and panties.*

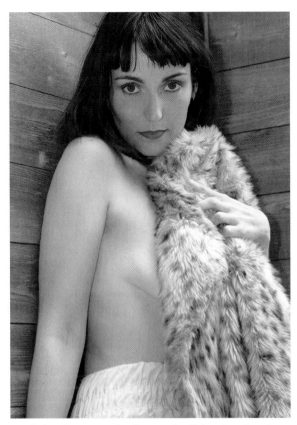

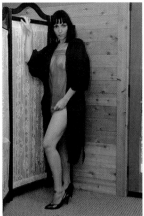

Robe and Negligee *A robe over a negligee adds more possibilities to the photographic session.*

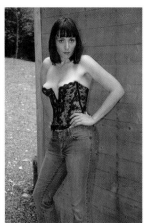

Jeans and Bustier *Jessica wears a bustier with a pair of jeans. This combination could actually be worn out as well.*

Bunched Up Pose *Using a faux fur coat with ruffled panties makes a nice combination. Notice that they are both light colored, as is the background. The coats keeps your model warm when it is cold outside as well.*

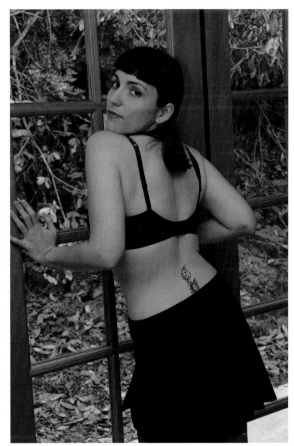

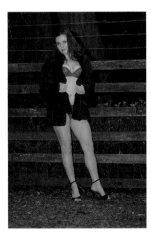

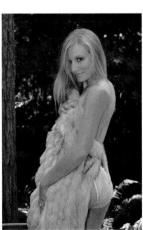

Fur Coat over Bra and Panties *Here is another example of a fur coat worn with lingerie. It was getting cool outside and Joanna appreciated the extra warmth it provided.*

Fur Coat and Panties *Fur coats seem to be popular choices. They don't have to be "worn" to be effective, as Melanie demonstrates.*

Bra and Skirt *It is possible to team up a bra with a skirt. A black bra was chosen to go with the black skirt so that they would match better. A white bra would cause too much contrast.*

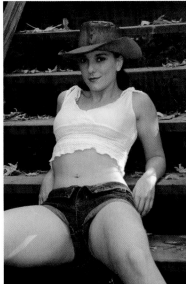

Fun with Jeans

Admit it. Everyone likes jeans and has at least a pair or two, maybe more. Jeans come in all sizes, colors, and styles. Sometimes people don't realize how sexy jeans can be. Here are examples of ways to mix and match jeans with other clothes, as well as poses you can use. It makes costuming simple for a boudoir shoot. There are jean skirts, jean shorts, and jean short-shorts. Jeans can be down-and-dirty, or add a pair of heels for a dressy look. You should keep an eye out for other pieces that will go well with a pair of jeans.

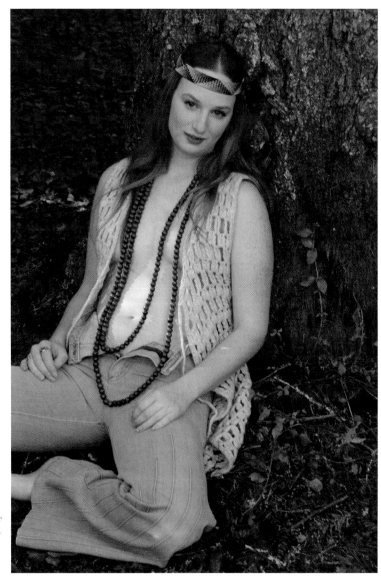

Jean Shorts *A pair of jean shorts either rolled up or torn off gives maximum exposure.*

Vintage Jeans *Here is a pair of bell-bottomed vintage jeans from the 1960s. They lend themselves to a hippie kind of costume with some beads, a crocheted top, and a headband.*

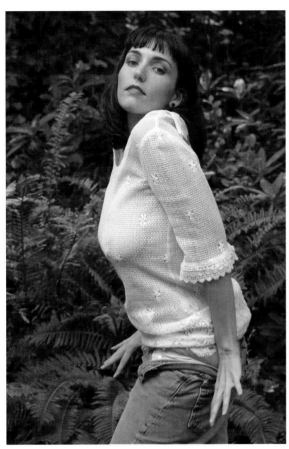

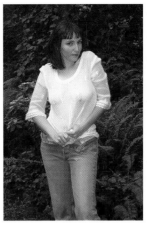

Jeans Paired with a Crocheted Dress *Here, Jessica wears a crocheted dress as a top to go with her jeans.*

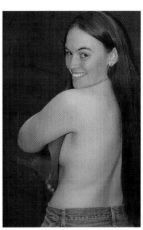

Just Jeans *Stephanie shows that just a pair of jeans is all you need.*

Jeans Coming Off *A sexy look is to have your model start to take her jeans off.*

Fishnet Dress and Jeans *A fishnet dress can be used for a sexy top with a pair of jeans, unbuttoned to show more of Joanna's tummy.*

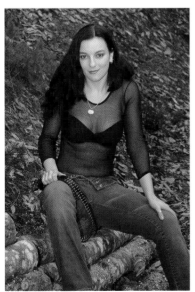

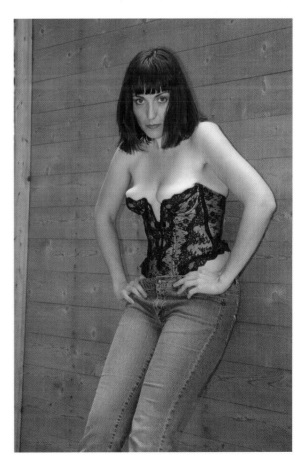

With a Bustier *Add a bustier for a top.*

Make Your Own Costumes with Fabric

With a few pieces of fabric and a few clothespins, you can make your own costumes. Although any kind of fabric can be used, we used 48" wide, stretch polyester. It is black on one side, with a shiny, brightly colored pattern on the other. That gives you two possible costumes with one piece of fabric. Three yards (nine feet) is plenty for these purposes. This fabric is available in a number of colors such as purple, blue, and green. It is relatively inexpensive. You don't need to hem the fabric. Add to this a few clothespins and maybe a small spring clamp, the kind with orange handles available at any hardware store for a couple of dollars. Now, simply wrap the fabric around your model in any kind of a pattern. Be creative with it. Pull it tight and stretch it on your model, as it will give slightly when you clamp it. Usually it is better worn without underwear; it tends to show panty lines due to its thinness and stretch.

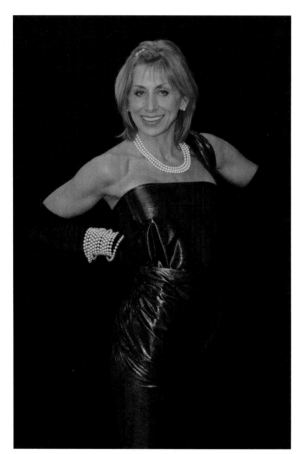

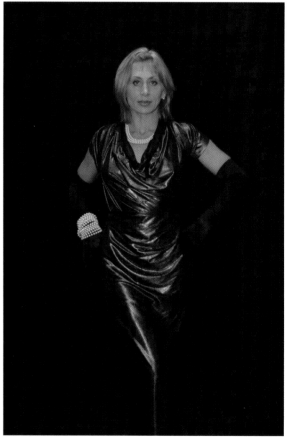

Dress 1 *Deborah wears the blue fabric strapless with the fabric finished by pulling it over her left shoulder.*

Dress 2 *Now the same fabric is wrapped a different way.*

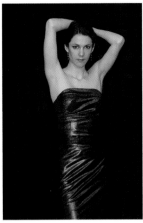

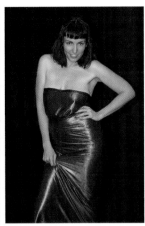

Dress 3—Front *This time the fabric is reversed on the bottom to show the black side. This is still done with one piece of fabric.*

Dress 4—Front *Similar to Dress 1, this time on Iona, but totally strapless without the bit over the shoulder.*

Dress 5—Front *Similar to Dress 4, but not so tightly wrapped. This time, the green fabric was used.*

Dress 5—Back *Here is how Dress 5 is held together with clothespins in the back.*

Dress 3—Back *The same dress from the back. The clothespin holding it together is hidden in the roll of fabric in the back. This outfit could be photographed from any angle.*

Dress 4—Back *You can see how this dress is held together with the use of a clothespin and an orange clamp as well. The clamp was needed because of the thickness of the group of the fabric.*

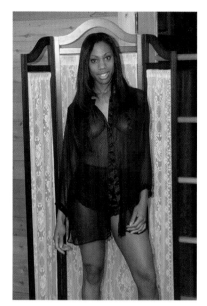

Loose Fitting *Amelia's sheer robe is way too big and doesn't look as good as it can.*

Using Clothespins to Adjust *The fabric is rolled up in back to tighten it up and held in place with a couple of clothespins.*

Making Clothing Fit

When you photograph, you don't have to have clothing that fits as perfectly as you do when you are going to wear it out in public. Here you can see that a few clothespins, which should be in every photographer's arsenal, are often all that you need. If you are going to be photographing the back, then you need to consider safety pins. Duct tape in various colors, such as black and white, can come in handy as well. Duct tape is a quick fix if a hem should tear or you have other minor clothing emergencies. Remember, you won't be wearing this out in public. It just has to look good for the camera.

When an outfit such as a dress, or jeans, or shorts is too tight, just leave them unbuttoned or unzipped. It will usually look much better and sexier that way, rather than looking too tight.

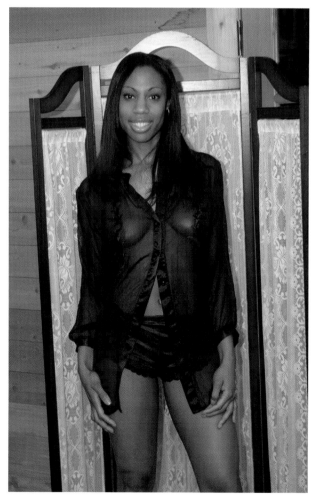

Better Look
Now it looks better.

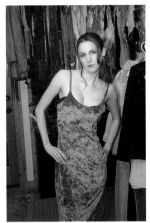

Too Big—Front View *This cute red dress is just too big for Iona.*

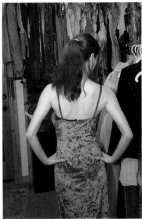

Too Big—Back View *You can see her black strapless bra and how the dress hangs loose under her arms.*

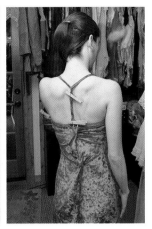

Adjust *It this case, the straps were twisted together and then pinned with clothespins to hold them.*

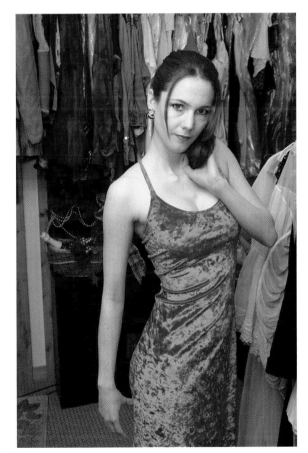

Better *Now it fits and looks much better. You need to be careful when photographing that you don't show the back of the dress, or else you will have to repair the image with some retouching in Photoshop.*

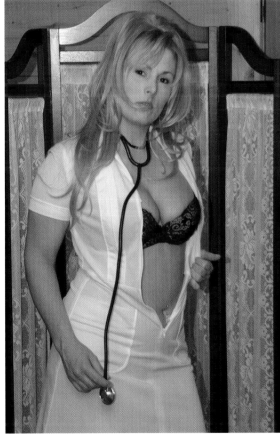

Too Tight *Here you can see that just leaving Tanya's dress unzipped will work on an outfit that is too tight otherwise. This way, it looks very sexy with her red bra showing and doesn't look too tight.*

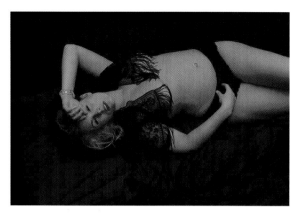

A Top *A lace shawl with fringe and a pair of panties is all that you need for this outfit.*

Working with Lace

Pieces of lace fabric are very fun and easy to work with. They are easy to find in the usual places such as thrift stores, yard sales, flea markets, as well as fabric stores. Usually a few dollars is all they cost. You or your model may already have some pieces. Lace fabric is sometimes used in tablecloths and shawls. It can be made into a dress, a top, a negligee, or wrapped in dozens of ways. Lace can be a little revealing or used in double layers to conceal more. It usually looks very feminine and sexy no matter how it is used.

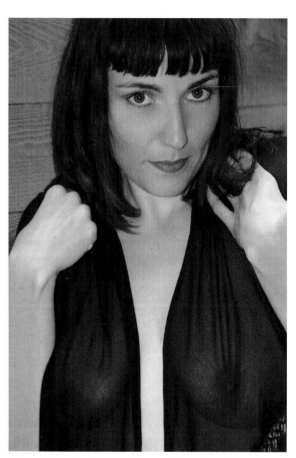

A Top *A piece of lace draped over Jessica's shoulders makes a simple, quick, and sexy top.*

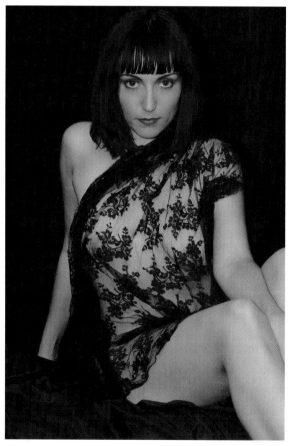

Wrapped *You can just wrap the lace around to make an outfit.*

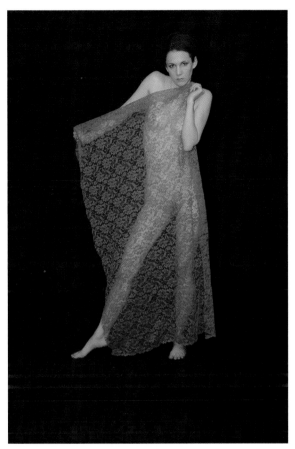

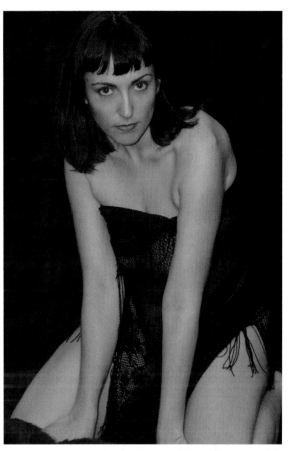

Peek-a-Boo *Simple lace fabric against a black background gives limitless possibilities. Nothing else was needed for this image.*

Lace Shawl *Once again a lace shawl has many different arrangement possibilities. It was just draped over our model here.*

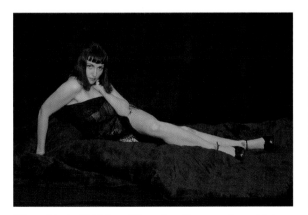

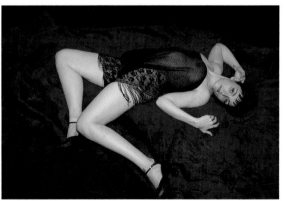

Wrapped Again *This is just a different piece of lace wrapped around Jessica, although it looks like a negligee.*

Lace Shawl Again *This is the same lace shawl as in the previous figure, but Jessica is sitting up and showing a different pose.*

Body Stockings

A body stocking is like pantyhose for the entire body. They are tight and stretch a lot. They are available in fishnet, sheer, lace, and many patterns and styles. They have various necklines, as shown in the accompanying figures. If posed well, body stockings are flattering to a wide variety of sizes and figures. You can add other pieces to a body stocking, like a skirt or jeans. Heels are always a good idea as they provide better shape to the calves and legs.

Most body stockings come with an open crotch. While this may be very useful from a feminine personal hygiene standpoint when wearing them out in public, it can cause photographic problems. If you want your photographs to be less revealing, it is easy to sew the crotches closed. All of the studio's body stockings have been sewn closed. With a bit of thread, a needle, and a few minutes, nearly anyone can do it.

Body stockings are not very expensive. They can be purchased online for anywhere from about 10 to 25 dollars, tax and shipping included. They usually come in one size to fit from about 95 to 165 pounds and in a plus size as well. They do stretch a lot.

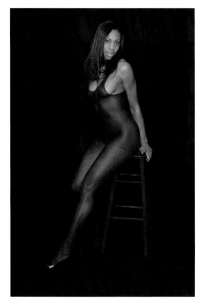

Black Sheer Body Stocking *A black sheer body stocking is very sexy and elegant looking.*

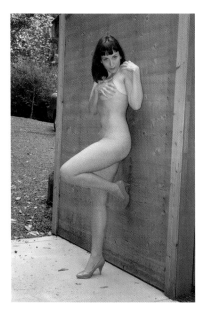

Fishnet Body Stocking *Fishnet body stockings are probably the most popular. They are available in a huge variety of colors, although black, red, and white seem to be the most popular.*

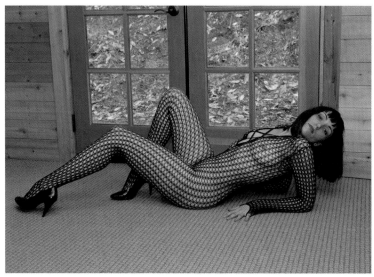

New Fishnet Pattern *Besides the regular fishnet pattern, there are variations such as this crocheted one that has a larger opening.*

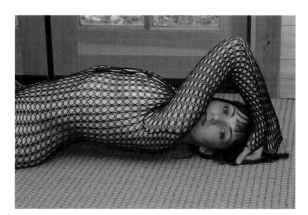

Lying Down

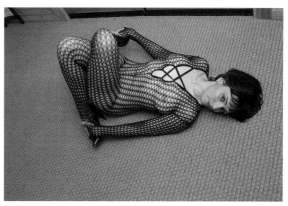

Pretzel Pose *The crocheted body stocking makes a nice pattern when Jessica makes a pretzel pose.*

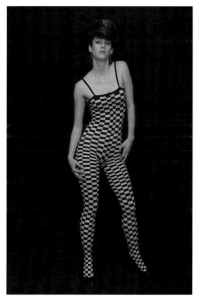

Checkerboard Pattern *Because of the popularity of body stockings, manufacturers are coming out with different styles and patterns, as shown in this checkerboard pattern body stocking that Iona is wearing.*

Seated *Their versatility is enhanced with different poses.*

Squatting

Holiday Themes

When you are looking for photo ideas, think about the holidays. There are a number to consider. In the examples, Christmas, Independence Day, and Valentine's Day were used. For a few dollars, a Santa's hat is available during the holiday season at most grocery stores. Add it to some red lingerie and throw in a suitable background. A reindeer rug along with a black backdrop and a wood stove were used. Simple is better. Use just enough props to give the flavor without overwhelming the model with too many details. You want the viewer to look at the woman, not all of the props. Don't let the props distract the viewer.

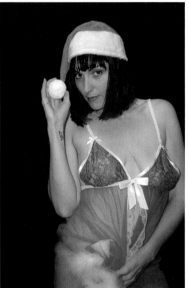

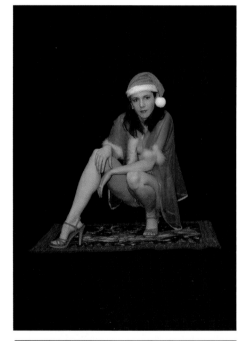

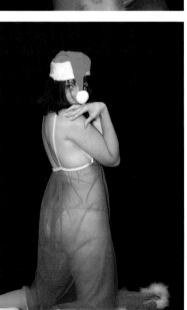

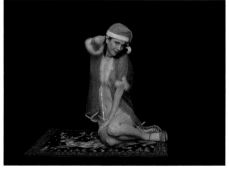

Santa's Hat *Santa's hat with red lingerie makes it look like Christmas.*

Background *Adding in a reindeer rug adds a bit to the image.*

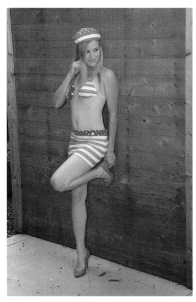
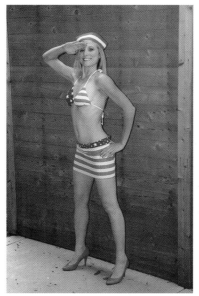
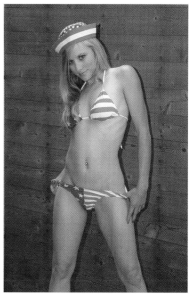

Fourth of July *It is Independence Day and Melanie celebrates by putting on her patriotic bikini along with a red, white, and blue sailor hat and a pair of red heels.*

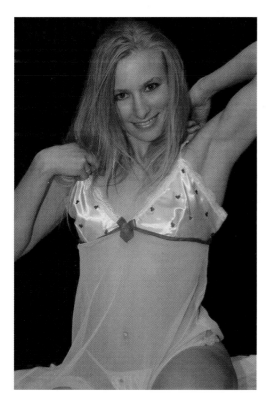
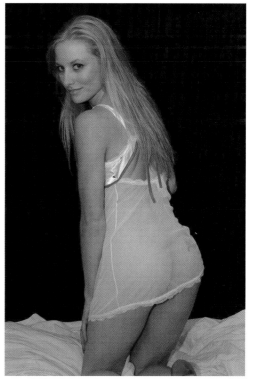

Valentine's Day *An appropriate white negligee with red hearts is worn to signify Valentine's Day. More heart shapes, such as a heart-shaped box of chocolates, could be added without overwhelming the image, if done in moderation. Notice that the panties have been removed for the photograph from the back. Although the panties fit well in the front, they were baggy in the back. This is a problem, especially with inexpensive lingerie used for photography, and needs to be watched for.*

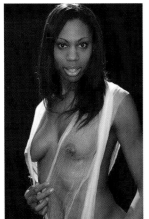

Make Your Own Costume with Cheesecloth

What is cheesecloth? It is a very fine, gauze-like material that is used in making cheese to remove the cheese from the fluid. It is also used in staining items and other projects. A bag with a piece of cheesecloth in it, which is about three feet by six feet, sells in most hardware stores for about two dollars. The material can be doubled or tripled by folding it over to make it as revealing or as modest as you would like. When it is used in single layers, it can be pretty sheer. You can use a plastic spray bottle filled with water to make it wet in spots. The fabric easily sticks to the body when wet. It also becomes very clingy and sheer, even in multiple layers. It makes an inexpensive and very sexy costume. When you are finished, just fold it over a plastic hanger and allow it to dry. It can be used again and again.

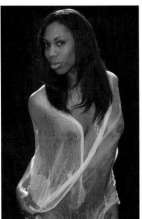

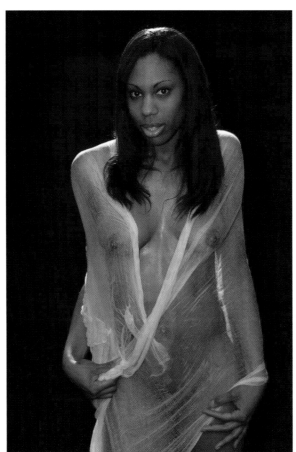

Wet Cheesecloth *Amelia draped the cheesecloth on and then it was sprayed with water to create these clingy, sexy images.*

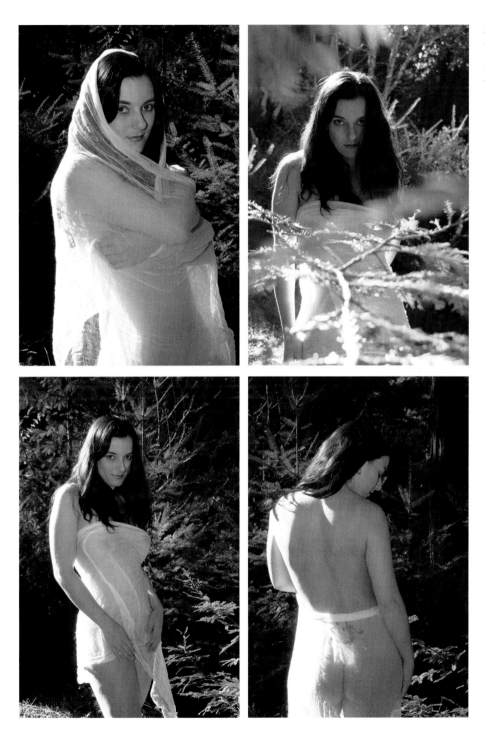

Dry Cheesecloth *Joanna draped the dry cheesecloth in a variety of interesting ways. In most cases the fabric will still stick to itself enough to stay on, but it does not cling to the figure as well as when it is wet.*

LOCATIONS

There are many locations you can use for boudoir photography. Everyone has different locations available, but you will be able to use many of these places.

Turn the pages and explore some of the many ideas that are available to you and learn how to maximize their potential.

You can use your car:

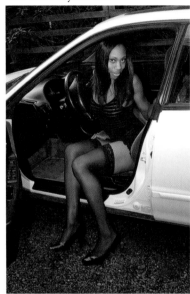

The desk in your office:

On a hill in your yard:

In front of your woodstove:

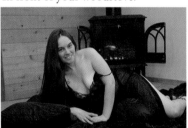

Outside on a log:

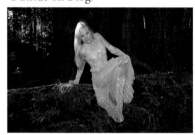

Outside in the rain:

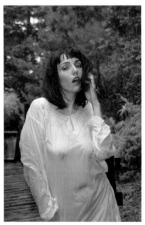

On some steps:

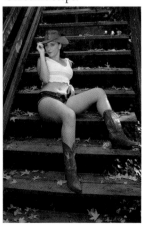

In front of a bamboo fence:

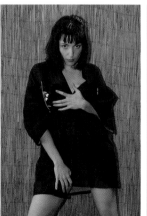

In your bathtub:

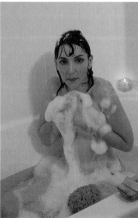

In your home office or library:

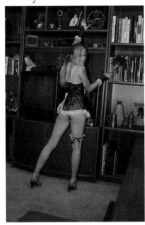

On the deck:

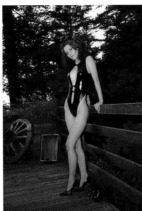

In the kitchen:

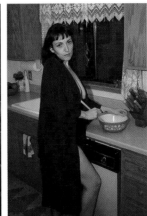

In front of a wooden wall or fence:

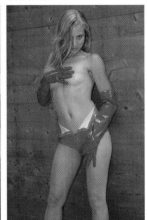

In a corner:

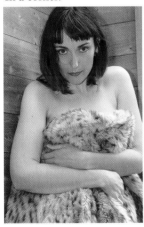

In your shower:

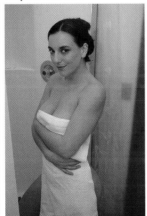

On a wall in the woods:

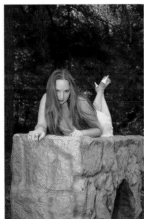

Or in your own studio:

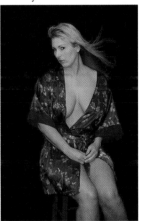

In a pile of leaves:

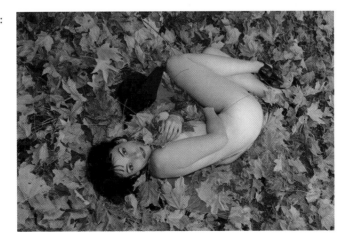

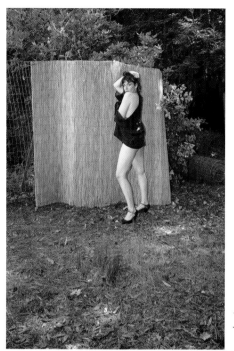

Simple Does It—Cluttered Backgrounds

This is a simple lesson. Backgrounds should be simple and uncluttered; otherwise, they distract from the beauty of the woman in the photograph. How do you decide what to remove? If it doesn't add to the image, then take it out. You have a number of options. You can move around to find a better camera angle that doesn't show the cluttered background, move closer or zoom in to eliminate the background, add a new background to hide the clutter, or you can physically remove items that show in the photographs.

Adding Bamboo Background *To hide a wire fence, a storage building, and a pile of lumber and building materials, a length of rolled bamboo fencing is stood up against the fence and tied into place.*

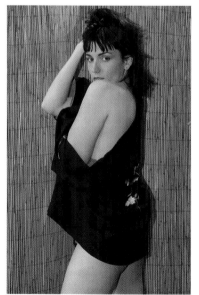

Resulting Photograph *This is what the resulting photograph looks like with a telephoto lens from the same position as the previous figure.*

Second Setup *For a second setup, Jessica rolls the fencing back to make a hideaway of sorts.*

Resulting Image *Jessica peeks out of the bamboo that she rolled up.*

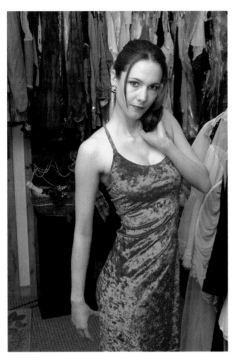

Cluttered Background
Attractive woman, cute dress, distracting, cluttered background.

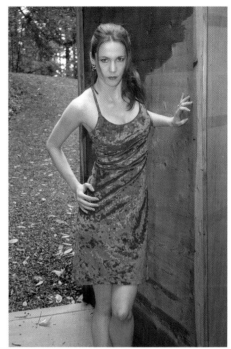

Simple Background *We moved Iona outside to a much simpler background, and the focus is now on her instead of the clutter.*

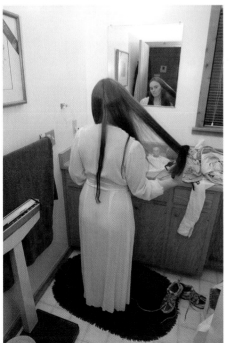

Cluttered Background
What a mess! Although this is realistically what the bathroom looks like during a photography session, it doesn't make for an attractive photograph.

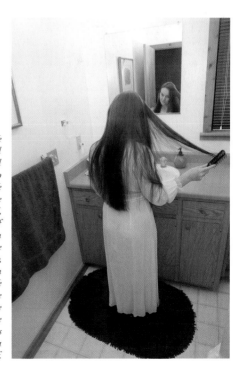

Clutter Removed *We moved the makeup and clothes off of the counter and floor by sliding them off to the side just out of view. We also took the scale out of the image, straightened the towel, and removed the robes off of the back of the door (you can just barely see them in the before photograph). Finally, we removed the picture on the wall in the doorway. We could have also closed the bathroom door. Now the photograph is much more appealing. All of the changes we made took about a minute and a half.*

Photographing in the Forest

It's nice to get out of the house sometimes and go someplace else to photograph. Here are some examples of ways you can use the forest as a backdrop for your images. Almost any costume, or even no costume, will work outside in the forest. You can use leaves as well. Obviously not everyone will have access to a location where they can drag in a heavy, claw foot bathtub. Still, you may have family or friends that own a farm or a ranch, or you may own a vacation home in a wild area where some of these things are possible. Be careful if you decide to use public land like a wilderness area or park. Depending on how revealing your photographs are, you could be breaking the law as well as offending other park visitors. Be discreet, or better yet, arrange for access to private property so that you won't be disturbed. Some of these images are sexy without being too revealing. They were all photographed on private land that adjoins the studio, but many of them could have been done elsewhere. Look at the examples to get ideas for your own costuming and posing in the forest.

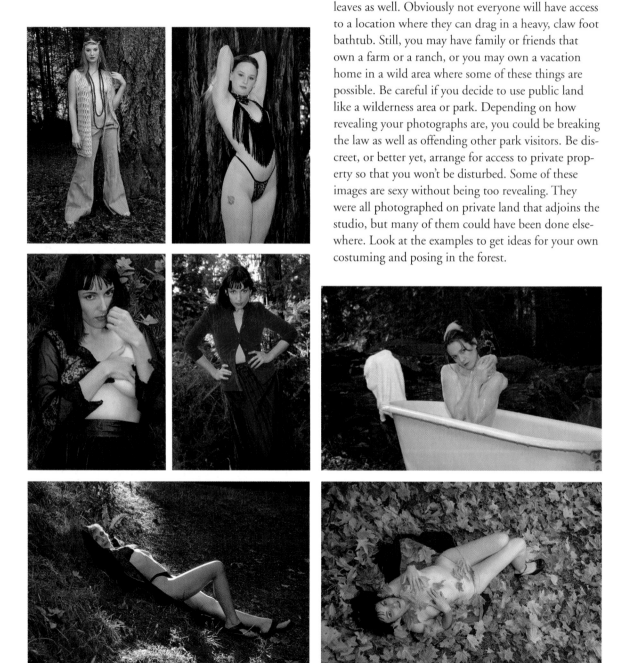

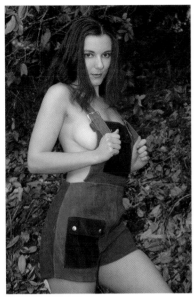

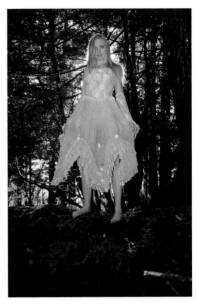
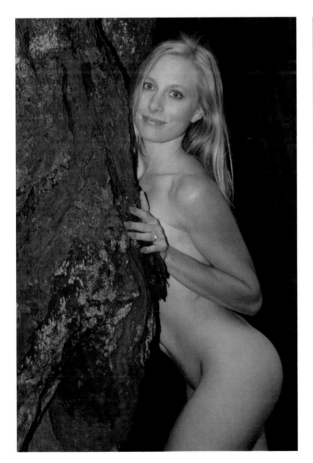
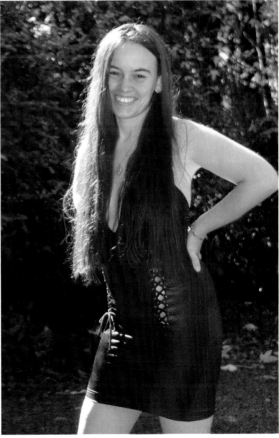

Shooting on Black

Using a black background will work with many different costumes, poses, and props. It is probably one of the most versatile backgrounds. It can be difficult to keep clean, especially if you have pets, but most dirt and hair will not show up in photographs. A reusable fabric or lint brush will work to keep the worst of the debris off. It is easy to retouch with Photoshop, if necessary.

So how do you get a black background? Black velvet makes the best background because it absorbs nearly all of the light that hits it, making it a very deep black background. Unfortunately, velvet is fairly expensive. A good substitute is black robe velour. It is much less expensive and is what was used in all of the black backgrounds in this book. To make a large background such as was used here, buy a bolt of black robe velour, 48 inches wide. If you sew, cut the bolt into thirds, each 48 inches wide.

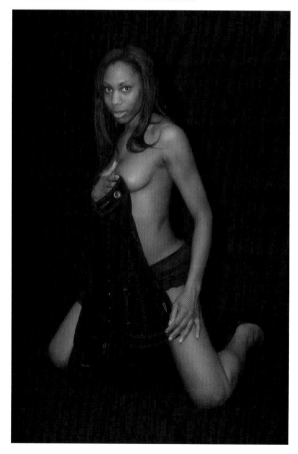

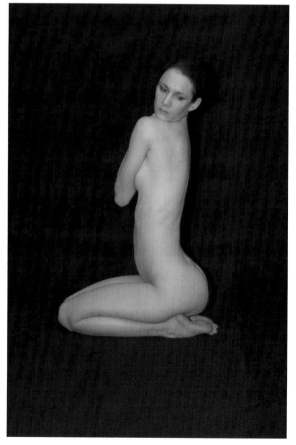

Sew them together, side-by-side, being careful to keep the grain of the fabric running the same way (otherwise the sheen will be different in different segments). This will make a background 12 feet wide and about 18 to 20 feet long. That is plenty big enough to do almost any kind of photography. If the space you have available to photograph in is much smaller, you might get by with a smaller background and can therefore purchase less fabric.

Black works well as a background for colorful costumes such as colored scarves or a pink boa. You can also vary it by using other fabric on top of it, such as cream-colored sheets, a red comforter, or burgundy faux fur. The more contrast you have between the costume and the background, often the better it will work.

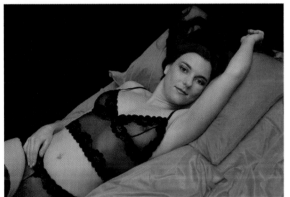

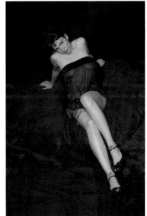

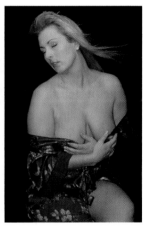

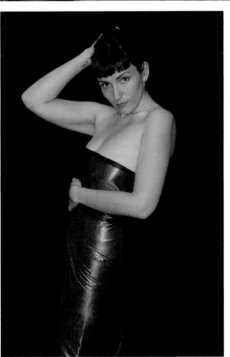

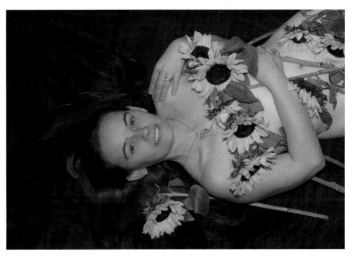

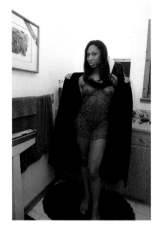

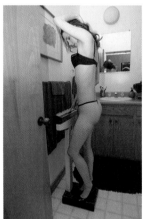

Working in a Small Bathroom

Working in a small bathroom is much more difficult than working in a large space. Unfortunately, most people have small bathrooms. The studio bathroom is fairly small, with a sink, small counter, a toilet, and a small shower. The total size is about 7-1/2 feet by 8 feet. With everything in the bathroom, it seems even smaller. It is obviously not laid out for ease in photography. It is difficult to back up far enough to get the model in the photograph. This calls for the widest-angle lens that you have. These photographs were taken with a 15–30mm zoom lens, usually on 15mm. Since it is not a full-frame digital camera, it is equivalent to 22.5mm on a 35mm camera, still a very wide-angle lens.

One problem with wide-angle lenses is their distortion. Objects closer to the lens appear to be larger. If you shoot down at your model by holding your camera at eye level, it will make her look short and squat, not a very attractive look. If she is standing, get down on your knees to photograph. Try to maintain the camera level in the middle of her body. This will give the most natural-looking proportions. If you have a zoom lens, get back as far as you can and zoom in to minimize the wide-angle effect.

The examples show some different angles and poses to assist in your photography. Note the use of the mirror in several different ways. A mirror works great to show both sides of the model's body. Also, having her do something, like putting on makeup or brushing her hair, will add some realism to the images. Don't forget to use the bathtub and shower if you have them available. The photographs can be sexy without having to be very revealing, even in the case of a bathtub or shower photograph where you can use towels or other props.

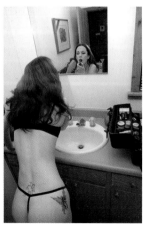

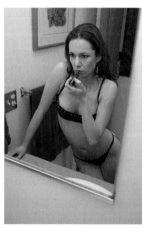

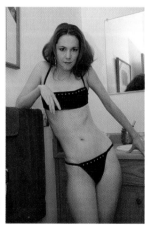

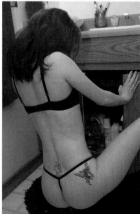

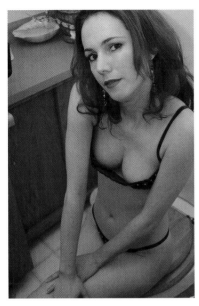
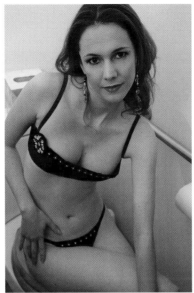
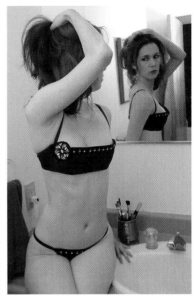

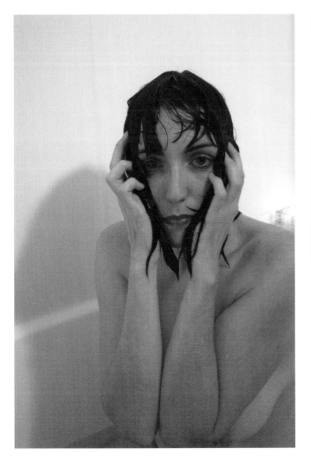
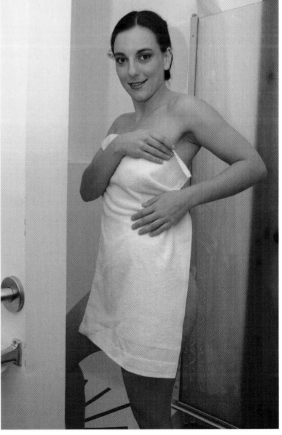

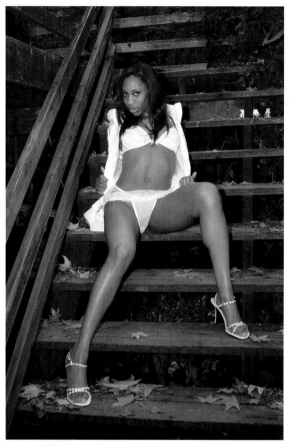

Using Stairs

Stairs are fun to use because they offer so many posing opportunities. The model can lie down and get comfortable. In these examples, the same set of stairs was used, but, depending on the model, her costume, and her posing ideas, the looks are quite different. Shorts, dresses, and lingerie are all completely at home on a set of stairs. Notice how the posing stretches out the model to make the legs look longer. Pointing the toes helps as well. Don't forget to use the railing. On the railing, bending over will emphasize cleavage nicely. Look for repeating patterns in the steps and railings to add interest.

Sometimes it is tough for some models to know how to pose on stairs. They are used to just walking up and down them. One way to start her out is to have her sit on the steps part way up (or down). Then tell her to just relax and get comfortable. The same is true on the railings. If she is comfortable, it will create nice expressions.

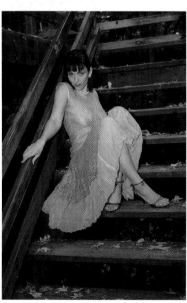
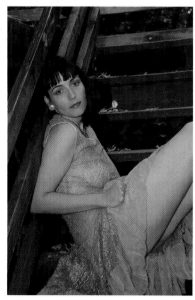
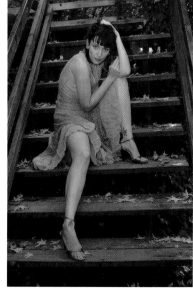

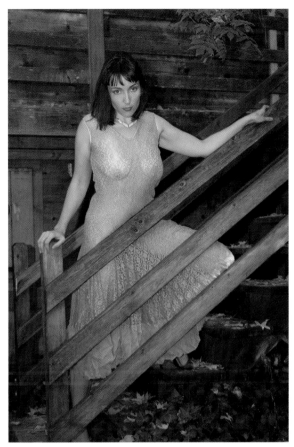

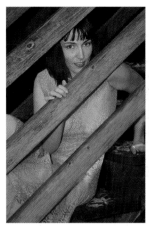

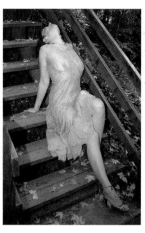

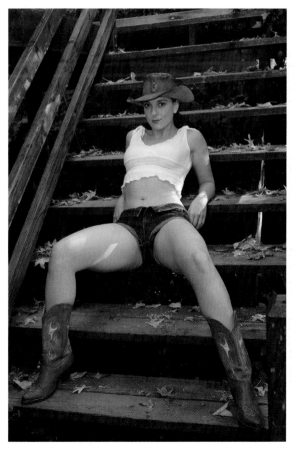

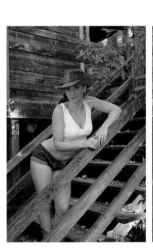

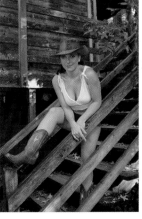

Using a Car

Most people have a car or access to one, so that makes it a great prop to use in your photographs. It helps to have privacy, so you need to have a place to park your car, perhaps in the backyard or even in the garage, where you won't be disturbed or viewed. The next step is to clean out all of the clutter. The car doesn't have to be perfectly clean inside, but old fast food bags and CDs lying about will detract from the photograph you are creating. The outside of the car and the windows should be reasonably clean. Either do it yourself or take it to a car wash. Once the car is clean, decide on a costume or two. Mini dresses, lingerie, swimwear, or even a pair of overalls will work. Think in terms of what is sexy to you about a car. A bit of thigh showing as a woman gets out of the car in a short skirt is one thing. Showing cleavage while bending over to work on the car is another. Then there is bending over to retrieve something from the car. All of these ideas show a bit of the private side of a woman, and that is what makes them sexy.

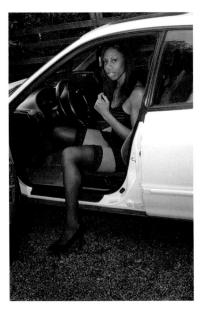

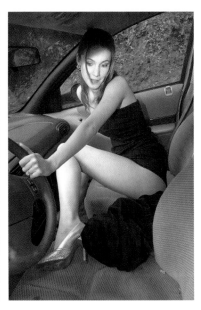

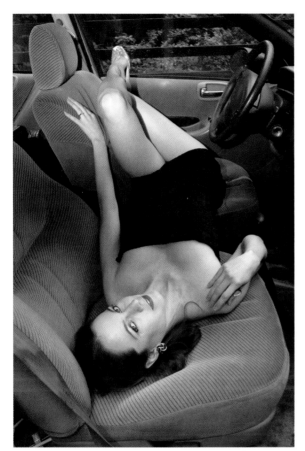

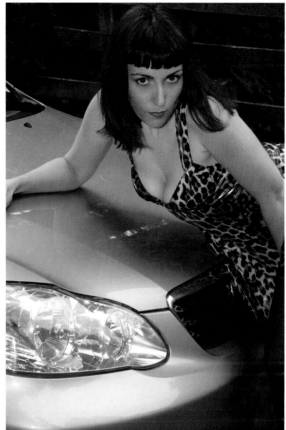

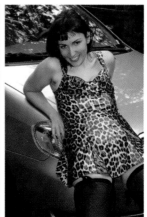

Using a Tree

Trees are everywhere and can be a great prop to use. Large trees, like redwoods, that have been hollowed out by fire can be interesting to use. Dead trees that have fallen add even more possibilities. What can you do with a tree? You can hug it, lean against it, sit down and lean against it, or use the fallen tree or log in the same way. Costumes are boundless. "Outdoorsy" clothes seem to work especially well. Check out these examples for costume and posing ideas.

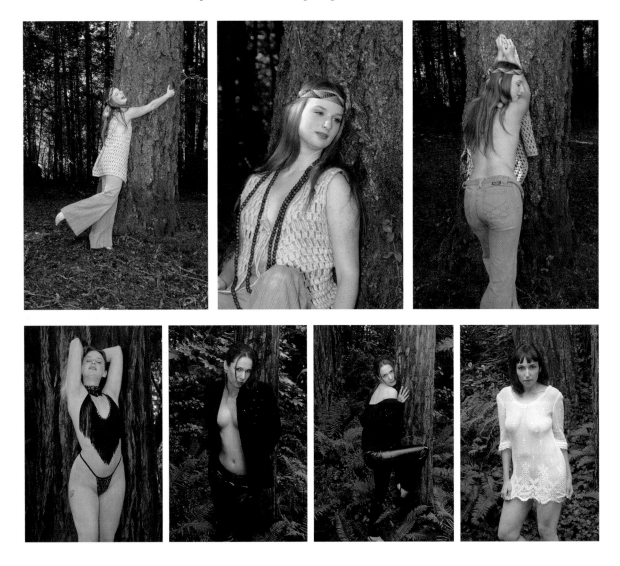

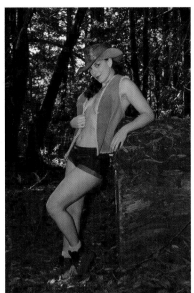
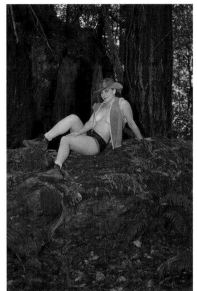
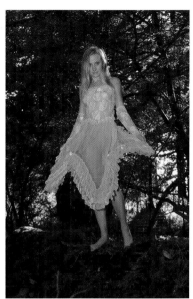
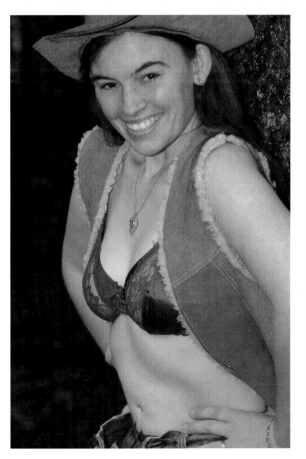
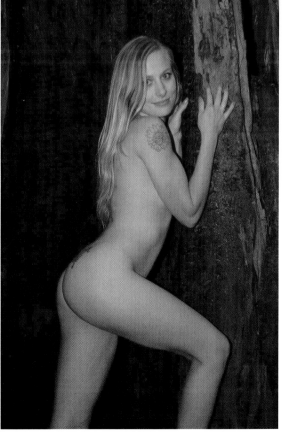

The Kitchen

Kitchens offer an inviting selection of locations and props. There are counters and appliances galore, and the samples here just begin to touch on the possibilities. Most kitchens have a lot of things on the counters and a bit of clutter. So, besides cleaning everything that is in view, it is very helpful to move some of the clutter that is otherwise distracting in the background. Lingerie or lingerie with a robe are good costume choices. Props can include cooking tools and dishes and even food.

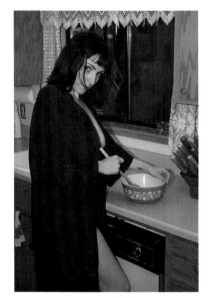

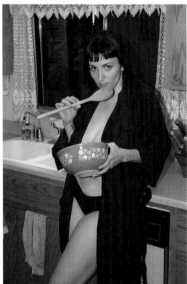

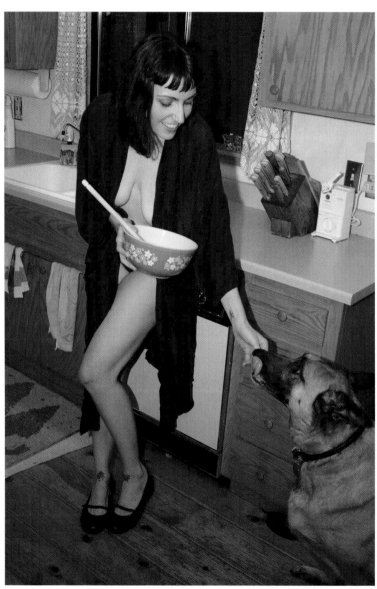

Prepare Food *Jessica pretends to make some cake batter. Her attempts are so convincing that Sequoia, a Belgian Malinois dog, asks for a taste. First, Jessica pretends to taste it, and then gives Sequoia "a little bit of nothing."*

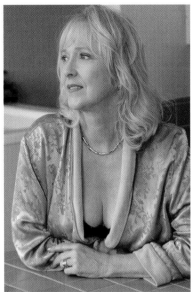

Appliances *Linda uses the refrigerator as a backdrop.*

A Counter *A counter makes a nice prop in a close-up. In the second image, you can see how the close-up isolates Linda.*

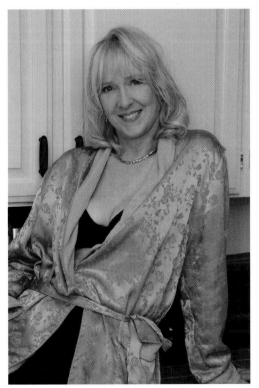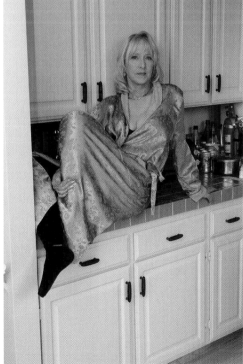

Sitting on a Counter *You can have your model sit on the counter, which makes for interesting poses. In the first image, you can see that zooming in means less moving of things.*

The Office

A large number of people today own their own business or have a home office. This makes it an ideal location to photograph and give your images some variety. There are lots of possibilities in the office for boudoir photographs, depending on the furniture

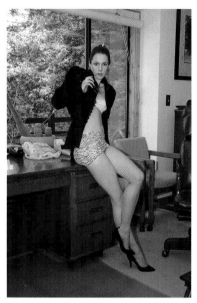
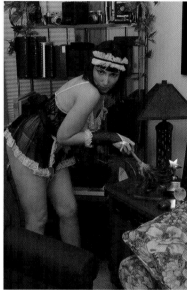

available. Some offices like the one shown have large windows, desks, chairs, bookcases, display cabinets, and even a couch. Each of these pieces has its own suggestion for poses and costumes. In the examples are costumes such as the French Maid or Sexy Secretary, but lingerie, jeans, or almost any costume will work. It helps to pick up the clutter found in a typical office and make sure the office is clean. Otherwise it will detract from the image and the woman. Notice in the examples that the props are often simple, as are the poses and costumes. Simple will help to concentrate attention on the model.

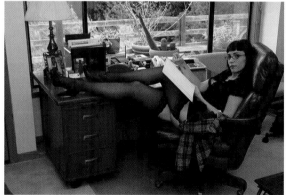

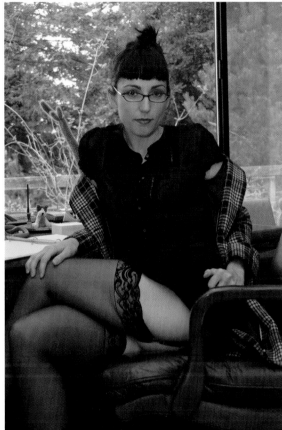

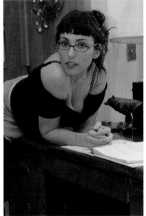

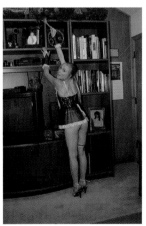

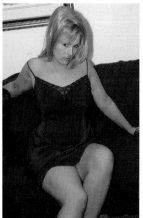

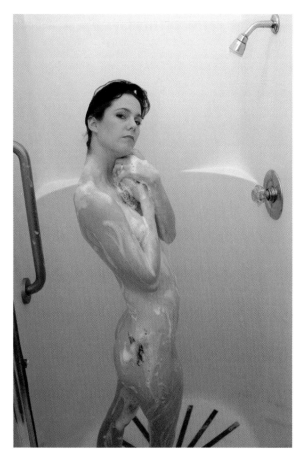

Prop the Door Open *Prop the door open to have the widest view possible.*

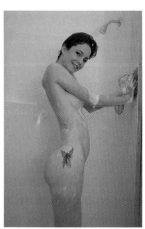

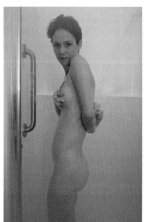

A Shower Scene

Even a plain and small shower makes a great location. The water and steam add to the overall flavor. You will need a wide-angle lens if you have a small bathroom or tight quarters as shown here. A 23mm (35mm equivalent) lens was used for all of these images. Here you can see that the shower curtain was pushed back and the shower door propped open for many of these photographs. Be sure to use props. Here the translucent door, soapsuds, and a towel were used as props. You could also use a washcloth or a back-scrubbing brush.

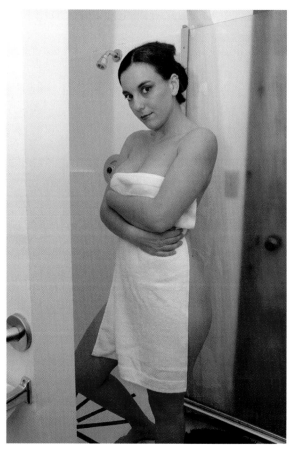

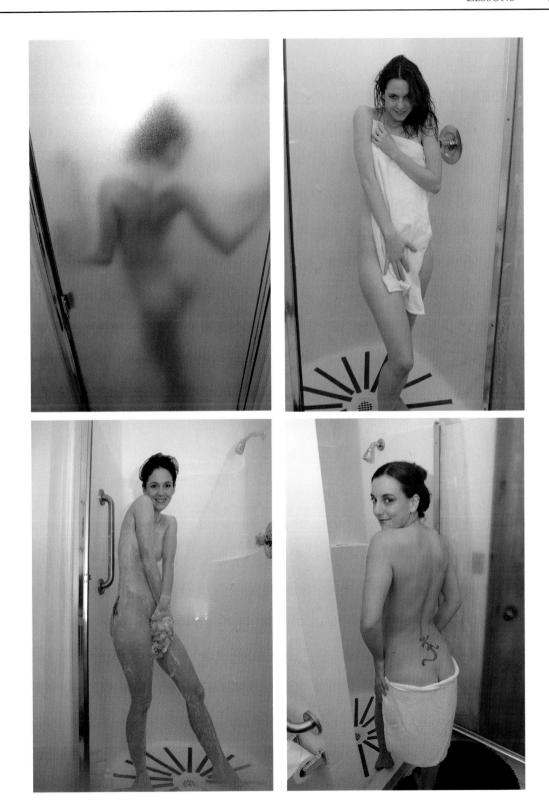

A Bathtub Scene

Here we have sample images from two different bathtubs. One is a plain, fiberglass shower-over-tub style in a tiny bathroom, and the other is an ornate and beautiful tile tub without a shower in a very large bathroom. While it is fun to work with the ornate setup, not everyone has access to one. What are the alternatives? You can add plants, candles, and the like around your tub if you have space. You could even stack a board on bricks to make a shelf in front of the plain bathtub. You can try photographing with candlelight. You will get a much warmer (red) look to your image. Look at the difference between the first figure and second figure. You can also try different posing as in the third figure. If your model is a little shy, she can wear a bathing suit, which you can cover with bubbles. That is what we did here. In the ornate bathtub photographs, the model is wearing a strapless bikini in all of the images, and bubbles were simply arranged to cover it up.

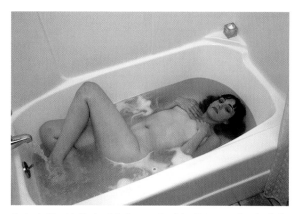

Bathtub Lit with Flash *A flash was used to light this image so the colors look very natural.*

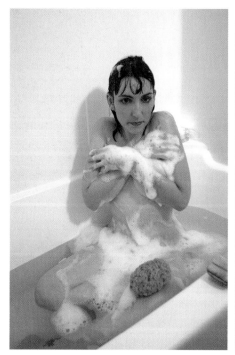

Bathtub Lit with Candles *Here, mainly candlelight was used to light this image. Compare it to the previous one to see how much redder it is. You could correct the color more if you desired, but it was left this way for romantic effect.*

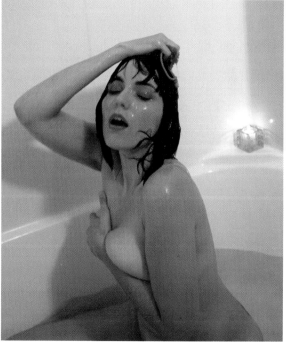

Different Pose *Don't limit yourself to ordinary poses, especially in a plain setting.*

When working in a more ornate situation, be aware of the color of the walls. Here, the deep burgundy of the wall reflects back onto the subject and the bubbles. Note the burgundy color reflected in the bubbles in the leftmost figure and how it is missing from the following figure where the flash is more direct.

Wall Reflects Back Color *The reflection of the light from the colored wall affects the color of the first image.*

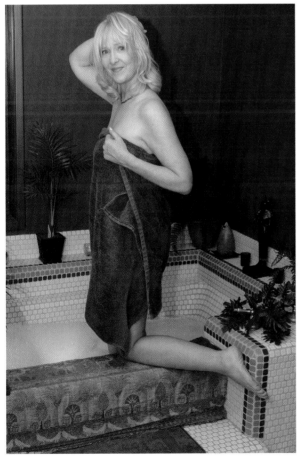

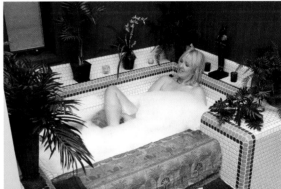

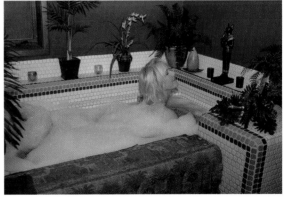

Ornate Bathtub Poses *When you photograph in a bathtub, don't forget to have images of your model getting into the tub and lying in various positions in the tub. She could also be sitting on the side of the tub as well.*

Working with a Couch

Almost everyone has a couch, which is a great location to use. If you have a patterned couch like the one in these examples, it sometimes just won't work with the outfit you have chosen. In that case, just throw a sheet or some fabric over it. If you don't have a couch, or it just doesn't look right for what you have in mind, then throw a couple of large pillows on the floor and put a comforter or blanket over them, and presto, you have a couch. You can also use a miniature couch, or "posing bench," as shown in two of the photos. Watch yard sales, flea markets, and thrift stores for pieces like this that can be moved easily. When you are using a couch, don't forget about using the pillows or adding your own to make interesting poses.

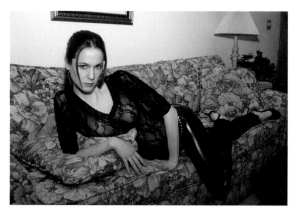

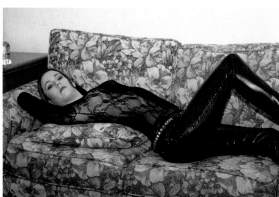

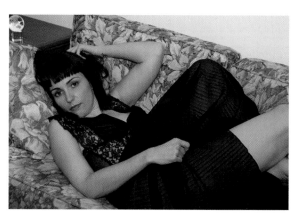

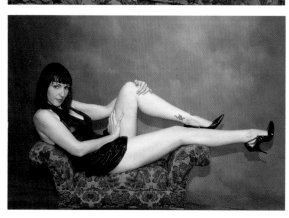

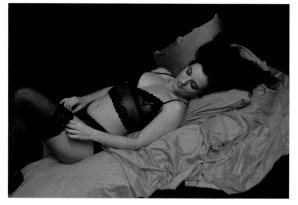

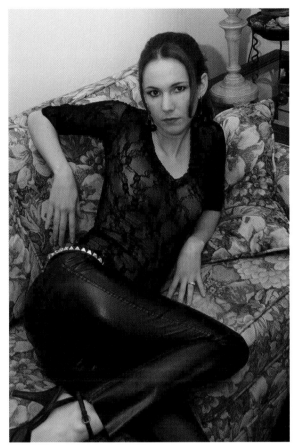

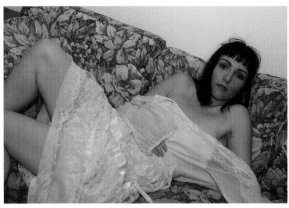

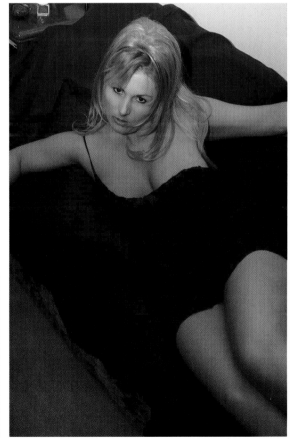

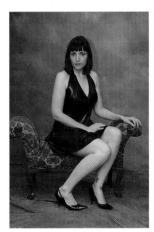

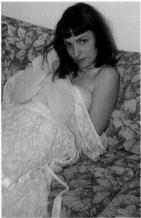

PROPS

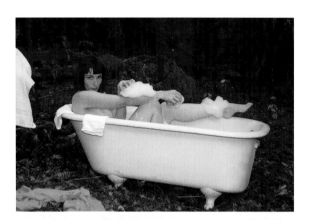

The number of props suitable for use in your boudoir photographs is truly limited only by your imagination. The lessons that follow use a variety of props that many people will already have or that can be purchased inexpensively at thrift stores, swap meets, garage sales, online, or at discount stores. Other lessons throughout the book often include props to help support the image. Generally with props, less is more. That is, the use of just a few props helps to tell the story, while using too many will overwhelm the woman in the photograph. Always remember that making your model look great is your primary purpose in a boudoir image.

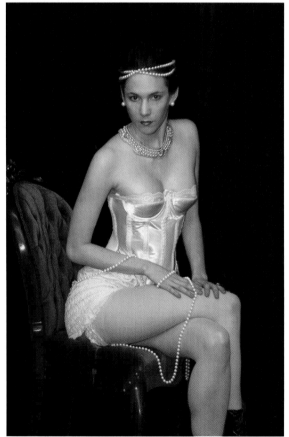

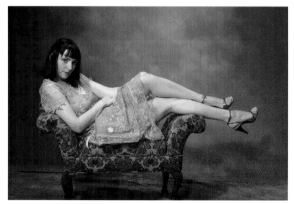

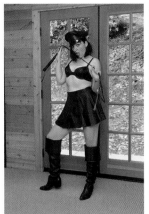
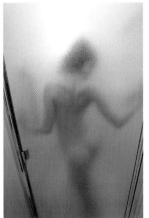
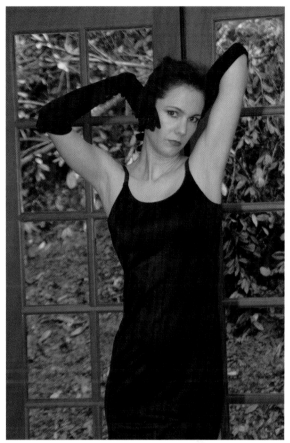
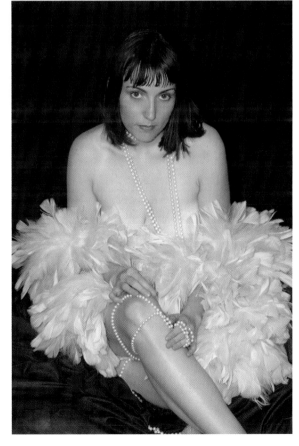
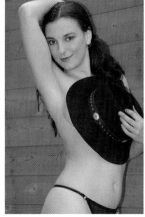

A Box Fan on a Stand *The fan is pointed directly at Tanya and designed to lift her hair up.*

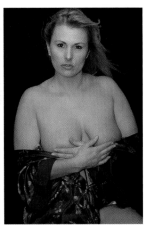

Example *Here is an example with the fan in the position shown in the previous figure.*

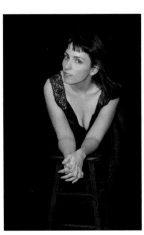

Without the Fan *Without the fan, Jessica's hair lies flat.*

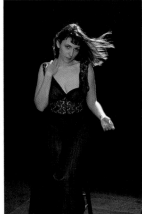

With the Fan *With the fan, the image looks much more alive. A small and inexpensive hair light (see the "Advanced Lighting Techniques" discussion in Section 4) was also added here to help separate Jessica's dark hair from the dark background. It also helps to show off the windblown hair as well.*

Using a Fan

In this case we are talking about an electric fan, like one you would use to cool off in the summer. In these examples a 20-inch box fan mounted on a stand was used. The stand makes it easier to use a large fan, but you could also set it on a table or a stack of boxes. Experiment with any fans that you already have, but it may take a somewhat powerful fan, depending on the thickness and heaviness of your model's hair. It helps if your model has clean hair before trying this.

The fan will automatically give you a variety of different images, depending on how the wind blows your model's hair. Experiment and don't be afraid to create a lot of images to capture that variety. With digital photography, you can always delete those that you don't like or that don't work. The three examples at the top of the next page show how much windblown hair changes in just a few seconds.

The wind blowing directly in your model's face will make it difficult for her to keep her eyes open. This is even truer if she wears contacts. If this is a problem, try moving the fan slightly more to one side.

If all else fails, have her close her eyes and open them on the count of three, when you can press the shutter release. You can also have her close her eyes like she is deep in thought and photograph her that way.

Have your model shake her hair frequently and run her fingers through her hair to make it easier for the wind to blow it.

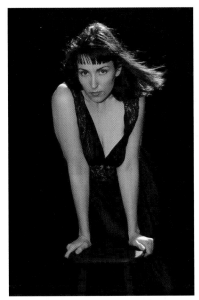
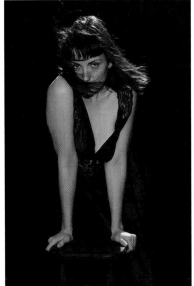
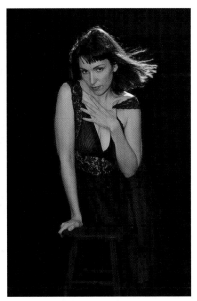

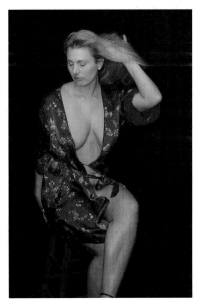

Closed Eyes *The wind in Tanya's face causes her eyes to close, as she has to blink more frequently.*

Closed Eyes *Tanya closes her eyes on purpose and the image is quite sexy.*

Run Her Fingers through Her Hair *Tanya runs her fingers through her hair and shakes it to keep it airborne.*

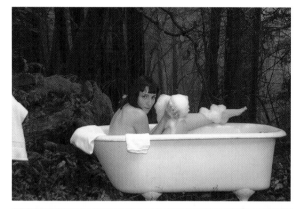

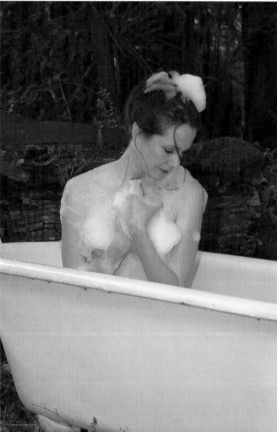

Bubbles in Use *Long-lasting bubbles can be used to create images like this.*

Making Bubbles

When you work with water, for example in a bathtub or shower scene, bubbles come in very handy. Sometimes it is difficult to create long-lasting bubbles. With the following techniques you will find it easy to do. A word of warning: Be very careful about using electrical appliances, such as the mixer used here, around water. It can be very hazardous. Never use electrical appliances in a bathtub with someone in it. As an extra precaution, always make sure the appliance is plugged into a ground fault circuit interrupter (GFCI). GFCI circuits are required in new construction in most areas if the outlets are located outdoors, in bathrooms, or within ten feet of the sink in the kitchen. Always double-check your electrical connections for safety reasons.

Use Dish Detergent *Use a small tub and add a few inches of hot water. The small tub means it will fit between your model's legs as she sits in the outdoor bathtub. The hot water makes using the bubbles more comfortable. Don't use water so hot that it might burn you or your model. Next, add a few capfuls of your favorite dish detergent.*

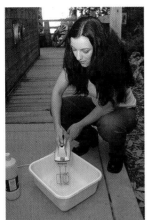
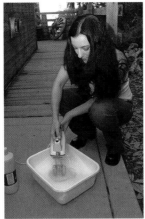
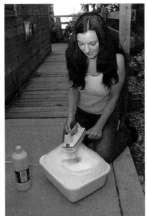

Hand Mixer Use a hand mixer set on the fastest speed and mix with it just as you would any other mixing task, moving it back and forth. Watch the bubbles rise. Continue until you have enough bubbles. Be careful when using any electrical appliance near water. Never use it in the tub with someone in it. Be sure to use a GFCI outlet as well. When the bubbles go down, just use the mixer again to refresh them. You or your model can use your hands to scoop up bubbles and place them wherever needed.

The Results Here are the results you should expect… a tub packed full of bubbles.

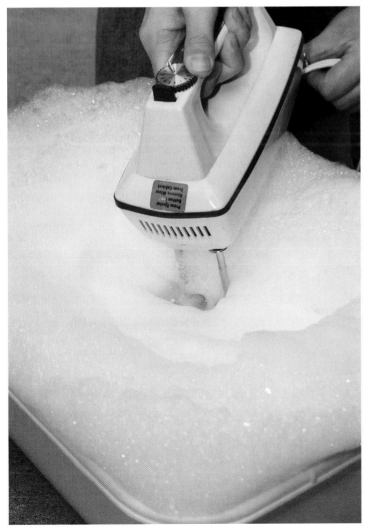

Using a Shower Door

A shower door is a quick and easy prop to use. The pattern of the door makes it interesting. Be sure to clean the door well. Water spots and soap scum will really detract from the overall effect. An on-camera flash pointed at the ceiling will work nicely to illuminate the scene. If you point the flash at the door, you will get ugly reflections from the glass. Another way to light is to point a bright light (such as a clamp lamp) at the ceiling behind you to brighten the area.

You can adjust how revealing the photographs are by how the model poses.

You can also control it by moving the model closer to or farther from the door.

Finally, you can have your model half in and half out of the shower to diffuse some areas and reveal others.

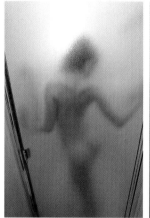

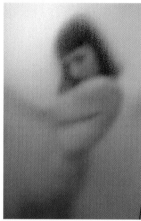

Bunched Up Pose *Even pointing the flash at the ceiling, it is possible to get a hot spot or reflection from the door, as shown here. This could be corrected in Photoshop, but it is easier to adjust the lighting as much as possible first.*

Not Revealing *Depending on how the model poses, the photograph does not have to be very revealing, even though she is nude in the shower.*

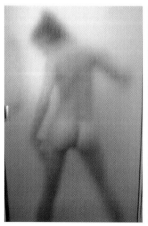

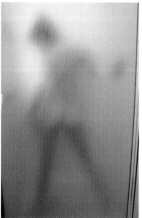

Closer to the Door *Iona is closer to the door, which shows more.*

Farther from the Door *Iona moves away from the door to make the photo less revealing.*

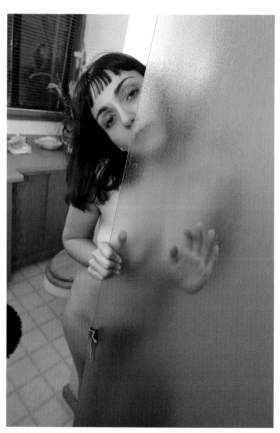

Half-In and Half-Out

Iona demonstrates just a few of the pose possibilities. The rough surface of the door gives the photos an artistic, impressionistic appearance. The photos become more diffuse as the model moves farther from the door.

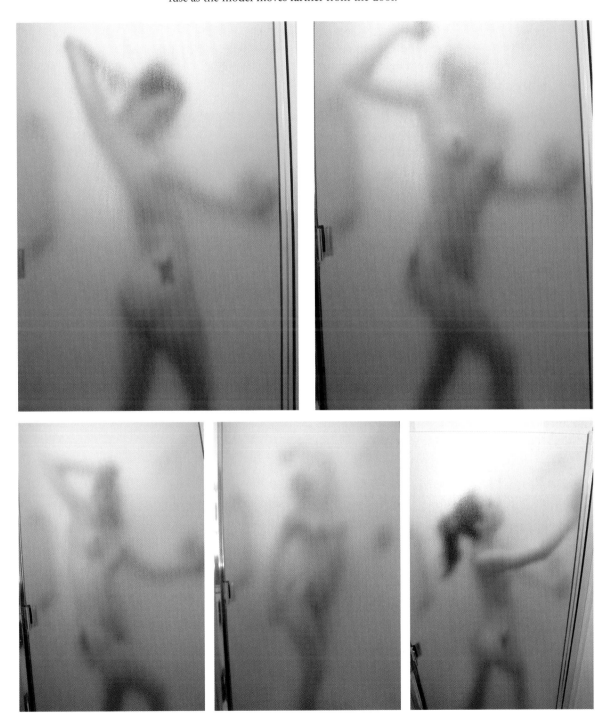

Using Whipped Cream

Using food for a prop can be fun, but it is usually pretty messy. Choose a location that can stand the mess. Obviously, if the weather cooperates, and you have privacy, then outdoors is a great option. Here an indoor location was selected because of cold weather. If you are using whipped cream, it tends to melt and get runny because of the model's body temperature. A trick is to use shaving cream to do all of the designs and cover-ups. It will hold its shape for a long period. It is not as tasty as whipped cream, so an aerosol can of whipped cream is used for a bit of whipped cream on the fingers, for touchups here and there, and as a prop for the model to hold. Iona is having fun in these images. We could have also done patterns, or even created a whipped cream bathing suit out of shaving cream.

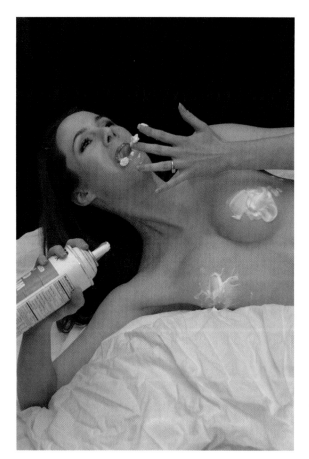
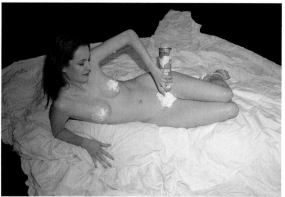
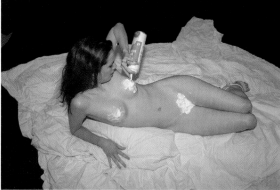

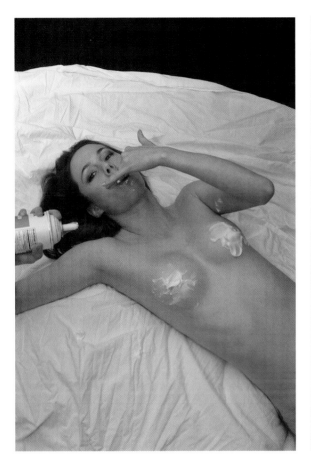

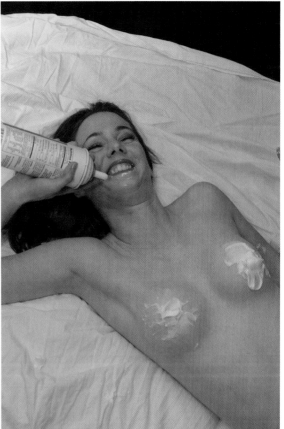

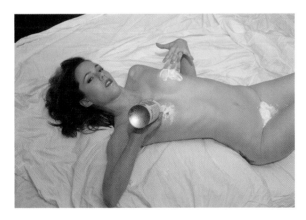

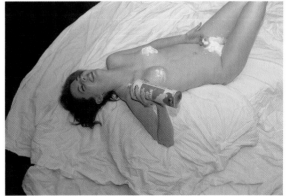

Using a Feather Boa

Feather boas can be used by themselves or with another costume. They come in a variety of thicknesses, from thin to very large. They can be purchased new online for about five dollars and up and are often found at flea markets and thrift stores for a few dollars. The cheaper ones have small feathers and are thin. More expensive ones are made with turkey feathers and can run up to 50 dollars or so. Most of the feather boas will shed feathers over time. Save the feathers and they can be used for costumes as well!

Variety of Colors *These are just a few of the colors of feather boas that are available.*

Bag o' Feathers *The loose feathers are kept in a bag to use as a costume.*

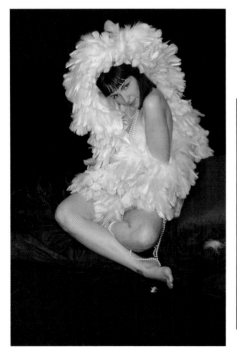

The turkey feather boas are huge and can overwhelm your model if you are not careful. Here Jessica is totally covered by one pink turkey feather boa. These boas are also surprisingly warm. Keep that in mind if you are working in the summer in a warm environment.

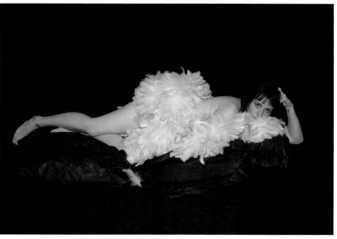

Turkey Feather Boa *Jessica is in a turkey feather boa wrap and not much else.*

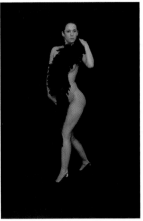

Covered by Turkey Feathers *These figures show how large a single strand of a turkey feather boa can be.*

Use a small feather boa with other costumes, such as the 1920s flapper dress, to add bit more fun.

Other props, such as strands of pearls along with the feather boa, will make a complete costume.

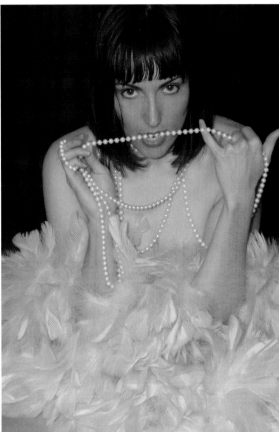

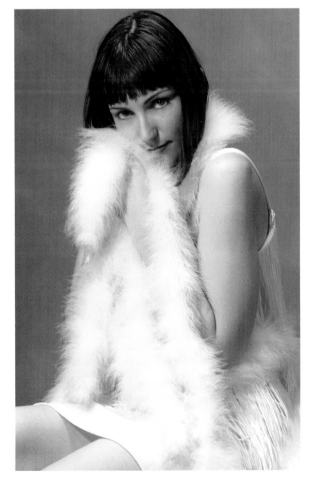

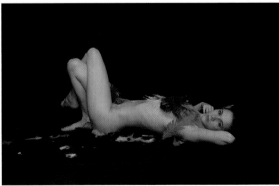

Bag o' Feathers *Iona wears a "costume" made of loose feathers that had fallen out of the feather boas as they were handled.*

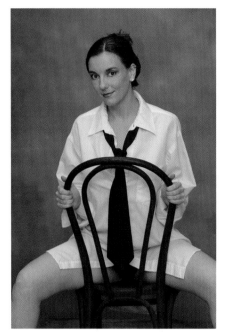

Bentwood Chair *Sitting backwards in a chair like this works well. It adds a bit of interest and doesn't obscure the costume or the model.*

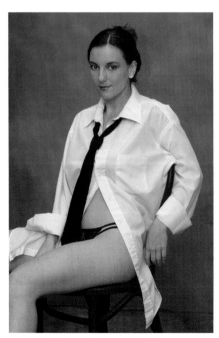

Bentwood Chair *The same chair used the normal way lends itself to entirely different poses.*

Using a Chair

A chair is a common prop found in every home. A simple bentwood prop chair, like that shown in the first figure, can be purchased at a thrift store, yard sale, or flea market usually for five to ten dollars. New, they are available online for about 70 dollars. They can be painted in black, white, or other colors to go with the standard backgrounds that you will be using. If you paint a chair black, use matte black paint rather than gloss black. Gloss black will reflect light because it is shiny. The matte black absorbs light and does not reflect it. In that way, it doesn't distract from the model or cause bright highlights which you have to deal with afterwards. Any chair can be used, so keep an eye out at thrift stores and yard sales for fancy or unusual chairs.

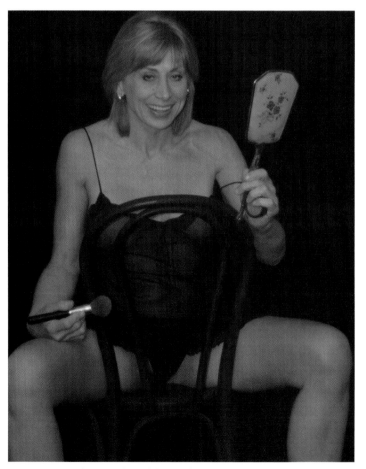

Props *For variety, don't forget the possibilities of adding a few simple props as Deborah is doing with a hand mirror and brush.*

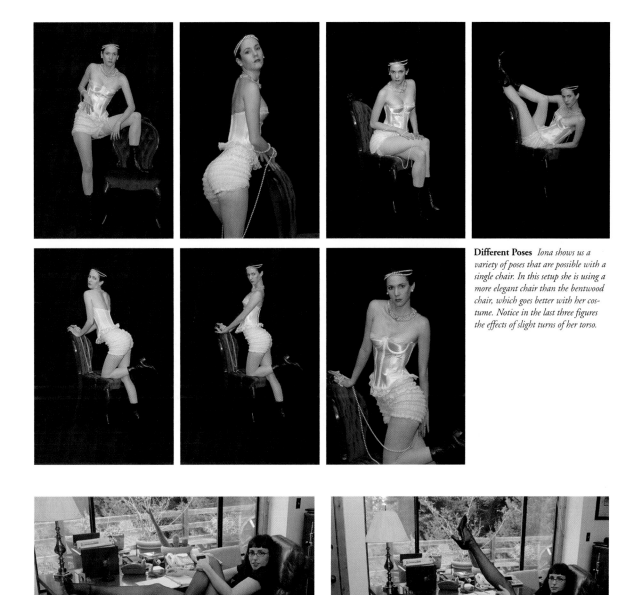

Different Poses *Iona shows us a variety of poses that are possible with a single chair. In this setup she is using a more elegant chair than the bentwood chair, which goes better with her costume. Notice in the last three figures the effects of slight turns of her torso.*

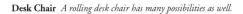

Desk Chair *A rolling desk chair has many possibilities as well.*

Using Gloves

Gloves seem to add an air of elegance to a photograph. Long, elegant gloves can be purchased new online starting at around ten dollars. They can also be found regularly, and very inexpensively, at thrift stores, flea markets, and garage sales. You may have a few pairs, be able to borrow them, or have family members that will give them to you. Ask around. If you purchase lingerie, especially sets designed for play, they may come with gloves. Don't be afraid to take a pair of gloves from one set and use it with other costumes. In your searches through yard sales and thrift shops, always keep your eyes out for gloves, even if you don't have an immediate need. A box of gloves, kept close by for easy access while you are photographing, will help add appeal to your images.

No Gloves *Here is an elegant and sexy evening gown worn without gloves.*

Gloves and a Costume *This costume came with a pair of gloves.*

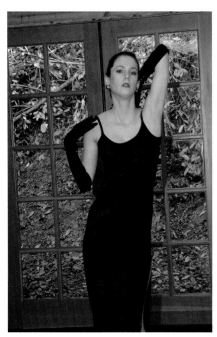

With Gloves *This is the same evening gown with a pair of long, black evening gloves added. It appears more elegant.*

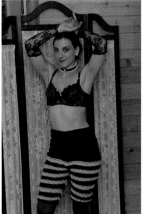

Romantic *Gloves are added to this costume of period lingerie to give it a more romantic feel.*

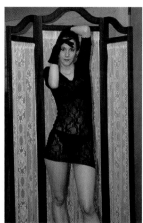

Vintage Gloves *These 1940s vintage gloves go well even with this modern lace lingerie.*

Gloves Added to an Outfit *These long gloves are added to a 1920s flapper dress to build up the effect more.*

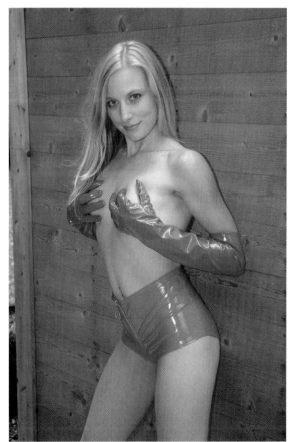

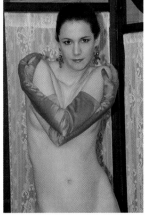

Gloves as the Costume *Iona shows us that the gloves can be the entire costume.*

Gloves as a Major Part *Gloves can be a major part of a costume. These red vinyl gloves substitute for a top, which wasn't available for these vinyl shorts.*

PHOTOGRAPHY ANGLES

There are many different angles you can choose when photographing your model. Some angles will be more flattering than others. Carefully choosing your angle will determine your background and foreground as well. The lessons that follow will help you to select angles to assist you in difficult situations.

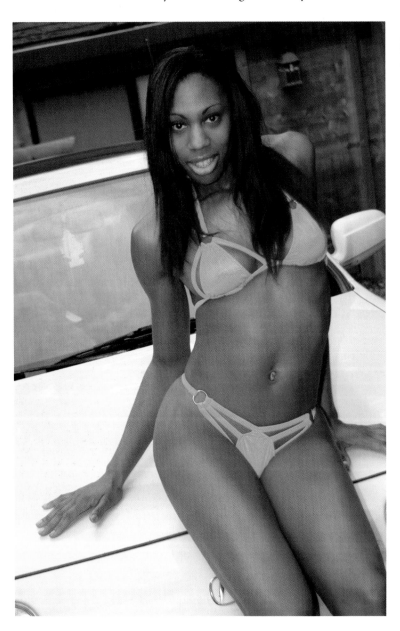

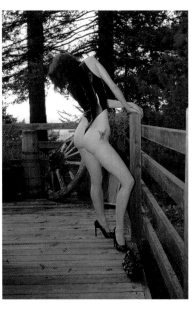

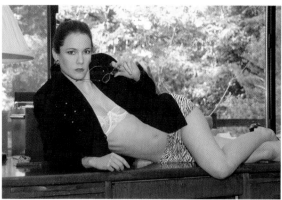

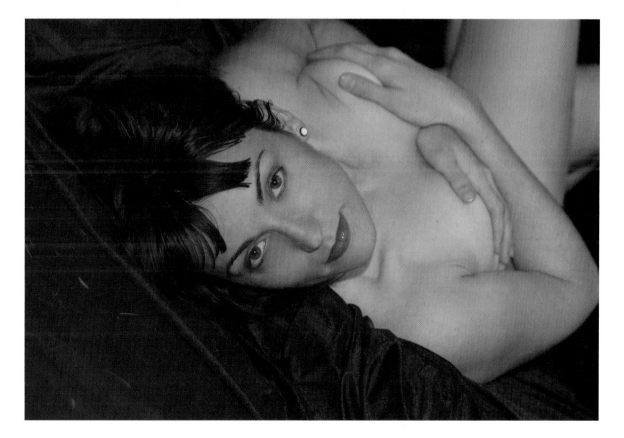

Working in a Tight Space

It doesn't take very much space to create beautiful, sexy images. The images in this lesson were created in a 4' × 8' space. Having a mostly clear space focuses the attention on the woman you are photographing rather than being distracted by other objects. In these samples, the images are cropped in tightly. To get this much space, you may only have to move a piece of furniture. Be sure to brush away any carpet marks if you work on carpet. If you get up high on a stepstool or ladder and shoot down at your subject, it will reduce the space requirements as well.

Overall View of Space
Here is the overall view of the space in which the previous image was created. The space is only 4' × 8' of clear floor space. All of these images were created in that small space.

Tight Space *Even an image like this can be created in a very small amount of space.*

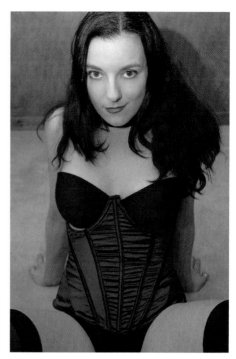

Lower Angle *A lower angle was used, so the image was cropped in tighter to avoid distracting elements on the sides.*

Different Pose *A different pose was used from the same lower angle.*

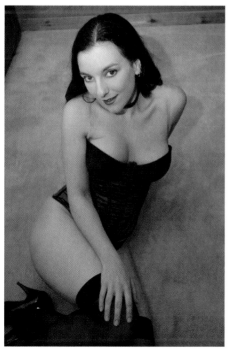

Zooming Back a Bit *The camera was zoomed back a bit to reveal Joanna's entire figure. Notice that she is doing a "curled up pose" because of the tight space. A piece of furniture shows in the back left corner, and the wall shows in the back. These would be removed in the final image by cropping the image slightly or cloning it out in Photoshop.*

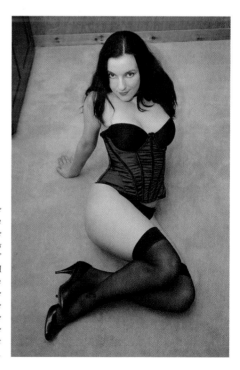

Get Down to Shoot

If there is one thing that photographers can do to change their photography and add variety, it is to change the angle at which they photograph. Unless you happen to carry around a stepladder, the easiest way to do this is to get down on one knee and photograph up at your model when she is standing. The ideal location for your camera is below your model's waist. This has the added advantage of making her legs look longer, usually a desired trait of boudoir images. If you do this consistently, you will wear out one knee on all of your pairs of jeans.

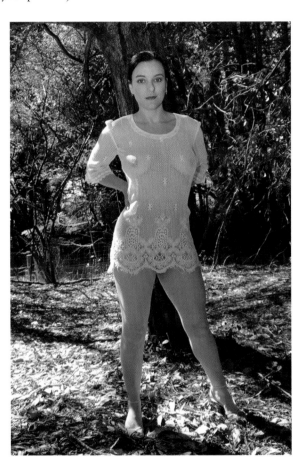

Standing *The problem with standing while photographing a model is shown here. Joanna is shorter than the photographer. The wide-angle lens (24mm equivalent to 36mm on a 35mm camera) also helps to make her legs seem short and stubby.*

Getting Down *The photographer kneels and the camera is at about the level of Joanna's waist. Compared with the previous figure, her legs look much longer here.*

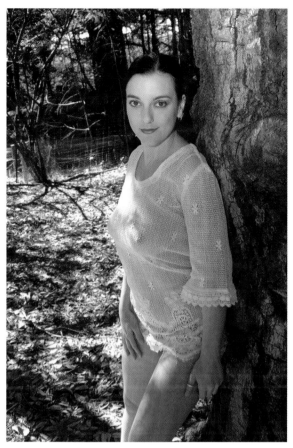

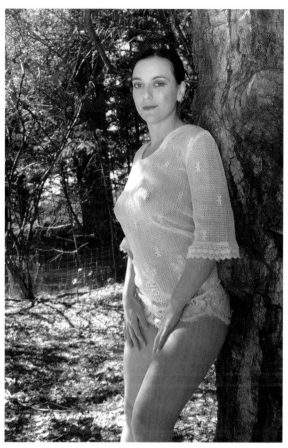

High Angle *The difference is not as pronounced in this and the following figure. In both cases the image is pleasing, yet they are different.*

Lower Angle *By simply moving to one knee, you can have more choices without even having to change the pose.*

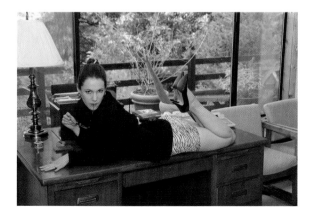

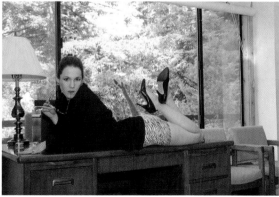

High Angle *Once again the photograph is taken from a standing position.*

Low Angle *By getting down to a lower angle, a lot of distracting elements on the desk and outside are eliminated quickly and easily.*

Avoid Wide Angle

The wide-angle setting on cameras is overused in photographs of people. If the photographer is standing close to his model when he begins photographing, it is natural to begin photographing at eye level and zoom back to get a full-length photograph. When that happens, a distorted photograph occurs. If you are just starting out, avoid the use of wide angle. As you become more experienced, you will learn when and how to use it. Generally, photographs of people, especially boudoir photographs of women, are best done by backing up and using a telephoto lens or telephoto setting on your zoom lens.

Too Close *A distorted photograph results from being too close and using a wide-angle lens.*

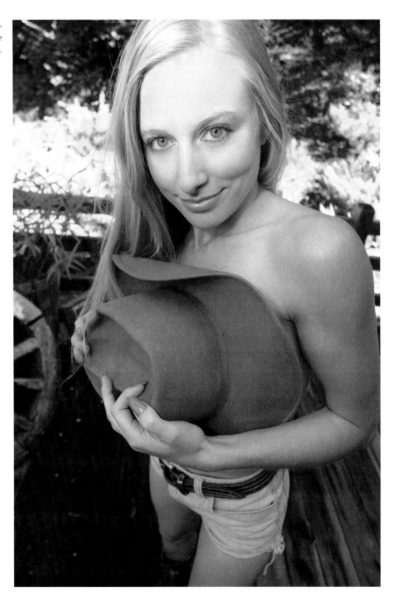

When you are taller than your model and you use a wide-angle lens at eye level, it makes her head look large and her legs look short and squat. In other words, it creates the opposite of the way that most women want to look.

Wide Angle *Melanie's legs look short and her head looks large in this view taken at eye level with a very wide-angle lens, equivalent to a 22.5mm lens on a 35mm camera*

Better *In this case, a less wide-angle setting on the zoom was used and the angle of view is lower. This makes her legs look much longer than in the previous figure. The setting was equivalent to a 32mm lens on a 35mm camera.*

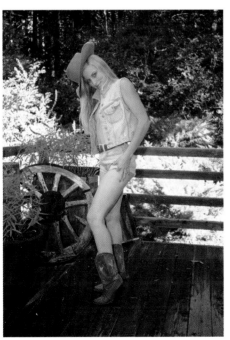

More Telephoto *This photograph looks better still because even more of a telephoto setting was used, approximately the vision of a normal human eye. This photograph has even less distortion. The setting was equivalent to a 45mm lens on a 35mm camera.*

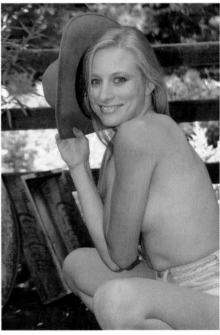

Least Distortion *This photograph is much tighter because of the telephoto setting used. The setting was equivalent to a 129mm lens on a 35mm camera. This image has the least amount of distortion and shows off Melanie's proportions the best.*

Get Back and Zoom In

Looking for variety in your photographs? Don't forget to include close-ups. Using a zoom lens, you can frame close-ups without even having to move. The telephoto perspective of zooming in is often more flattering in portraits in general and specifically in boudoir images. It makes the proportions of the body look more natural. Look at the examples to see how more variety is created simply and easily by coming in closer with your lens. An added benefit is it that it helps to remove distracting elements from the sides of the image.

 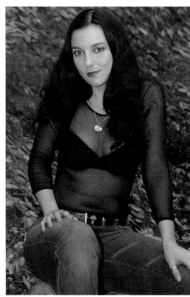 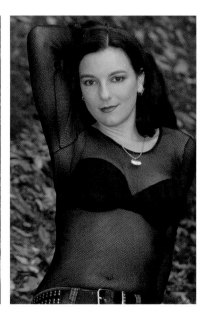

Full Length—Half Length—Close Up *Three different images of Joanna were created by varying the zoom length of the lens and asking her to change her pose very slightly for each one. The elapsed time was less than a minute to create these three different images.*

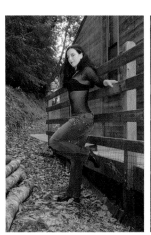 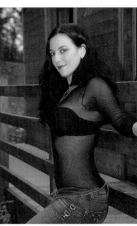 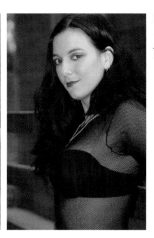

From a Wider Angle *The three-step routine is repeated for a standing, profile view. Note the somewhat lower angle.*

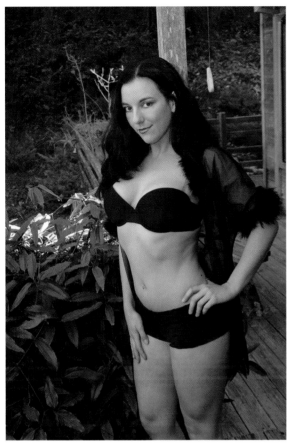 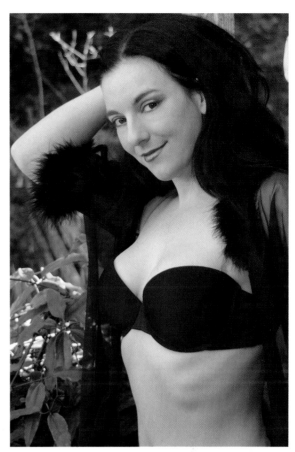

Downward Angle *Two different views created with the zoom. In this case the photographer was standing and shooting down somewhat at the model.*

 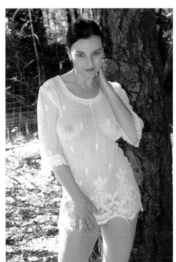

Another Example *Here is another example of a full-length photograph followed by closer photographs created by zooming in.*

BREAK THE RULES

The earlier lessons have given you "rules" to follow. Once you have learned the rules, only then are you in a position to break them. What kinds of rules? Rules such as not keeping the model's legs straight, using a wide-angle lens up close, cutting into body parts, shooting down at your model with a wide angle-lens, or shooting into the light. In this section, we talk about breaking the rules and still coming up with beautiful, sexy images.

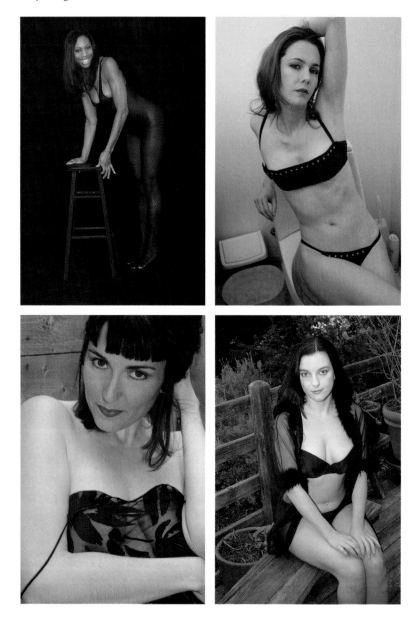

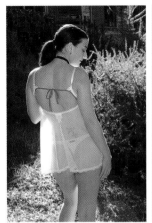

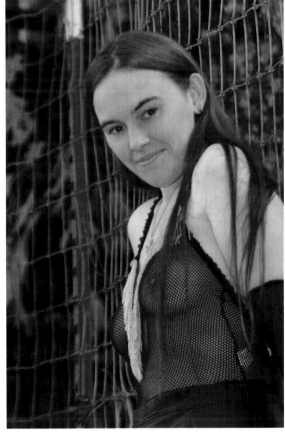
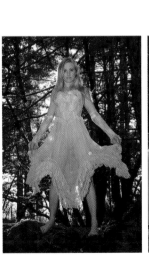

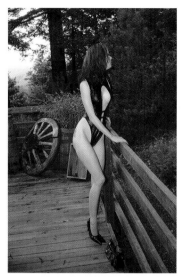

Straight Legs

You've been following the rules and having your model bend her legs. Usually this is the most flattering to a woman's figure. The curves of her hips show off better, and often, her legs look more attractive as well. Now we want to look for situations where straight legs will look as nice or even better.

Bent Legs *Usually bending her legs gives the model the best look.*

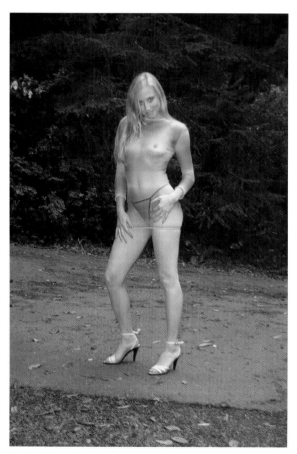

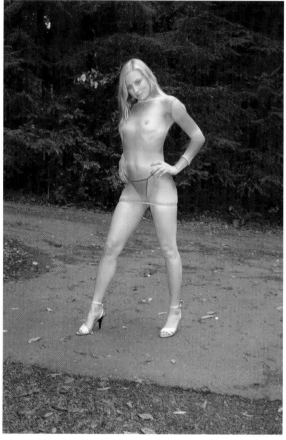

Stretch It Out *Here is the same outfit and location with and without straight legs to show the difference in the two poses. While both are attractive, the straight-legged pose appears more dynamic and stronger. It shows the woman to have more "attitude."*

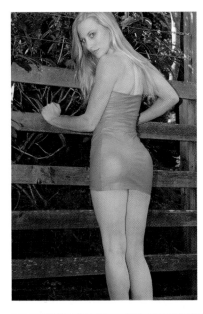
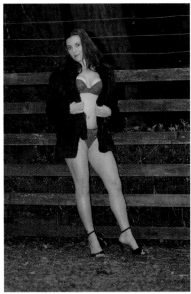
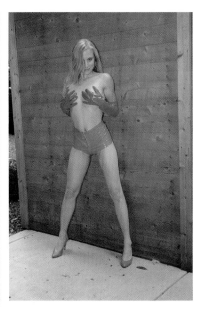

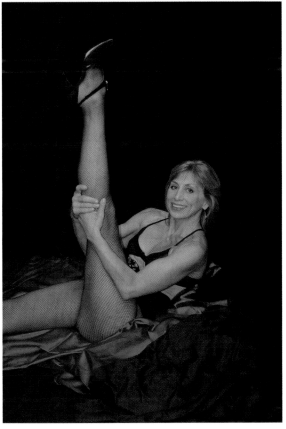
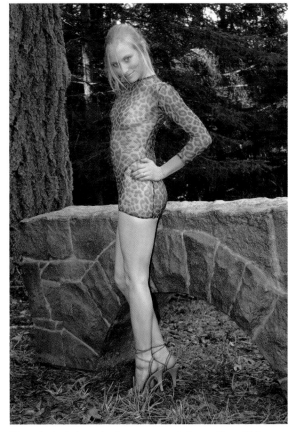

More Pose Examples *Here are more examples of poses that work with straight legs. The tension in the legs makes the pose strong, and often sexy. Be careful, because straight-leg poses will not work with a softer boudoir image.*

Wide Angle

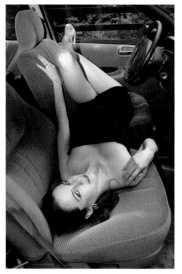

Earlier lessons have emphasized avoiding the use of wide-angle lenses, but there are cases in which you might want to use a wide-angle lens. Sometimes you might have to if the space is very confined, such as in a bathroom, in a car, or even in a kitchen. If you use a wide-angle lens, you have to watch for distortion. Usually, you want to bring the level of the camera down to the height of the middle of your model's body. Whatever is closest to the camera will seem larger than whatever is farther away. If the photographer is standing while photographing, the model's head will be closer to the camera and thus seem larger than her legs, which are farther away. Photograph it both ways: from a standing position as well as from a kneeling position, and see for yourself. This is easy, quick, and nearly free to do with digital.

Car *There is usually just not enough space in a car to use a regular lens. It calls for a wide-angle lens. Be sure to watch distortion when working this close.*

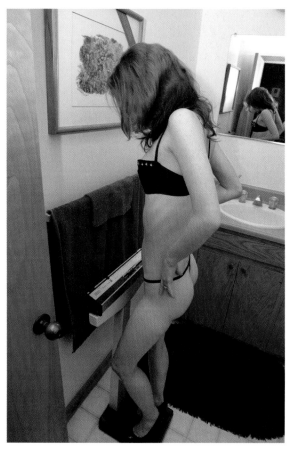
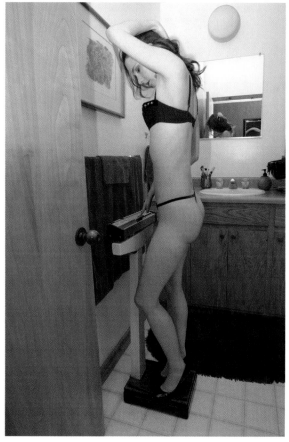

Watch Positioning *In a small bathroom, a wide-angle lens comes in handy. Because the photographer is standing, notice the distortion below the chest level in the first figure. While this may work for a special effect, it is usually not the effect you want in a sexy boudoir image. By kneeling in the second figure, the distortion is reduced greatly.*

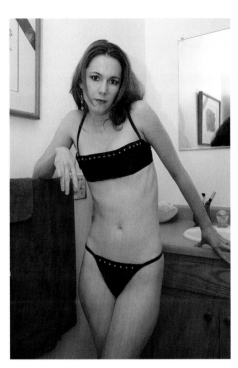
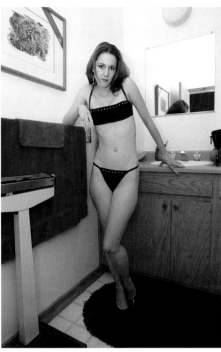

Close-Up Versus Full Length *You can often get a nice image with a normal lens, even in a tight space, but the use of a wide-angle lens will give you a full-length photograph. Be sure to bring the camera down to about the height of her waist by kneeling to avoid distortion.*

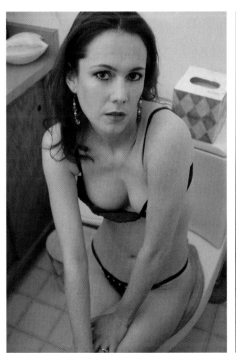
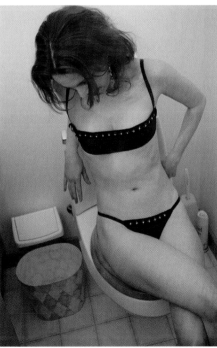

Special Effect *If you use a very wide-angle lens and get in close and shoot down, you get a special effect image. Using the same lens but getting down lower presents a more flattering image of your model.*

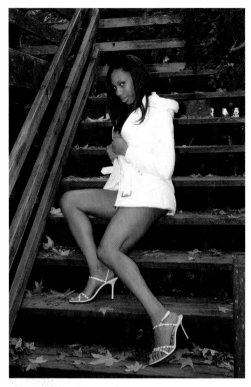

Body Parts

No, drop any ideas of a chainsaw massacre or some macabre ritual. This section is breaking the rule about showing the entire woman. Every woman has some parts she or you really enjoy. These areas need to be featured with the usual flattering poses, but they can be enshrined as details among all of the other images that you create of her. Ask her about her favorite areas of her figure. She may be shy at first, but persist. Then add to that list the areas that you enjoy looking at as well. Carefully frame and pose them to make them as perfect as possible. Also select flattering costumes. Keep your eyes open as you photograph her throughout the session. Sometimes a costume, a pose, or even a certain light pattern will really flatter her. Be alert and don't be afraid to move in close either literally or by using your zoom lens to capture that moment. Here are some sample ideas to consider.

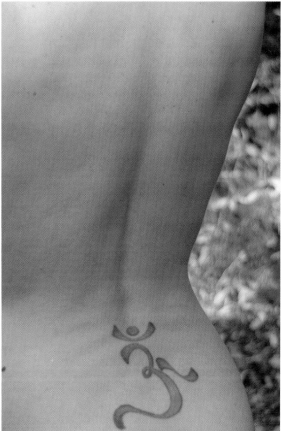

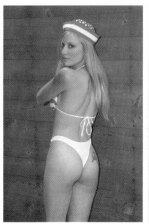

Shoot into the Light

Photographers are always told to put the light behind them when they photograph. What can you do if the background is ugly in that direction, or if you have no other choice? In those cases, you shoot into the light. In fact, once you understand posing and the operation of your camera equipment, it is often preferred to shoot into the light.

You need some kind of a fill light, either a reflector or an on-camera flash. When you add light in the front, you get a much better image with the face properly exposed. You need a little practice to add just enough flash fill and not too much. The amount of flash needed is affected by the distance that you are from the subject. Some flash units are automatic and will adjust for the distance when attached to the proper automatic camera, Some cameras have a function where you can adjust the amount of flash by small increments until you have it correct.

Putting the back light of the sun behind her, but slightly off to one side will often give more shape to her figure and hair.

Shooting into the Light *If you shoot into the light without any kind of fill light, this is the result. The light is mostly behind her and off to one side. The background is properly exposed, but the face is too dark.*

Better Exposure *Using a flash fill gives her face more exposure without changing the exposure of the background. Notice the pretty light in her hair and along the side of her figure.*

Variety *For variety, have your model kneel down and you can photograph slightly down at her. Avoid a wide-angle lens in this position. Then you can kneel down in front of her. Notice how this changes the background and gives you more variety.*

Light Behind *The light is behind Joanna and slightly off to the right side of the image.*

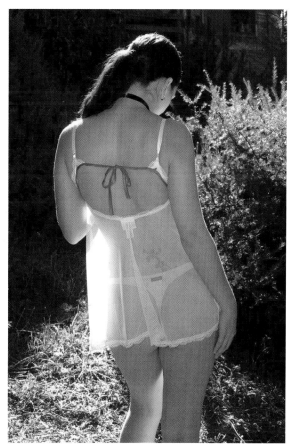

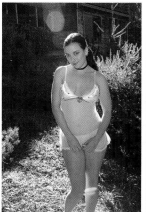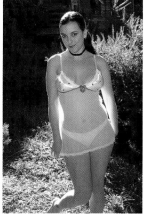

Watch for Lens Flare *When you photograph directly into the light, use a lens hood to keep light out of your lens. If you still get lens flare as shown in the first image, then move your position slightly. Sometimes there is a bit of shade from a tree, which you can step into to shade your lens. You can also use your hand over the top of the lens carefully to shade it. Watch to make sure your hand doesn't show in the image.*

Light Behind *Don't forget to photograph her from the back as well. Notice how the light from behind shows through her costume. Choose your costumes to take advantage of that lighting.*

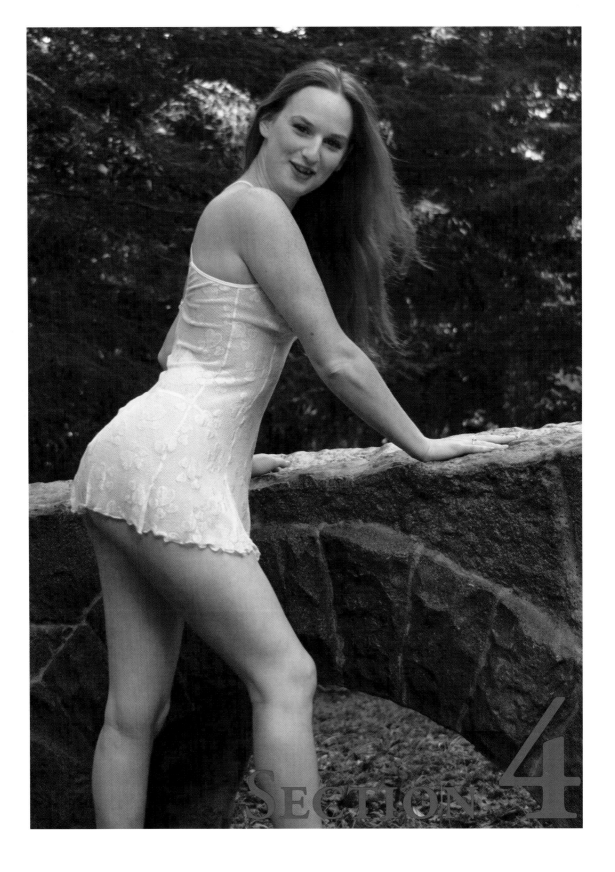

SECTION 4

ADVANCED TOPICS

IF YOU HAVE BEEN practicing the earlier lessons, then it is time to propose some more advanced topics. These topics will take more time to prepare, more equipment, more specialized props, more learning, or all of the above. Feel free to use these suggestions as stepping off points for more exploration of the boudoir subject on your own. These topics include creating a "boudoir series," which is a group of images that go together. It means developing your own style of photography, the thing that makes you more unique and different from other photographers. It includes using more advanced lighting techniques to get beyond the basic ones used primarily in the lessons up until now. And finally, it includes a few more advanced boudoir photography projects to give you ideas to explore on your own.

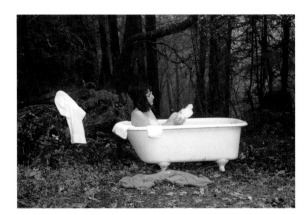

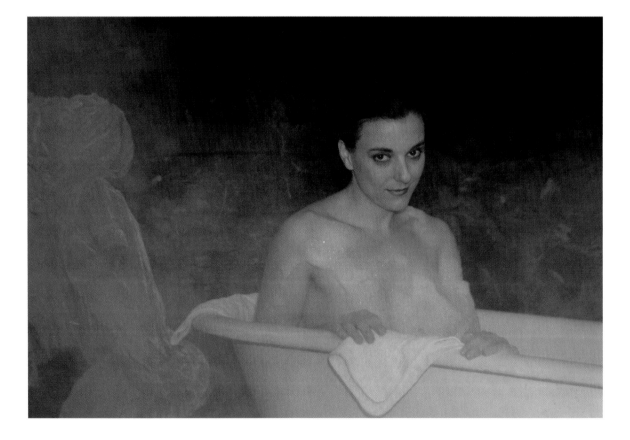

CREATING A BOUDOIR SERIES

A "boudoir series" is similar to a portfolio of images of one woman. If you are just photographing one woman, such as your wife or girlfriend, then this will be a natural for you. If you are a professional, or want to turn professional, the understanding of this concept will provide you with much better financial rewards for your efforts. The concept is to develop a cohesive body of work with one woman as your centerpiece. When you think in these terms as you photograph, it will lead you to produce a series of images that go well together. If you are a professional, it will lead to an album with many images in it. This means larger sales because your client will want all of the images if they go together. If the images are a jumble of styles, techniques, and the like, they won't flow well together, and your client will not be as inclined to purchase as many. If you are an amateur, the rewards for following this will be great praise from the woman in your life and pride in putting together something special.

Since a series is a group of images that go together, you need to determine the underlying theme. Of course, the woman herself is one theme. Another theme could be a costume, a location, props, or a situation. Each client's album or a portfolio is often made up of several different series. What is needed is variety. By providing variety, you are giving your client a choice. If you give her more variety, she will want to include more images in her album.

Some theme suggestions:

- Pick out one costume and use it in as many locations as possible (indoors, outdoors, different rooms, studio, different outdoor locations).

- With one costume, try for as many poses as possible (sitting, standing, lying down, front, side, back, from above, from below).

- Gather a group of related costumes, such as sports uniforms or different lingerie sets, and use them.

- Tell a story. It could be a woman getting ready for her bath (brushing her hair, running the bath, adding bubble bath, lighting candles, getting undressed, getting in the bath, and bathing).

- Try one location and do as many different costumes as you can logically fit in.

- Use the same prop in every photograph.

- Use a variety of related props (gloves or costume jewelry, for example).

A single session may have more than one of these themes, or it may require several sessions to accomplish your goals. Edit tightly before showing your client or model. The first image shown is a lasting one.

Pose Series *Here is a series of images of Jessica photographed in one location with one costume. Notice how she moves around and plays with her costume to give a lot of variety in only these few images.*

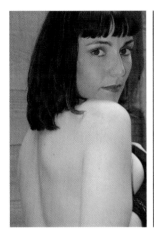
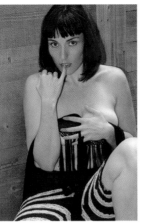
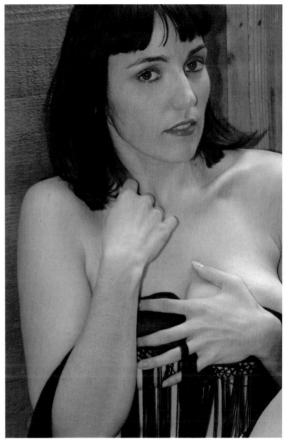
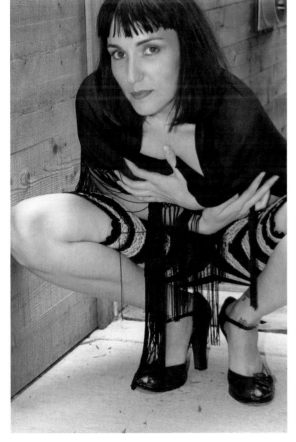
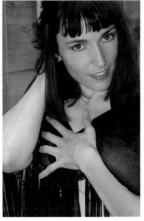
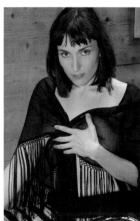

DEVELOPING YOUR OWN STYLE

What is a photography style? It is what sets you apart from all of the other millions of photographers. It is a signature that makes your work recognizable. It is what makes you unique and is one of the more important aspects of photography. It is certainly important for professional photographers if they wish to make a good living at photography. Without a style, you are just turning the crank and are at the mercy of the lowest bidders for jobs. With a style, clients will come to you because they can't get what you offer from anyone else. Price becomes a secondary concern. If you are an amateur with no desire to turn pro, having a unique style will help give your work focus and increase your enjoyment of your hobby.

How do you develop a style? Here is a list of suggested exercises:

- Develop your own strengths.

- Follow your heart.

- Strive to go beyond the literal nature of your work.

- Check books out of the library to study other photographer's work.

- Search online for photographers and study their work.

- Go to sharing websites like Flickr and browse the millions of images to see what turns you on and what turns you off.

- Buy photography books and study the masters.

- Look at as much photography as you can. You will identify with some of the images and it will help to give direction to your work.

- Move beyond the mere imitation of your favorite photographers. We all go through that phase. But keep it a phase.

- Your style will change over time. Let it.

- Use the advantage of digital and photograph a lot. The more you photograph, the more your style will have a chance to grow.

- Learn new techniques and see which ones you enjoy. Keep those, discard the others, and keep moving.

- Get feedback from qualified critics such as other photographers. If you are a professional, or want to become one, join a professional association that has regular meetings so you can have your work reviewed. Otherwise, join a club or utilize one of the online photo critique websites. Accept the criticism gracefully and let it flow over you, learning what you can. Remember, there is no growth without pain.

As you do this process, you will learn a lot about yourself. Allow yourself plenty of time to develop a style. Focus on doing the work, not on creating a style. Do the exercises listed on the previous page, forcing yourself to, if necessary. It is just like practicing the piano or other instrument. You will not get better unless you practice, no matter how much you want it, no matter how much you think about it. Just do the work and enjoy the process. The results will come.

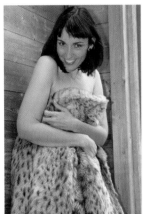
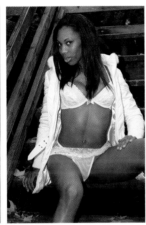
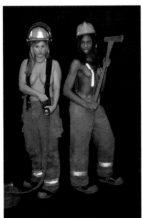

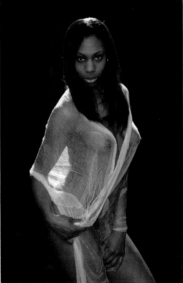
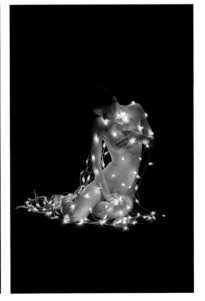

ADVANCED LIGHTING TECHNIQUES

There are a number of simple and relatively inexpensive advanced techniques you can use with your lighting to improve your photography.

Silhouettes

The first, and certainly the least expensive technique is to make silhouettes. It does not require any additional equipment, just a different way of thinking.

To create the silhouette, you need to adjust your camera. Some cameras have a manual mode, which allows you to reduce the aperture and expose for the bright background instead of the darker foreground. Other cameras have an adjustment usually indicated by +/- to increase or decrease exposure. You can experiment by adding a couple of stops of "+" and looking at the results. Keep trying it until you are happy with your image.

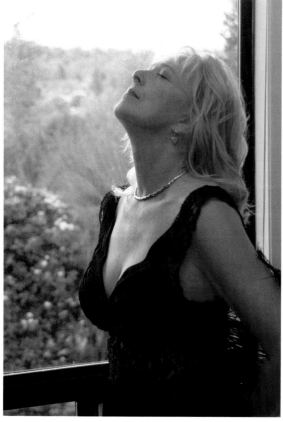 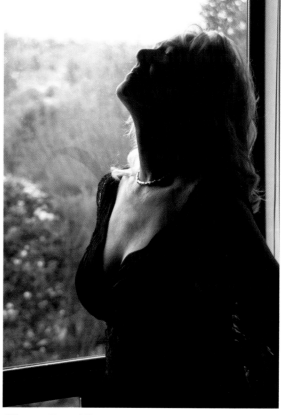

Regular *A regular boudoir portrait against a window was taken with a flash mounted on the camera providing the light in the front. A light modifier was used on the flash to soften the light.*

Silhouette *Using a different setting on your camera and fill flash, you end up with this silhouette.*

Hair Light

When working indoors, one of the nicest ways to spice up your photographs is to add a hair light. A hair light is a small light placed up high behind the model to light the hair. It helps to separate the model from the background and adds a nice glow around her hair. You will need a brighter hair light for women with dark hair than for women with light hair.

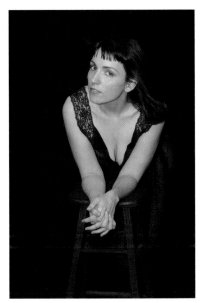

No Hair Light *No hair light was used on this image of Jessica.*

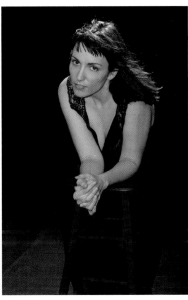

Hair Light *A small hair light was used up high about eight feet behind Jessica.*

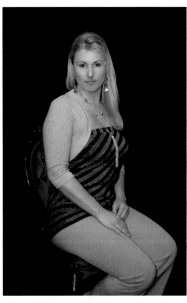

No Hair Light *No hair light was used on this image of Tanya.*

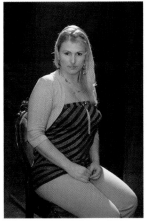

Hair Light *A small hair light was used up high about eight feet behind Tanya. Since she is a blond, you have to use less hair light or it will be too bright and "blow out" her hair.*

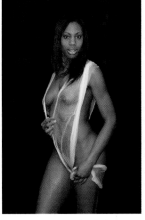

No Hair Light *No hair light was used on this image of Amelia. Notice how her hair blends into the dark background.*

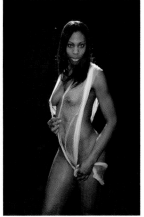

Hair Light *A small hair light was used up high. It separates Amelia's hair and figure from the background. It's called having good separation.*

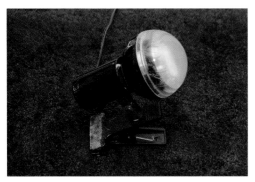

A hair light can be an AC-powered slave flash. It is screwed into any lamp socket and it will fire when it sees the flash of another flash unit such as the one on your camera. That is why it is called a "slave." You can use a clamp lamp purchased at a hardware store to screw it into. Then you can clamp it up high to act as a hair light. You can purchase these AC slave flash units at a camera store or online at someplace like eBay. The prices vary from about 16 to 50 dollars for a small, brand new, screw-in slave flash.

Hair Light *A small, screw-in, AC-powered slave flash unit. It is screwed into a clamp and attached to the wall. To reduce the flash brightness, you can tape some paper in front of it*

Wall of Light

This wall of light is a diffuser made from a fitted single bed sheet over a frame made from PVC piping. The PVC pipe is 3/4-inch schedule 40 (thick wall). The joints are just pushed together so that it can be easily disassembled and stored. You can make a stand for it, as shown, or simply lean it against something. It makes a very nice soft light when lights are aimed through it. They can be studio strobes, hot lights, sunlight, or even several of the AC flashes. The softness of the light is determined by how far behind the diffuser the lights are set.

Wall of Light *A Wall of Light diffuser is made from a fitted bed sheet and PVC pipe.*

PROJECTS TO STIMULATE YOUR CREATIVITY

The following sections will describe more creative ways to create beautiful boudoir photos. Use your imagination to expand upon these ideas.

Using a Fog Machine

A fog machine can add a bit of mystery to your images. Commercial photographers will spend hundreds of dollars for a professional fog machine made for photography. There is a simple and effective solution. You can purchase an electric insect fogger at a hardware store for around 60 dollars. This is one place where you should only buy a new fogger. NEVER buy a used fogger for use in photography. They are normally used for insecticides and could poison your model or you with the residue left inside. Starting with a new fogger and only using them outdoors is much safer. The fog fluid is purchased at a camera store or online. It is made by Rosco. Be sure to get the water-based version, #8207. It is not inexpensive, but a liter will last a long time in the small doses that you need. If used indoors, it may cause problems in high concentrations, plus it will leave an oily residue over everything. Indoors, the machine can fill a good-sized studio to a dense fog in less than a minute. It is much better and safer to use out-doors. You need a calm day or the wind will blow the fog away quickly. Sweeping the machine back and forth will give a nice coverage. Be careful about touching the barrel or setting it against objects. It gets quite hot and can burn you. The barrel will stay hot as long as it is plugged in. It doesn't have to be producing fog to stay hot. Unplug it when you are not using it, and don't let it sit against flammable objects or leave it unattended. It is also pretty noisy when it is operating. If you are using it in your backyard, the fog looks a lot like smoke. You may care to warn your neighbors so that they do not call the fire department and interrupt your session.

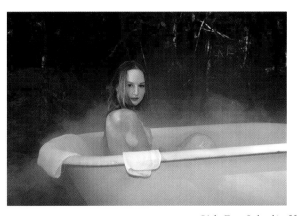 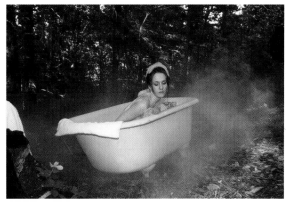

Light Fog *Only a bit of fog was used in these images.*

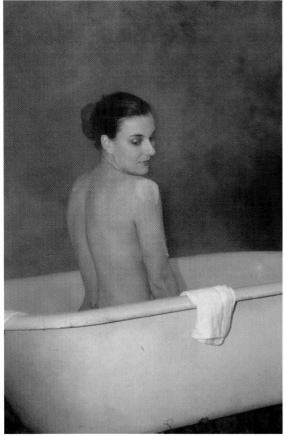

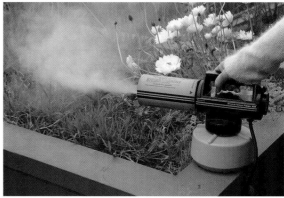

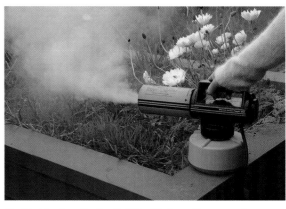

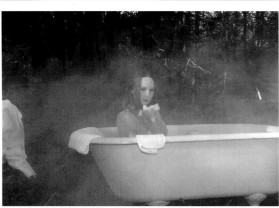

Heavier Fog *Heavier fog was used in these images.*

Fog Machine Puts Out Fog Quickly *The fog machine puts out fog very quickly. From a wisp to a lot, only six seconds elapsed here.*

Outdoor Bathtub

The outdoor bathtub is one of the most popular setups offered at our studio. You start by finding an antique, claw foot bathtub. This one was purchased at a house wrecking company and cost less than $100. The legs don't match, so a discount was given. The legs can't be seen in the photographs anyway. The tub is very heavy. Several men were needed to lift it out of the van and set it on the ground. Be careful and don't hurt yourself trying to move it. This one sits in place year round. When it is not being used, a piece of plywood, cut to size, sits on top and a small tarp covers it to keep water and debris out. It makes it easier to clean it before each use.

The tub is not filled with water when it is used in a photograph. To give the illusion of water, a basin with hot, soapy water is placed on the bottom of the tub, between the model's legs. To provide for model comfort, several large bath towels are folded and placed in the bottom of the empty tub. Another towel is laid across the inside of the back of the tub. Cast iron is cold on the bare skin! Keeping the model covered in a thick robe until the last minute is another detail of model comfort. A model that is too cold will not have happy expressions. Some of the example images were done when the temperature was in the low 50s and high 40s. In one case, there was a gentle rain as well.

A variety of poses are possible, as can be seen in the examples. Back poses with a bit of soapy bubbles are very sexy and often acceptable to a woman reluctant to have images that are too revealing. If it is very cold, then just sitting on the edge of the tub in a robe will make a nice image. If you don't have a yard where you can set up a tub, it can also be used in a studio or a garage. A rolling platform with casters can be made or purchased so that one person can move the tub on hard surfaces. Be careful and don't injure your back if you are moving it by yourself. If used in a studio, then a black or white background can be used.

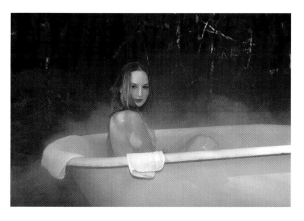
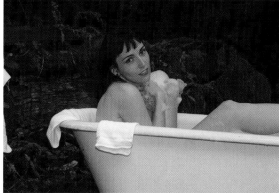

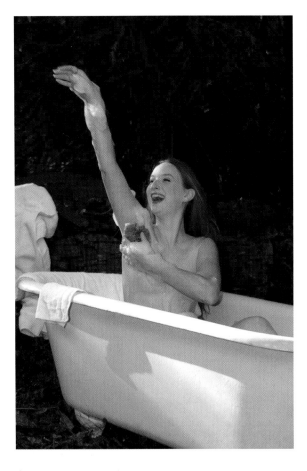

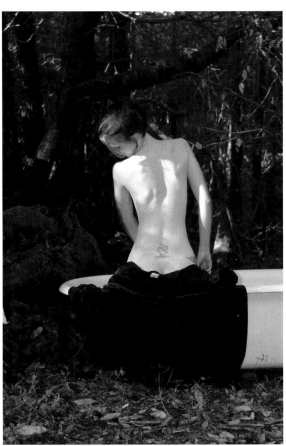

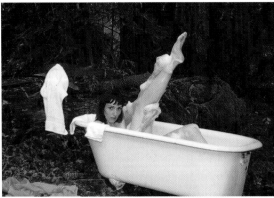

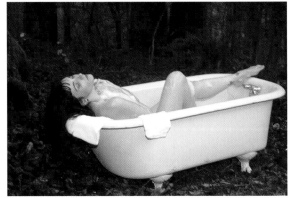

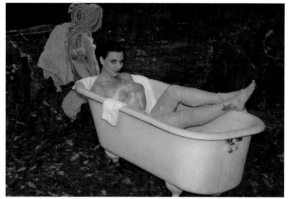
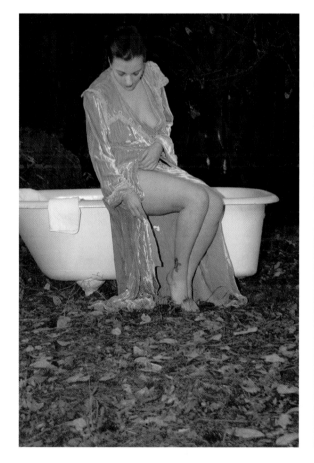
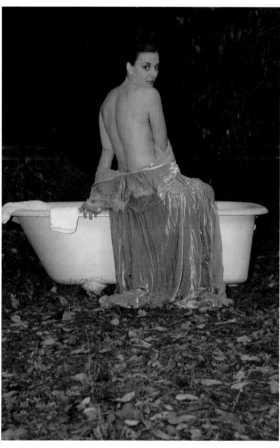

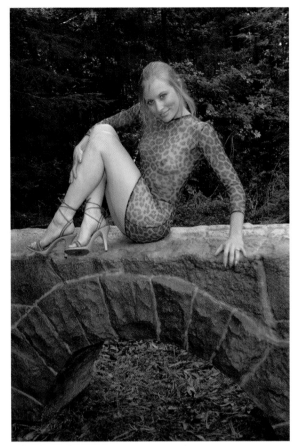

Rock Arch

The rock arch prop is a very versatile and fun prop to use. It is in the advanced section because it is somewhat expensive. It consists of two pillars and an arch that sits on top of them. They look very realistic, even in person, but are made of foam and then painted, so they are lightweight. One strong person can carry each piece. They are not heavy, but awkward and bulky. Several companies make and sell similar items. The cost of the set is in the hundreds of dollars. Some people make their own, or if you have a yard, you could build a real arch out of rock. The purpose of this section is to give you ideas that you can apply in your own situation. Only the arch is used in these examples, with the

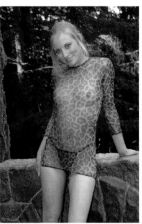

It Can Be a Bridge *Using only the top piece, the arch, it can be a bridge. In the bottom image you can see both ends. In the top figure, the image was cropped so it looks more like a bridge. Adding some gravel or rocks underneath it would make it look like a dry streambed underneath and look more realistic.*

Or a Wall *Either the arch or a pillar laid on its side can represent a wall, which the model can lay on, sit on, or lean against.*

occasional use of one pillar, not the entire three-piece set. Rather than use the set in the manner in which it was meant, these examples show different ways to use the prop. Keep this in mind as you use any kind of a prop or clothing item. After using it the way it was intended, think a bit about how else it might be used. Don't be afraid to experiment. That is the beauty of digital… you can always delete your mistakes!

Pillar or Ruin *Now the arch is placed on one end and a pillar is used on its side as a base. It looks like some kind of strange pillar or a ruin of some old building. Both will give you and your model new posing ideas and makes the prop set much more useful.*

SECTION 5

THE BUSINESS SIDE

PHOTOGRAPHERS SEEM TO dislike reading and studying about business topics. At professional conferences, business topics are often the least popular seminars. If you really enjoy being a photographer and want to make a living at it, or even if you just want to earn some money, then this could be the most important section of this book.

BECOMING PROFESSIONAL

What is a professional photographer? There are two things that make a photographer professional. The first is that the photographer charges for the work and attempts to make money at it (you don't actually have to show a profit). The second is that the photographer operates the business in a professional manner. That means treating clients, colleagues, suppliers, models, and everyone else involved in the business in a respectful manner, following a set of ethical principles, and following a set of professional standards. It is useful to join a professional photography association. All professionals in any profession should belong to an association of their peers. The two national organizations best suited for boudoir and other portrait photographers are the Professional Photographers of America (PPA) and Wedding and Portrait Photographers International (WPPI). PPA has regional, state, and local affiliates. The local affiliates have monthly meetings and the regional and state affiliates usually have their own annual conventions. Both PPA and WPPI have an annual national convention and a monthly magazine. PPA can be contacted at www.ppa.com. WPPI can be found at www.wppionline.com. You should be able to find a group of professionals to meet with on a regular basis. By doing that, you will gain a group of peers to help you problem solve and with whom you can share valuable business tips.

Business Opportunities

Finding business opportunities is one of the toughest things about turning professional, and it is becoming more difficult all of the time. Entire books have been written on the subject, so only a brief outline will be covered here. There are several steps to be followed. First, decide what photographic services you can offer. Second, figure out who will purchase your services—your "target market." Finally, you will need to let them know that you exist by marketing to them.

What photographic services can you offer? Boudoir photography gives you a lot of possibilities. The first thing that comes to mind is, of course, boudoir portraits for women. You could also do boudoir-style images for magazines such as *Maxim*, *Playboy*, and similar, mainly male-oriented publications. Lingerie and swimsuit advertisements and catalogs are a related area, as are model portfolio images. Each of these areas has different possible clients and therefore different marketing plans.

Starting with boudoir portraits for women, who are your possible clients? There is nearly always a reason why a woman would purchase a boudoir portrait. Generally women who have reached a milestone in their lives are the ones most interested in having a boudoir portrait created. These are women who have reached a particular birthday such as 21, 30, 40, 50, or even 60 years. Women who have just lost a lot of weight, who are getting married, who have a new boyfriend, who have an anniversary coming up, who just had plastic surgery, or who have just gotten divorced are also good candidates. Specific holidays such as Christmas and Valentine's Day as well as the birthday of their significant other are usually good times as well.

Developing a relationship with a gym, a plastic surgeon, a weight-loss clinic, or similar organizations can pay off with referrals. Sometimes you can set up a promotion such as a half-price session fee with a new or renewal gym membership. Joint promotions with other businesses are a very cost-effective way to market. Usually advertising in a newspaper or magazine is the most expensive way to attract new clients. In any marketing campaign, repeatability is the key to success. If you place an ad, for example, you will need to repeat it in every issue for months to have any effectiveness. Generally, a single ad is a waste of money.

Direct mail can be expensive but effective with the right mailing list. You can purchase a list or prepare your own by creating and utilizing relationships with other businesses. Doing a joint mailing with other businesses is also cost effective. You both mail out each other's literature to your own set of clients. You help promote them and they help promote you.

In you are interested in pursuing magazine work, also called "editorial," you need to become a member of Editorial Photographers (EP). Visit their website, www.editorialphoto.com, to learn about this area of photography. There are many possible pitfalls that you need to avoid. Often, having a website and a web-based portfolio is a requirement. You should start by making a list of the magazines you are interested in working with and contacting them to see what their submission requirements are. They will often have a website with contact information and the kinds of materials that they are looking for. If you have trouble in this area, your local librarian can help you.

To get advertising and catalog work, you will need to promote yourself to manufacturers, wholesalers, and retailers in those fields. You can research these companies at your local library and then contact them. Visiting their website is a good start to find out the proper contact person. You will face a lot of rejection, so don't give up. If you strike out, just start again.

MODEL RELEASES

Why would you need a model release? A model release is needed whenever you show the images to someone else, such as in your portfolio or on a website. You also need them whenever you want to license the images. Since boudoir images can be a sensitive subject for many people, it is doubly important that you get a model release for all photographs that you want to do anything with other than sell to the woman you photographed.

Model releases are used as a contract between you and the model. They should be written, even though oral model releases are acceptable in some US states. A number of professional photographer organizations provide copies of suggested model releases. One place to check is the forms section of editorialphoto.com. The model release can be a simple one or two sentence document printed on a note card, or it can be an entire page of tiny print. The rules and laws governing model releases vary in different states and countries. It is beyond the scope of this book to provide the various releases that might be appropriate for your individual situation. You should contact your own attorney who is knowledgeable about rights to privacy and other laws. This book cannot offer legal advice. Instead, a listing of what each release must contain is listed below.

There are two kinds of model releases. The first is simply written permission from the model to do specific things with the images you create. It can be in the form of "I give you permission to…." The disadvantage of this type of release is that the model can simply withdraw her permission at any time and for any reason. The more common type of release is a contract between the model and the photographer. In the case of a contract, it must contain an offer, an acceptance, and "consideration" or payment in some form. This is where matters get sticky. In some states, New York for example, no consideration is required to make a model release enforceable. In other states, it must be a monetary amount, even one dollar. Still other states have set a minimum monetary amount, for example 25 dollars, to make a model release valid. Many states allow the consideration to be photographs in either printed form or on a CD or DVD. This is why it is important to contact an attorney and to do research to find out the requirements in the states or countries in which you will be photographing.

COPYRIGHT SUBMISSION

By international copyright law, your images are copyrighted when you push the shutter release. From a practical point of view, in the United States you must register your images with the Copyright Office, part of the Library of Congress. Only with registration can you recover punitive damages (up to $100,000 per infringement) and attorney fees. Without registration, lawsuits are usually too expensive and a waste of time. They need to be filed in federal court and the costs can easily run up to $100,000 for your legal fees. Without registration, no attorney will take your copyright case on contingency. With registration, the other side's attorneys know that it is usually in their client's best interest to settle out of court with you. These are the reasons why you absolutely must register your photographs if you are a professional photographer whose work is published either in print or on a website.

It is actually not very difficult or expensive to register work once you get the hang of it. Your work can be small digital images (360 pixels by 240 pixels is a good size), with medium compression, in a JPEG format. You can register as many images as you would like on one or multiple CDs for the same 30 dollar fee per submission, as long as the images have not been published. Use the gold archival CDs. I know the subject seems complicated at first. Setting up a workflow that works for you will take a little bit of time the first time you submit. After that, it takes maybe 30 minutes per

submission. If you photograph regularly, submitting on a regular monthly schedule makes the most sense and provides the most protection. You create the small digital images with a Photoshop action, so it runs while you are doing other things. It takes about 30 minutes to prepare a submission whether you have 5 images or 5,000. It could take a bit longer if you have 50,000 images because you will have to burn a few CDs. I did about 15,000 images in one submission, and it took less than an hour.

First visit the US government's website at www.copyright.gov. Download the proper forms. Most likely you will be able to use Short Form VA. Here's a brief description of this form.

- **Section 1**—The title of the work, something like: "Unpublished Collection-MM/DD/YYYY (date) Joe Photographer xxxx images (number)."

- **Section 2**—Your name, address, phone, and e-mail address.

- **Section 3**—The year of creation. This is the year the collection was finished. Usually that will be the current year even if you're including photographs from several years ago.

- **Section 4**—Since these are unpublished images, skip Section 4.

- **Section 5**—Type of authorship. Check the box for photograph.

- **Section 6**—Sign the form.

- **Section 8**—Fill out where you want the certificate shipped.

Enclose a check for 30 dollars and the CD(s) of your images. Use a trackable mailing service, such as FedEx, so that you will have a record of the delivery. Make a copy of everything, including the CDs, and put your copy in a manila envelope with the date and description on the top edge to make it easy to find if you ever need it. Be sure to use the gold archival CDs. Now mail the submission copy. Once the package is received at the Copyright Office, keep your copy of the receipt (available online for FedEx and similar carriers) in your manila envelope and file it away. Set up a new envelope for each submission. In about three to five months, or a bit longer if they get behind, you will receive a certificate from the Copyright Office with the date they received it. File this certificate in your envelope. For more information on copyright, visit www.editorialphoto.com. Keep in mind that some of this information changes over time.

SECTION 6

RESOURCES

THIS SECTION WILL PROVIDE you with a number of resources to improve your boudoir photography. It is chock full of suggestions for locations, props, costumes, and scenarios. Use the lists to stimulate your own ideas. Not every idea will work for you. You might not have access to a forest, but you might have a large, nice bathroom with a sunken tub. If you don't have a studio, you can move furniture in your living room, or take the cars out of the garage. You will have to improvise in many cases. No one has it all. Start with what you have now and then slowly branch out. As you branch out, trying new ideas, this is the section for you to turn to.

In addition to the lists, there is an introduction to digital photography, a glossary, and a list of suggested books to read. Use these items to advance your education and experience.

DIGITAL PHOTOGRAPHY BASICS

Digital photography has been rapidly replacing film-based photography over the last several years. It is a good assumption that you are reading this book because you are either interested in digital photography or already have a digital camera. Because of that, little space will be given here to convince you to try digital photography. There are some significant advantages to "going digital," but also some disadvantages.

Some of the advantages:

- You only print what you need, thus reducing printing costs.
- Images are easy to share images with your family and friends around the world.
- You can create electronic photo albums.
- You can review your images right after taking them. This is one of the most powerful benefits of digital and considerably speeds up the learning process.
- The operational costs of digital are much lower since you don't have to print out each image or purchase film, and you can delete images that you don't like.
- It is much easier to retouch and fix flaws in digital images to make them perfect.
- It is much easier to print digital images yourself than to print film images, plus no toxic chemicals are involved.

Some of the disadvantages include:

- Many cameras have a lag time for autofocus, which slows down the photography process.
- Many cameras have shutter lag—the period between when you push the shutter and when the picture is taken. This can cause you to miss photographs.
- The startup cost of the equipment is more expensive when you add in the costs of the camera, media cards, computer, printer, and supplies.
- The cost of a digital camera is higher than an equivalent film camera.
- You need access to battery power to use the camera.
- You will spend much more time on the computer processing your images than you would by just dropping off a roll of exposed film for printing at the lab.
- You must back up or you risk losing all of your images in an instant.
- A lot more technical skills are required than with film cameras.
- It is more difficult to get acceptable exposure with digital than it is with negative film.
- Purchasing digital equipment can be difficult and time-consuming trying to compare all of the features and understand which are important.

Resolution

One of the first issues that you will have to understand is resolution. Each "small piece" of a digital image is called a pixel. The more pixels an image has, the finer detail can be rendered in a photograph and the bigger an enlargement can be made of a photograph. The number of pixels is known as its resolution. Pixels are measured in the millions. Each million is called "mega." So a five-megapixel (MP) camera is one that has five million pixels. The actual resolution is measured as so many pixels per inch (ppi). Sometimes you will see this incorrectly stated as dots per inch (dpi), which is a printing term to describe the number of dots used to print an image in a magazine, newspaper, or inkjet printer, where dots of ink are used to print the photograph. In computers and cameras, the correct term is ppi. Computer monitors usually show images at 72 ppi and high-quality printers use 300 dpi. The number of megapixels tells you how large you can print your image. Cameras of four to five megapixels are usually more than adequate for most boudoir images. Select the highest resolution possible in the camera's menu.

File Format

Most digital cameras store their images in a file format known as JPEG. All that you need to know is that JPEG is a compressed file format that works by throwing out data to save space when saving the image. Besides JPEG, some cameras offer higher quality formats such as TIFF and RAW. The higher quality comes at a price. They both take up considerably more storage space so you get fewer images on a memory card. For the most control in processing your image, choose RAW if your camera has it available. It allows you to have much more control over adjustments in exposure than JPEG allows.

Compression

Most cameras use varying levels of compression when saving a JPEG image. This compression is selected in the camera menu by selecting items like "normal," "fine," or some other setting. Select the least amount of compression possible. You can tell when you have selected the best setting because the number of images available to be saved on your memory card will be the smallest. The more compression that is used, the more data that is thrown out and the lower quality the image will be.

Color Balance

Color balance is the overall color of the scene. Each device, such as camera, monitor, and printer, renders color in a different way. You can adjust the color with software afterwards. You can also get software and hardware to calibrate the color so it is repeatable and realistic. You want a print to look like your monitor when you order a print from a lab. If you become a professional, you will want to calibrate your entire workflow.

White Balance

The color of the prevalent light affects the color balance of the image. You can adjust this color by using a white balance adjustment that most cameras have. You do this by setting the camera for the type of light, for example, daylight, flash, room light, shade, and so on. Some cameras allow you to tweak the color by setting a custom white balance. Most people set the white balance on auto. If this provides satisfactory results, then you can use auto. If not, set the white balance for each type of lighting that you encounter.

Batteries

The batteries that you use in your camera will determine how many images you can create at a time. Some cameras use special rechargeable batteries. Others use regular batteries, which are easier to find when you travel. Make sure you always have spare batteries, so you don't lose that special photograph.

Noise

Film produces grain. Typically, the higher the speed of the film, the larger and more obvious the grain. In digital the equivalent is called noise. Noise is multicolored pixels. This noise is usually increased during low-light situations and when using higher ISO settings such as 400, 800, 1600. If you use sufficient light and lower ISO settings, depending on your camera, you will not have too much of a problem with noise. SLR cameras have larger sensors and tend to have less of a problem with noise than point-and-shoot cameras. There is software available to somewhat smooth out noise in your images.

Sharpening

Digital cameras use a filter over the sensor inside the camera. This filter tends to soften the image. You can sharpen the image with software, either in the camera or later, in the computer. Although it seems like it would be easier to sharpen in the camera, the software in the computer is more powerful and can do a better job. In addition, the amount of sharpening is dependent on the size of the image. Since you will be sizing the image later in the computer, it is better to do any sharpening as the very final thing before printing or sending it to the lab, and not do any sharpening in the camera.

Digital Zoom

Digital zoom is not a real zoom. It is merely an enlargement of portions of the image in the camera. Like sharpening, it is better to do any "zooming" (cropping) later in the computer rather than in the camera.

Memory Card

A memory card is the small electronic storage device that slips into your camera to record your images. There are a number of different kinds of memory cards. You should get the kind required by your camera. Other kinds will not work. Be sure to have plenty of cards. You don't want to run out of storage space. Check your owner's manual to learn how many images will fit on each of your cards.

Card Reader

While nearly every camera can be connected to your computer to download the images, it is much more convenient to have a separate reader to do that. Besides being able to continue using your camera, it puts less wear and tear on your camera. They are not very expensive either. They connect to your computer's USB or FireWire port.

LOCATION SUGGESTIONS

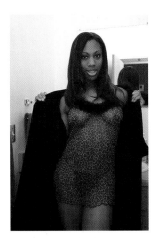

Here is a list of suggestions for locations where you can take your boudoir photography. It is likely that you will not have access to every location, but it should help to give you some ideas and get those creative juices flowing.

- 18-wheeler cab
- 18-wheeler truck
- Attic
- Back porch
- Backyard
- Balcony
- Basement
- Bathroom
- Bathtub
- Beach (private)
- Bed and Breakfast inn
- Bedroom
- Brick wall
- Camper
- Car
- Chainlink fence
- Deck
- Desert
- Dining room
- Family room
- Field of wildflowers
- Fireplace
- Forest
- Front porch
- Garage
- Geometric patterns in wood, brick, and stone used as a backdrop
- Guest room
- Home library
- Home office
- Home studio
- Hot tub
- Hotel room
- Kitchen
- Laundry room

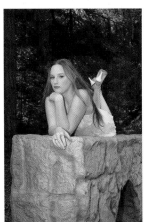

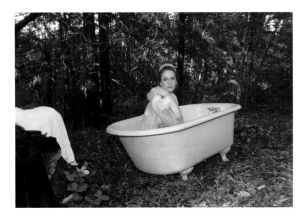

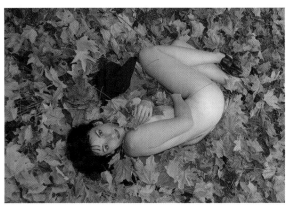

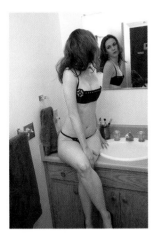

- Living room
- Log
- Motel room
- Mountains
- On a bedspread on the floor
- Pile of wood
- Private airplane
- Private elevator
- RV
- Sand dunes
- Shower
- Spa at home

- Stairs
- Stone wall
- Studio
- Swimming pool
- Swing set
- Tire swing
- Trailer
- Tree
- Tree house
- Tree swing
- Utility room
- Wooden fence

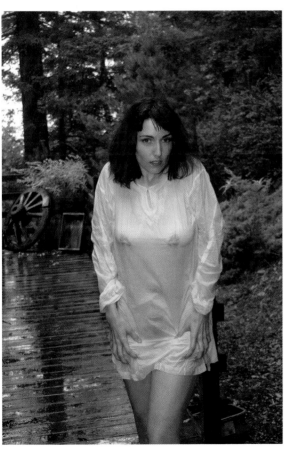

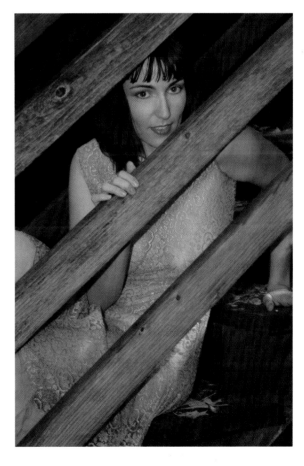

PROPS

Adding a few props to your photograph will help tell the story. Don't overdo it, however. Fewer props to give a hint will work better than overpowering the image with too many.

- Animal/pet
- Axe
- Back-scrubbing brush
- Barbells
- Bathtub toys
- Beach towel
- Beach toys
- Bench
- Bicycle
- Blankets
- Body paint
- Boots
- Bubbles
- Camera
- Camera on a tripod
- Car
- Cast for an arm or a leg
- Cat
- Cell phone
- Chair
- Chaise lounge
- Chocolate syrup
- Christmas decorations
- Comforters
- Computer
- Construction helmet
- Costume jewelry
- Couch
- Crutches
- Desk
- Desktop computer
- Dog
- Electric fan
- Exercise bike
- Fainting couch

- Fan to hold
- Feather boa
- Feather duster
- Feathers
- Float for pool or beach
- Flowers
- Foam packing peanuts
- Food
- Football shoulder pads
- Garden hose
- Garden sprinkler
- Glasses
- Gloves
- Golf clubs
- Guitar
- Hair clips
- Hair comb
- Hairbrush and mirror
- Handcuffs
- Hardhat
- Hat
- Headband
- Hiking stick
- Horse
- Ice cream
- Inner tube
- Kitchen tools
- Kitten
- Ladder
- Laptop computer
- Loofah
- Makeup
- Makeup mirror
- Makeup tools
- Milk

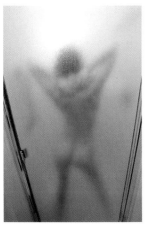

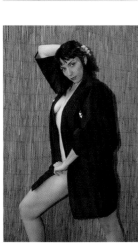

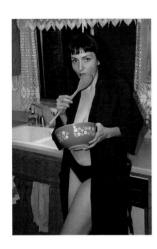

- Mirror, full length
- Motorcycle
- Motorcycle helmet
- Musical instrument
- Office chair
- Office desk
- Old-fashioned phone
- Peanut butter
- Pillows
- Private airplane
- Radio
- Riding crop
- Rope
- Saddle
- Scarves
- Sea sponge
- Shower curtain
- Shower door
- Sleeping bag
- Snake
- Stair climber
- Step stool
- Stool

- Sunglasses
- Telephone
- Telephone with long curled phone line
- Tennis racket
- Tent
- Tool belt
- Tools
- Toy gun
- Treadmill
- Tuxedo tie
- View camera
- Wading pool
- Water
- Weight bench
- Wheelbarrow
- Wheelchair
- Whip
- Whipped cream
- Wigs
- Wooden crate
- Workout equipment

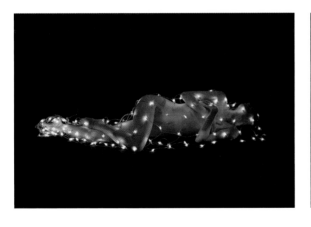

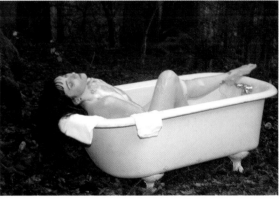

COSTUME SUGGESTIONS

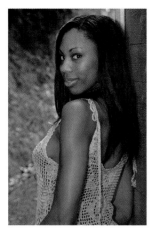

There are so many costume possibilities that it is virtually limitless. You may have some of these in your closet already or you can borrow them from friends. Shopping trips to thrift stores, garage sales, flea markets, and swap meets will enable you to enlarge your collection easily and inexpensively.

Here's a list of costumes I use frequently:

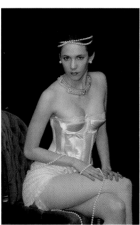

- 1940s cone-shaped bra and panties
- Animal-print mini dresses
- Animal-pattern negligees
- Apron
- Army uniform
- Baby-doll negligee
- Ballet dancer
- Bikini
- Black teddy
- Bodysuit
- Boy shorts panties
- Bra and panty set
- Bra, panties, garter belt, stockings
- Business suit
- Bustier
- Camisole top
- Caution tape
- Chamois bikini
- Cheesecloth
- Cheerleader
- Chemise
- Club wear
- Construction worker
- Crocheted body stocking
- Dancer's outfit
- Denim jacket
- Denim shorts
- Doctor's coat
- Evening gown
- Fabric
- Feathers

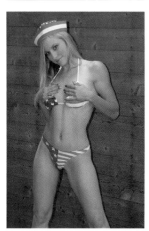

- Firefighter turnouts
- Firefighter brush gear
- Fishnet body stocking
- Fishnet mini dress
- Flapper dress
- Flowers alone
- Formal gown
- French maid outfit
- Fur coat
- Greek goddess dress
- Halloween costume
- Hiking shorts
- Hippie outfit
- Holiday outfits
- Hot pants
- Jeans, no top
- Jeans, western shirt, boots
- Jeans, with bra
- Jeans, with blouse open
- Just heels
- Kimono
- Lace body stocking
- Lace dress
- Lace fabric
- Leather bra top
- Leather bustier
- Leather jacket
- Leather miniskirt
- Leather pants
- Leather thong bikini
- Lingerie mixed with regular clothes
- Little black dress

- Lycra mini stretch dress
- Maid's outfit
- Man's shirt
- Man's tie alone
- Marilyn Monroe–style white dress
- Merry widow
- Mini dress
- Miniskirt and bra top
- Motorcycle outfit
- Mrs. Claus outfit
- Navy uniform
- Negligee
- Nurse's uniform
- One-piece bathing suit
- Overalls, denim
- Pantaloons
- Petticoat
- Pom-poms alone
- Raincoat over bra and panties
- Raincoat with nothing underneath and hat
- Renaissance costume
- Roaring '20s costume
- Robe, sheer
- Robe, terrycloth
- Ruffled panties
- Sarong
- Scarves
- Scuba diver
- Secretary's business suit
- Sheet

- Short-shorts
- Shorty negligee
- Silk pajamas
- Silk robe
- Silk scarf
- Slip
- Spandex mini dress
- Stockings in black, white, red, and nude
- Strapless long dress
- Sundress
- Sweater
- Tennis outfit
- Thong bikini
- Tool belt with torn off t-shirt
- Towel
- T-shirt for wet t-shirt look
- Tube dress
- Tuxedo and bowtie
- Umbrella
- Variety of heels
- Velvet coat
- Velvet robe
- Vest
- Vintage lingerie
- Vinyl bustier
- Vinyl miniskirt
- Vinyl pants
- Vinyl shorts
- Wedding dress
- Workout clothes

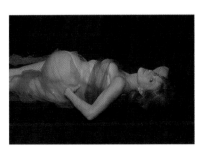
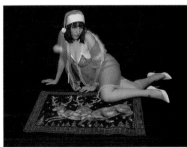
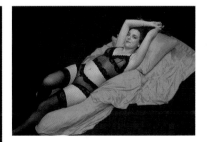

SCENARIO SUGGESTIONS

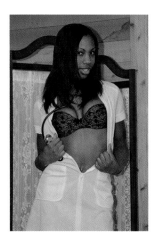

Sometimes it helps to think about photographing scenes from a movie. If you have a short story, then it makes it easier for the model to think of poses and for both of you to think of props and locations.

- Bathing in the backyard
- Camping in the forest
- Champagne and strawberries in front of the fireplace
- Cheerleader coming to visit
- Choosing the right outfit to wear
- Cleaning in the nude
- Cooking
- Dancing to music
- Female sailor out for a night on the town
- Femme fatale
- Firefighter coming to the rescue
- Flowers all over the place
- Getting dressed to go out
- Getting undressed for bed
- Getting undressed outside
- Going out jogging
- Kids gone for the weekend
- Laundry day and nothing to wear

- Lying on the couch
- Maid's visit
- Making dinner
- Making the bed
- Motorcycle momma
- Nurse coming to treat a patient
- On vacation
- Opening the refrigerator to plan a meal
- Out for a bicycle ride
- Out for a tan
- Overnight camper in an RV
- Painting herself with body paint
- Playing in the rain
- Playing with food
- Putting on lipstick
- Putting on makeup
- Sexy secretary staying after work
- Shaving her legs in the tub
- Skinny-dipping

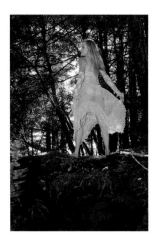

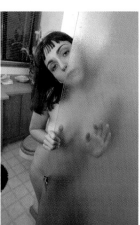

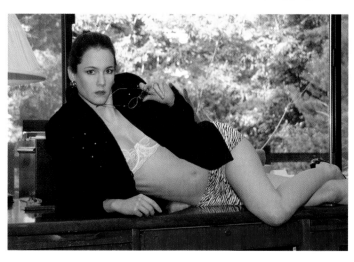

- Soldier coming to capture someone
- Taking a bath
- Taking a shower
- Tempting the repair man
- Trying on clothes
- Vacuuming
- Visiting her husband at the office
- Waiting in the bedroom for her husband to get home
- Waiting in a hotel room for her lover

- Washing dishes
- Wearing lingerie to clean
- Whipped cream adventure
- Woman inviting the viewer into her shower
- Woman stuck on the highway
- Wood nymph tempting the viewer in the woods
- Working in the kitchen on a hot day
- Working out and getting sweaty

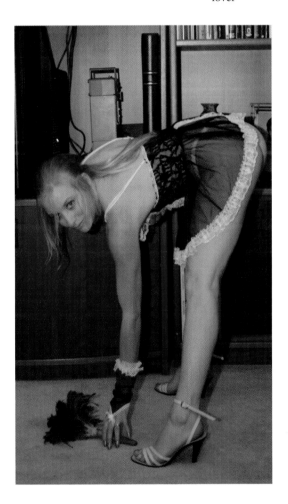
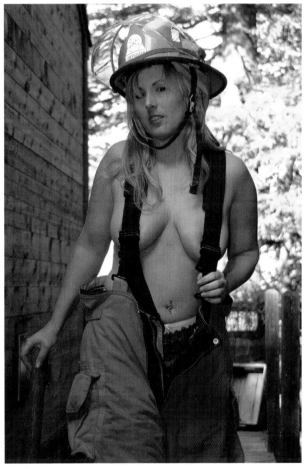

GLOSSARY

There are an incredible number of terms used in digital photography. Here are the definitions of many of them.

35mm camera A popular camera size that uses 35mm film cassettes. Standard lenses for digital cameras are often compared to the same size lens on a 35mm film camera and called "35mm camera equivalent."

accessory shoe The shoe on top of the camera that is designed to hold electronic flashes or other accessories. Most accessory shoes on modern cameras have built-in contacts for an electronic flash. *See also* hot shoe.

ambient light The natural, existing light around a subject that is available without the photographer having to add more. It can be indoors or outdoors.

aperture The opening in the lens that the light travels through on its way to the sensor. The size of the opening is controlled by the camera settings and can be larger or smaller to let in more or less light. A number such as f 5.6 indicates the size of this opening. *See also* f number.

aperture priority A setting on the camera where the photographer sets the aperture desired and the camera automatically sets the shutter speed. A photographer uses this setting when he wants to control the depth-of-field by making it larger (more area in focus) or smaller (less area in focus).

application Refers to the software used on a computer. In digital photography, it is more specifically the software used to transfer the images from the camera to the computer, to process the images, and to save them in a more permanent form.

artifact An unwanted destruction or modification of a pixel or group of pixels which shows up in an image. It is often in the form of small, multicolored halos or other patterns in a photograph.

artificial light Any light that is not natural (from the sun). It can be an electronic flash, floodlights, or any other man-made lights.

ASA Stands for the "American Standards Association." Although they set standards for all kinds of products and measurements, in photography it referred to the speed or sensitivity of the film. It is no longer used and was replaced by "ISO."

aspect ratio A number such as 3:2 that represents the length of a photograph divided by its width. 35mm film and some digital cameras have an aspect ratio of 3:2, and other digital cameras and computer monitors have a ratio of 4:3.

autofocus A feature on most digital cameras in which the camera will determine the correct focus.

automatic aperture Means that the camera will determine the correct aperture for the photograph. The aperture remains open (brighter) until the shutter is pressed, at which time it closes to the correct size to take the photograph.

automatic camera A camera that selects a combination of shutter speed, aperture, and focus to produce a photograph.

automatic exposure (AE) Also called "autoexposure." The camera selects a combination of shutter speed and aperture settings based on its programming and the settings selected by the photographer to create a proper exposure. This "proper exposure" is not necessarily the "best" exposure in any situation. The more expensive the camera, typically the more sophisticated the camera's programming and the more easily it can handle difficult lighting situations. Even the most expensive and most sophisticated camera requires interpretation on the part of the photographer to create the desired image.

automatic flash An electronic flash that connects to a camera and sends information back and forth to select the proper amount of light to match the camera's settings. Like automatic exposure, automatic flash needs the input of a photographer to provide the best results.

automatic lens Remains open, set on its widest aperture, until the shutter is pressed. This is important when using a lens on an SLR camera. It is faster and easier to use and provides a brighter viewfinder on an SLR. The opposite of an automatic lens is a "manual lens." Manual lenses are rarely used with digital cameras except for special purpose lenses.

available light *See* ambient light.

back lighting Lighting coming at your subject from behind. It generally causes a glow around them. You need to watch for flare when using back lighting.

backdrop The scene behind a subject in a photograph. It generally refers to man-made backgrounds in a studio, but a backdrop could be used outdoors as well. *See also* background.

background In a studio, the "background" is the same as a "backdrop." Outdoors, it is whatever is behind the subject in the photograph. *See also* backdrop.

bit The smallest unit in computers. A bit is either one or zero. *See* byte.

bit depth The number of bits of data needed to represent a pixel. A typical digital image needs at least eight bits for each of the three colors (RGB = Red, Green, and Blue), giving a total of 24 bits needed. Some higher-end digital cameras can use 12 bits for each color.

blur When parts of a photograph are "smeared" and lacking in sharply defined edges. Camera or subject movement causes it generally, although the photographer can create it with some cameras by zooming while operating the shutter. It can be used as a creative tool. Don't confuse it with the image being out of focus or when it is caused by undesired camera shake. To eliminate blur, it is necessary to use a faster shutter speed.

boudoir photography Any sexy or glamorous photograph of a woman. Historically it has been photographs of a woman in lingerie in a bathroom or bedroom type of scene.

brightness Along with hue and saturation, brightness makes up the components of color. Brightness refers to the intensity of the light or image.

built-in flash Most digital cameras have a small flash built into the camera. These are often difficult to use and can overexpose or underexpose the image. They are usually not very powerful and are useful only for subjects 10 feet away or less.

byte The basic unit used in computers. It is made up of eight bits.

C curve A pose in which the subject's body is curved into the shape of a "C" more or less.

calibration The process of adjusting any digital device, such as a camera, monitor, printer, or scanner, to reproduce color in a consistent manner. An image file processed on a properly calibrated system will reproduce the same on any calibrated printer or look the same on any calibrated monitor. This is a process that all professional photographers must become proficient at.

camera shake Movement of the camera when the shutter is pressed. It will often cause unwanted blur. To reduce camera shake, hold the camera firmly and rest your body against a tree, wall, or other suitable support. Increasing the speed of the shutter or using a tripod will also help.

catch light The reflection of a light in the subject's eyes. Without it, the eyes often look dull and lifeless. It is often a problem outside when the light is on the side or in the back. Using a flash outside will usually add the catch light back in.

CCD Stands for "Charge Coupled Device." It is the light-sensitive chip used in many digital cameras that is used to generate the image. The small cells, or pixels, on the CCD send electrical signals to the camera's processor to create the image.

CD An abbreviation for compact disc. In digital photography, CDs are often used to store images and to transfer images from computer to computer. CDs vary greatly in quality and can have a life expectancy of anywhere from a few years (if you are lucky) for the really cheap CDs to 100 years or more for the archival, more expensive ones. They typically will hold up to 650 to 700 MB. The actual amount of storage available is somewhat less due to directory size requirements.

CD-R Refers to a CD that can only be written to once. *See* CD.

CD-RW Stands for "CD-Rewritable." Can be written to many times. Because of the possibility of overwriting and changing the information stored on a CD-RW, they are not as useful for long-term storage of images. *See* CD.

cloning A function available in image-editing programs to take a portion of an image and place it over another part of the image. For example a piece of "clean" skin can be cloned or stuck over the top of a blemish to remove the blemish.

close-up When the subject tightly fills the frame of the photograph.

CMOS (Pronounced "C-moss") Stands for Complementary Metal-Oxide Semiconductor. It is a type of image sensor used in some high-end digital cameras.

color balance The relationship of the different colors to each other. Normally, the concept is to adjust the color balance so that it reproduces as accurately as possible the scene that was photographed.

compact camera A small and usually simple camera that is often called a point-and-shoot camera.

CompactFlash A type of memory card used in some digital cameras to store images. Also called a CF card.

compression A technique where the size of an image file is reduced through various computational methods. This makes transmitting or storing images faster and takes up less room. Some methods such as JPEG lose data when they compress (called "lossy"), and others such as TIFF-LZW do not lose data (called "lossless"), but do not compress images as much.

contrast The range of brightness in a scene or photograph. It is the amount of difference between the brightest points, or highlights, and the darkest points, or shadows.

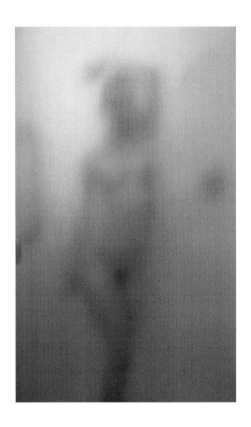

contrasty An image that has a large amount of contrast; for example, an image that has bright sunlight and dark, deep shadows has a lot of contrast.

cropping The method by which portions of an image are removed to improve composition or delete extraneous items from the photograph. It is also the name of a tool in Photoshop.

depth-of-field The distance, or depth, in a photograph that is in focus. It is also sometimes called "depth of focus."

digital camera A camera that uses a light-sensitive image sensor instead of film to record the image.

digital zoom A feature on some cameras that enlarges the image electronically instead of optically. It is not a true zoom and does not do anything that cannot be done later to the image on the computer.

download The process of getting the images from the camera or media card into a computer.

dpi Stands for dots per inch. It is a term used in the printing industry, and it is often used incorrectly in photography to refer to the resolution of a file. *See* ppi.

DSLR A "digital single lens reflex camera." *See* single lens reflex (SLR).

DVD A storage medium that can currently hold up to 4.7 GB. A DVD is the same physical size as a CD and, often, the same drive can be used to create (or "burn") both. New technologies are coming out to allow recording on both sides of special DVDs to double the amount of storage.

editing Sometimes confused with the term "retouching," editing refers to the selection of the best images.

EI *See* exposure index.

electronic flash A device that creates a bright flash of light to add light to a scene. Batteries often power it, although some studio units plug into the wall. The color temperature of the light it produces is similar to daylight, so it mixes well outdoors. Indoors, the light is colder (more blue) than the light produced by ordinary incandescent room lights.

existing light *See* ambient light.

exposure The combination of shutter speed and aperture settings allowing light to pass onto the digital image sensor.

exposure compensation An adjustment that can be set on many digital cameras to change the automatic exposure determined by the camera to better reflect the desires of the photographer.

exposure index Also called "EI." This is a number reflecting how sensitive a particular setting on the camera will be to light. It is a rating used by digital cameras to represent how they would act if the sensor were film instead of electronic.

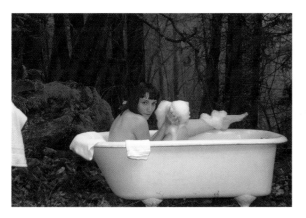

f-number Refers to how much light a lens will pass. The smaller the number, the more light it will let through. Usually the smaller the number, the larger the diameter of the front glass will need to be to let in the additional light. In addition, the smaller the number, the more expensive the lens will be. It is a number that relates the size of the focal length of the lens to the diameter of the lens.

f-stop The f-number setting on the lens. The generally used whole f-stops are 1.4, 2, 2.8, 4, 5.6, 8, 11, 16, 22, and 32. There are sometimes numbers in between, such as f1.8, which are partial f-numbers. Note that each f-stop provides twice as much light as the one above it. So f2.8 allows in twice as much light as f4.

fast lens A lens that has a larger aperture opening, allowing more light to enter the camera.

file format The generic term for the method of storing an image in digital form. JPEG, TIFF, and RAW are common types of file formats, but there are many more.

fill flash A method of using an electronic flash to add light to a scene to reduce the contrast. It is often used outdoors to remove shadows from a face or to brighten it.

fill lighting Similar to "fill flash" except that the lighting does not have to be from a flash. It could be from a reflector or a floodlight among other kinds of lighting.

film speed A measure of how much light is needed to provide an exposure on film. It is also a generic term that refers to a similar amount of light falling on a digital sensor. The "faster" the speed, or the higher the number, the less light that is needed to produce an exposure. There is usually a penalty paid in either increased grain (film) or increased noise (digital) when a higher speed is selected.

FireWire A technical specification and type of cable used to transfer data or images from one digital device to another. FireWire is faster than USB, another technical specification. It is also called IEEE 1394.

flare The bright light hitting the camera that causes a reduction in contrast and bright streaks or patterns in the image. Usually shooting into the light or having an object in the scene reflecting light directly into the lens causes flare. The use of a lens hood or other shading device will help to reduce this, as will moving to a different angle.

flash A sudden bright light used to add light to a scene. Today it almost always refers to an electronic flash, built-in or added on, although flash bulbs and flash powder have been used in the past.

flash exposure compensation Similar to "exposure compensation" except that it refers to an adjustment to increase or reduce the amount of light produced by the flash on the camera.

flash fill *See* fill flash.

flat lighting Lighting that produces little or no shadow. This results in an image that is lacking in light direction and contrast. Generally some contrast is desirable in a photograph.

floodlight A regular, incandescent light bulb used to light a scene, generally indoors. The light is continuous rather than an electronic flash and is usually quite warm. The color temperature of the bulb is warmer (more red) than daylight or an electronic flash.

focal length Tells the relative angle of view of a lens in comparison to other lenses. With digital cameras, it is related to a 35mm equivalent, the results of the lens if used on a 35mm film camera. The number is expressed in millimeters, or "mm." It is calculated by setting the focus of the lens to infinity and measuring the distance between the focal

point of the lens and the film plane or image sensor location. The focal length of a lens is usually engraved around the end of the lens or on the lens barrel. Lenses around 50–55mm are considered "normal" lenses because they approximately reproduce the angle of view of the human eye. Lens smaller than that are wide angle, showing a wider field of view in the image than the human eye. Lenses larger than that are telephoto, magnifying the scene so that everything appears closer.

focus An image is said to be "in focus" when it is sharp and well defined. Focus is also the process of adjusting the sharpness.

foreground Everything closest to the camera or in front of the main subject is considered the foreground.

formatting The preparation of the digital camera's memory card to receive images. It is similar to erasing the memory card. To avoid problems, it is best to format the memory card in the camera and not in a computer. It should be done every time after you have downloaded the images from the camera into the computer. Be careful when you format. It essentially erases the images from your memory card, although there is some software that can reverse the process if you have not taken any additional photographs yet. Sometimes formatting is also called initializing.

gigabyte (GB) About 1,000 megabytes, or about a billion bytes. It is a unit used to specify the size of camera media cards and disk drives.

grayscale Another term for a black-and-white image. Because there are no colors, just shades of gray, grayscale is a way of representing a black-and-white digital image without using RGB, thus it is one-third the size. Because it uses a bit depth of eight, there are 256 different shades of gray including pure white and pure black.

guide number A number assigned to electronic flash units to indicate how powerful they are. The higher the guide number, the more powerful the flash is. Use this number with caution. Manufacturers have been known to exaggerate this number by the way they measure it. It is dependent on the sensitivity setting of the camera, so the number is usually quoted, by convention, at an ISO of 100. The guide number is equal to the aperture (f-stop) times the distance from the camera to the subject and will reference either feet or meters. Thus a guide number of 40 means that you could use f4 at 10 feet. Usually, this number is useful when purchasing different flash units as a way to judge how powerful a flash unit is, but otherwise is not used very often with automatic cameras.

hard lighting Lighting that produces sharp shadows. It is produced when the apparent size of the light source is small in comparison to the subject size. Thus the sun produces a hard light, but a hazy day produces a soft light because the entire sky becomes the light. Usually in boudoir photography, soft lighting is more flattering and what we aim for unless we are trying to produce a special effect.

high contrast The opposite of flat lighting. When an image or scene is high in contrast, that means there are fewer tones between black and white.

high key An image made up mainly of light tones. An example would be a woman wearing a white dress on a white background. If done properly, a high-key image can be very striking because the skin tones stand out in contrast to everything else.

highlight The brightest part of an image.

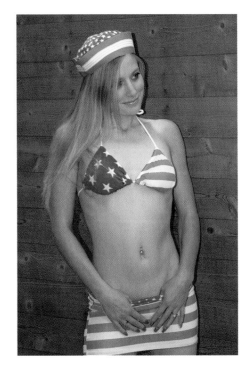

histogram A feature available on many digital cameras that shows a graphical representation of how many of each tone a photograph has in it. When an image is displayed on the camera's LCD (or in Photoshop), there is a button to activate and display a small graph. The graph should be a curve starting at the left (dark tones) side, rising in the center, and falling on the right (light tones) side. If the curve is not centered or is "piled up" at one end, it often indicates an exposure adjustment would be useful.

hot shoe What the accessory shoe on a camera is called when it has contacts that match up with the contacts on an electronic flash so that no cord is necessary.

HSB An abbreviation for the three parts of color: hue, saturation, and brightness. See each term separately.

hue The representation of color, often using a color wheel.

image browser Software or a computer program used to view images. An image browser is usually built into each computer and usually comes on a CD of software with each digital camera.

image-editing program A piece of software used to make corrections to images. Photoshop is an example of an image-editing program. Digital cameras usually come with an image-editing program on their software CD.

image resolution *See* resolution.

initializing *See* formatting.

inkjet A type of printer used to print images that operates by spraying tiny droplets of ink onto the paper. It usually uses ink in the colors of cyan, magenta, yellow, and black, the standard colors used in printing presses as well.

interpolation A technique used by computer programs such as Photoshop to enlarge images by creating pixels in between existing pixels. If done properly, and not to a high degree, it will result in a larger image than the original.

ISO Stands for "International Organization for Standardization," the replacement of ASA to set standards for many businesses and technologies. In photography it is used as a measurement of film speeds and now digital camera sensitivity. Thus you have ISO 400.

JPEG Stands for "Joint Photographic Experts Group." It is a file format widely used in digital photography. The file format compresses the size of digital images by throwing away data that the algorithm believes is duplicated. The amount of compression determines the amount of data that is thrown away. In Photoshop, the compression can be set from 1 (most) to 12 (least). Each time you open and resave the image, it throws away data and gets progressively worse. This should obviously be avoided. It is called a "lossy format" because some data is lost. The format of the filename is sample.jpg.

lens hood A device attached to the end of a lens to help shade the lens from light and prevent flare. Sometimes the lens hood is built in and simply slides out. Other times it is a separate device that must be snapped in place. Zoom lenses or wide-angle lenses often have a funny, almost flower-shaped lens hood because of how wide the lens sees. It is sometimes called a lens shade.

lens speed A rating of a lens based on its widest aperture or smallest f-number. A "faster" lens has a smaller f-number.

Liquid Crystal Display (LCD) The small display screen on the back of most digital cameras. This is one of the most powerful features of digital photography—instant feedback. Do not use LCD screens to judge exposures. Only histograms can help you there.

lossy format Refers to a file format that compresses a file to save space by throwing out or losing data. *See* JPEG.

low key The opposite of "high key." The tones in the image are usually middle or dark with no light-colored objects.

luminosity The brightness of a color.

manual focus The opposite of autofocus. The focus must be done by the photographer by hand instead of letting the camera do it. Manual focus is also a feature on some cameras that can be used in difficult situations where the scene is changing faster than the camera can focus, where the desired focus point is different from what the camera can select, or when objects are moving in between the camera and the subject, fooling the autofocus system.

media Where images are stored. Memory cards, CDs, and DVDs are all examples of media. *See* memory card.

megabyte (MB) A measure of how large an image is when it is opened up or stored in an uncompressed format. Although mega means million, a megabyte is actually 1,048,576 bytes due to the way measurements are done on computers.

megapixel (MP) Refers to how many pixels a camera uses. Mega means million, so a 3 MP camera has 3 million pixels.

memory card The device inserted into a camera on which to store images. It could be considered "digital film." *See* media.

midtones The tones in the middle between highlights and shadows. They are also called average tones.

model release Permission given by a model for a photographer to use an image in the way defined by the release. A model release is best done in writing and is governed by individual state laws in the United States or by the laws of other countries. Since a model release is a contract, the model must be given something of value in return. Things other than money can be "something of value," but that varies in each state or country.

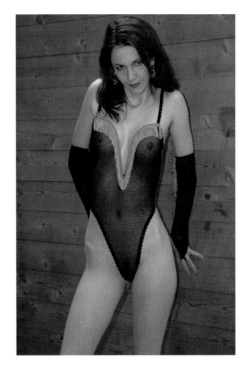

natural light Generally refers to light outdoors, so it means sunlight or naturally reflected sunlight.

noise Some people call noise "digital grain." However, noise is rarely an attractive feature of an image, whereas film grain can be. It can be recognized as multicolored speckles throughout the image. Noise is usually caused by too little light so that the image has to be enhanced electronically, either in the camera or after the fact. Noise is reduced by adding more light, increasing exposure time, reducing the ISO sensitivity, or all of the above.

normal lens A lens that closely approximates the view of a human eye. The 35mm equivalent is around 50–55mm.

on-camera flash A flash attached directly to the hot shoe of the camera.

optical zoom A zoom lens where the focal length of the lens changes by twisting, pulling, or pushing a button. The focal length of the lens changes by moving the various optical glass elements in relation to each other. It is a useful and convenient lens to have on the camera. It is usually just called a zoom lens.

overexposure When too much light arrives on a light sensor. Usually the image is very light with no detail in the highlights and few or no blacks in the image.

Photoshop A popular and somewhat expensive photo manipulation software made by Adobe. Professional digital photographers usually need to be familiar with and use this program or else pay someone else to do it.

pixel The smallest digital photographic element. It stands for picture (or "pix") element. Each pixel is made of a red, green, and blue (RGB) component.

pixelation The undesirable effect of seeing the image break down into pixels where the sizes of the individual pixels are larger than the detail in the image. Enlarging an image too much usually causes pixelation.

point and shoot Refers to a simple type of digital camera. *See* compact camera.

portfolio A group of images, usually in a nice folder or notebook, to show off the work of a photographer or model. It should show their style, range, and experience. It is used to show prospective clients.

pose The position of the subject in an image. It can be an intentional or unintentional position.

posing The act of making a pose. The posing can be done by the model or directed by the photographer.

ppi Stands for pixels per inch.

RAW A format offered by some digital cameras that stores the unprocessed electrical signals from the sensor in a special format. The RAW format is usually different for each camera. The advantage of the RAW format is that many decisions on things like white balance or color temperature can be decided by the photographer later and processed in the computer rather than in the camera. The photographer can try a number of options until he gets the image exactly the way he wants it. The disadvantages of the RAW format is that the file format takes up more storage space on the digital memory card, the camera often works more slowly, and it takes more post-production time at the computer.

recycling time Refers to the period of time after an electronic flash has fired until it is ready to be fired again. This period usually increases as the batteries get weaker.

red eye When subject's eyes appear to be red. The irises of the eyes are red instead of black because light from the flash is reflected back from inside of the retina directly to the camera. It can be avoided by moving the flash head away from the center of the lens either to one side or higher on an arm. It is difficult to do with many hot shoe flashes.

red-eye reduction A feature of some cameras where the flash has multiple short bursts of light before the main flash to reduce the size of the iris of the subject's eye so that there is less red reflection.

reflector Any object that will reflect light to use in a photograph. It can be a large white piece of cardboard, a sheet, or foil glued to a board.

reflector fill A way to reduce harsh shadows with a reflector instead of a fill flash.

removable media *See* media and memory card.

resolution A measure of how much fine detail is in an image either in a printer or a camera. It is often measured by pixels per inch (ppi).

retouching Changing things in photographs to reflect what the photographer saw in his mind rather than what was really there. Examples include the removal of blemishes not hidden by makeup, fixing straps that should not have been seen, or other kinds of manipulations.

RGB Stands for Red Green Blue, the three colors used to form a digital photograph.

Rule of Thirds A compositional technique. Dividing an image into three equal sections vertically and three horizontally gives an image with nine rectangles, sort of like having tic-tac-toe inscribed on the image. The four junctions where the lines meet are good areas for subject placement when composing a photograph.

S curve A way of describing the curved shape of a woman's body when it is posed in the shape of an "S." It is often a very graceful and elegant way to pose a woman.

saturation One of the three components of color and refers to the purity of the color. When a color is saturated, then it is the purest color possible.

SD memory card Stands for Secure Digital card. It is a physically very small type of memory card. *See* memory card.

shadow The darker portions of an image.

shadow detail The amount of detail that can be seen in the darkest shadow portions of an image.

sharpness The amount of definition between adjacent elements of a photograph. An image is said to be sharp when the edge between lighter and darker portions is very fine.

shutter The part that covers the aperture and is removed to take a photograph. The shutter blocks light from traveling through the lens and striking the image sensor on a digital camera. It can be made of curtains or blades.

shutter lag The amount of time between when the shutter release is pressed and the shutter fires. The best camera manufacturers try to make this time as short as possible. Be sure to test any camera before you buy to make sure any shutter lag will work okay with your subject matter.

shutter priority An automatic setting on a camera allowing the photographer to specify the shutter speed and have the camera select the aperture. It is often used when, for artistic effect, the photographer wants to use a slower shutter speed than the camera would normally select.

shutter speed The period of time that the shutter is open, allowing light to reach the image sensor. The faster the shutter speed, the less light reaches the sensor.

side lighting When the subject is lit by light coming from one side.

silhouette When the subject is dark and has no detail, but the background is lighter and is well exposed.

single lens reflex (SLR) A type of camera where the optical viewfinder sees through the same lens as the light sensor. This type of camera allows the photographer to see exactly what he will be photographing. It also allows the changing of lenses. SLRs are typically more expensive than other types of cameras due to their greater complexities.

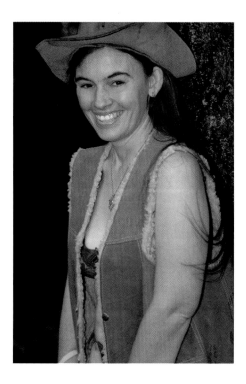

soft lighting The opposite of "hard lighting." It is lighting that produces shadows without a sharp edge. It is generally more flattering to women than hard lighting. It is produced by any light source that is large in comparison to the subject. The larger and closer a light source is to a subject, then generally, the softer it is.

stop A term used to describe either doubling or halving the amount of light, which equals "one stop." *See* f-stop.

studio Generally refers to an indoor location, such as a room, used just for photography. The photographer has complete control over many elements of an image such as lighting.

subject The main focus of the image.

telephoto Has a narrower field of view than the human eye does. It brings everything closer.

test shots An older term used when a photographer and a model worked together to create images for their portfolios. It is often replaced by the terms TFP or TFCD.

TFP/TFCD Stands for "trade for prints" or "trade for CD." It is a method of a photographer and a model working together for mutual benefit where the model trades a model release for either prints or a CD of selected images.

thumbnail A small representation of an image. It is usually grouped together with a number of other, similarly sized images so that a quick glance allows you to look at a group of images. They can be shown on a computer monitor or printed on a sheet of paper.

TIFF Stands for "Tagged Image File Format." It is a file format that is very commonly used. It takes up more space than a JPEG image, but it does not lose information when it is repeatedly opened and resaved. Any image that will be worked on should be saved in the TIFF format rather than JPEG. TIFF images are identified by having the letters "tif" after the period in the filename, as in sample.tif.

tripod A three-legged device designed to hold a camera steady to avoid camera shake on longer exposures.

tungsten light A type of light, usually called incandescent light, that is a continuous light rather than a flash. Typical room lights are tungsten, but not fluorescent lights. The color temperature is warmer (more red) than an electronic flash or daylight and compensation must be made for that.

ultra-wide-angle lens A very wide-angle lens, usually 24mm or wider. The photographer needs to be careful when using such a lens to keep his feet out of the image.

underexposure Where the image is too dark because not enough light reached the sensor to create a proper exposure. Although some corrections can be made, the resulting image will not be as good as if a proper exposure was done in the beginning. Extra noise often ends up in the darker areas of an image.

unsharp masking *See* USM.

USB Stands for Universal Serial Bus. It is another technical specification for transferring data between digital devices. It is slower than FireWire. USB2 is an updated and faster version.

USM An abbreviation for "unsharp masking." Although it is called "unsharp," it is actually a technique used to increase the apparent sharpness of an image by increasing the contrast of pixels next to each other. Programs such as Photoshop have the ability to perform USM.

white balance A control on digital cameras used to adjust how colors are recorded on a camera so that white appears white. Most digital cameras have settings like "auto," "tungsten," "daylight," and so on.

wide-angle lens A lens that has a wider field of view than the human eye or a "normal" lens.

window light The light illuminating an indoor scene that comes through a window. Normally, it is not direct sunlight, but a softer light from the sky areas.

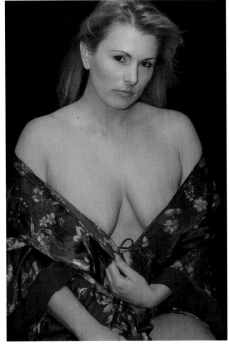

zoom *See* zoom lens.

zoom lens A camera lens with a variable focal length. It is probably the most popular type of lens in use today. Nearly all digital cameras with nonremovable lenses have zoom lenses built-in.

SUGGESTED READING

Here is a listing of books on topics similar to boudoir photography, along with a brief description or review of the book. It is difficult to recommend particular books because it depends on your taste in photography, your skill and experience level, and where you want to go next.

Photoshop

Title: *Adobe Photoshop CS: The Art of Photographing Women*
Author: Kevin Ames
ISBN: 0-7645-4318-0
Publisher: Wiley Publishing, Inc
Year published: 2004

If you are looking for detailed instructions on how to use Photoshop to make your images of women look great, then this is the book for you. The author goes into great detail and includes a large number of photographs to show you exactly what to do. Although this book uses Photoshop CS instead of the current Photoshop CS2, much of the information is applicable. There is no nudity in this book.

Glamour, Nude, and Figure Photography

Title: *Professional Secrets of Nude and Beauty Photography*
Author: Bill Lemon
ISBN: 1-5842-8044-1
Publisher: Amherst Media
Year published: 2001

Maybe too revealing for many people's tastes. It is limited to black-and-white photography. It is really directed at more advanced photographers and does not go into enough depth for beginners. It uses professional models. With those limitations, it is a good book overall.

Title: *Erotique Digitale: The Art of Erotic Digital Photography*
Authors: Roderick Macdonald; Minnie Cook
ISBN: 1-59200-526-8
Publisher: Course Technology
Year published: 2005

May be too revealing for many people's tastes. Beautiful photographs using professional models. Very creative ideas for more advanced photographers interested in the nude as a subject.

Title: *Digital Nude Photography*
Author: Roderick Macdonald
ISBN: 1-59200-105-X
Publisher: Muska & Lipman/Course Technology
Year published: 2004

May be too revealing for many people's tastes. Not enough detailed technical informa-
tion to suit a beginner, but a beautiful book with detailed information for the more
advanced photographer. The photographer used young, professional models with per-
fect bodies, not the kind of women available to the average photographer.

Title: *Classic Nude Photography: Techniques and Images*
Authors: Alice Gowland; Peter Gowland
ISBN: 1-58428-0409
Publisher: Amherst Media
Year published: 2000

May be too revealing for many people's tastes. It was written by one of the best-known
old-school, glamour-style photographers. It is limited to black and white and uses pro-
fessional models. This is a great book for those interested in classic nude photography
since it is a history of the genre using the authors' images from the 1940s to current
day.

Title: *A Comprehensive Guide to Digital Glamour Photography*
Author: Duncan Evans
ISBN: 2-8847-9047-0
Publisher: AVA Publishing
Year published: 2005

Uses professional models. May be too revealing for many people's tastes.

Title: *Nude & Beauty Photography: Kodak Pro Workshop Series*
Author: Nancy Brown
ISBN: 0-8798-5774-9
Publisher: Silver Pixel
Year published: 2001

May be too revealing for many people's tastes.

Title: *Classic Glamour Photography: Techniques of the Top Glamour Photographers*
Author: Duncan Evans et al
ISBN: 0-8174-3673-1
Publisher: Amphoto Books
Year published: 2003

No information on digital photography. Impressive photographs, but it is not directed
at beginners. Its technical explanations are too brief for beginners. It uses gorgeous
professional models.

Photographing Women

Title: *How to Photograph Women Beautifully: Professional Techniques for Creating Glamorous Pictures*
Authors: J. Barry O'Rourke; Michael A. Keller
ISBN: 0-8174-4018-6
Publisher: Amphoto Books
Year published: 2002

Written by J. Barry O'Rourke, a very well-known beauty and glamour photographer. He relies on a ton of professional equipment, a studio, and assistants. These are things not usually available to amateurs and beginners. Images are beautiful and the book is great for more advanced photographers.

Model Photography

Title: *Professional Model Portfolios: A Step-by-Step Guide for Photographers*
Author: Billy Pegram
ISBN: 1-58428-1375
Publisher: Amherst Media
Year published: 2004

Very good book for professional photographers trying to photograph professional models for fashion and their portfolios, and for models trying to get into "the business." Not as much information for beginners, those interested in the technical side of using digital photography, or those wanting to create intimate portraits.

ALL GOOD THINGS MUST COME TO AN END...

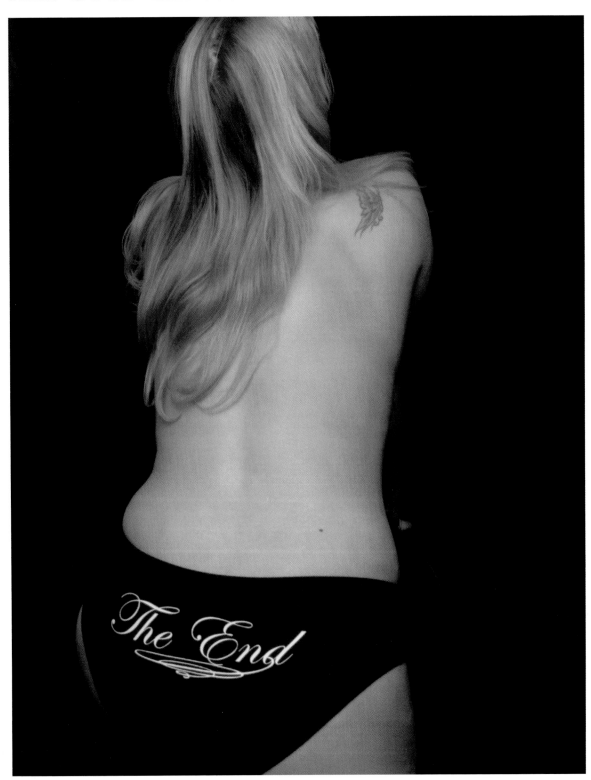

INDEX

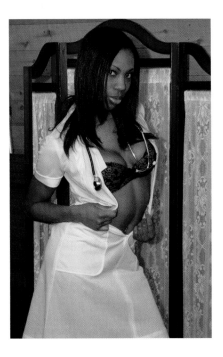

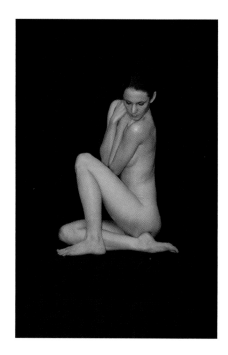

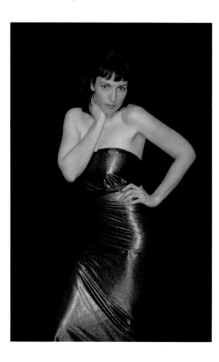